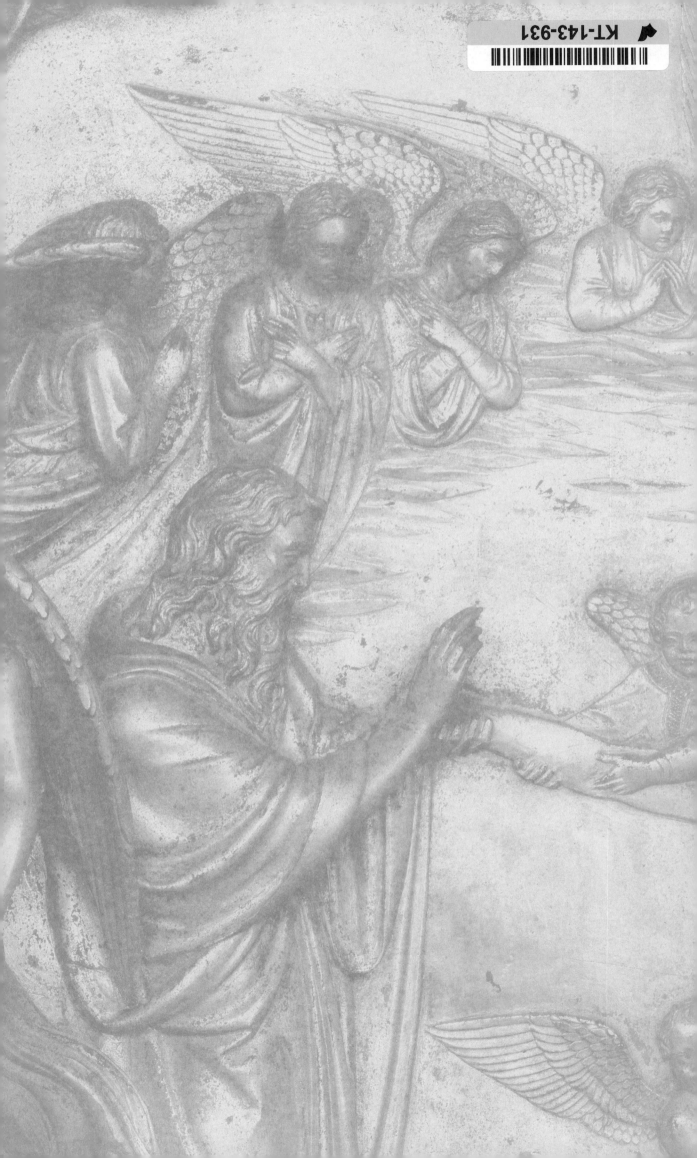

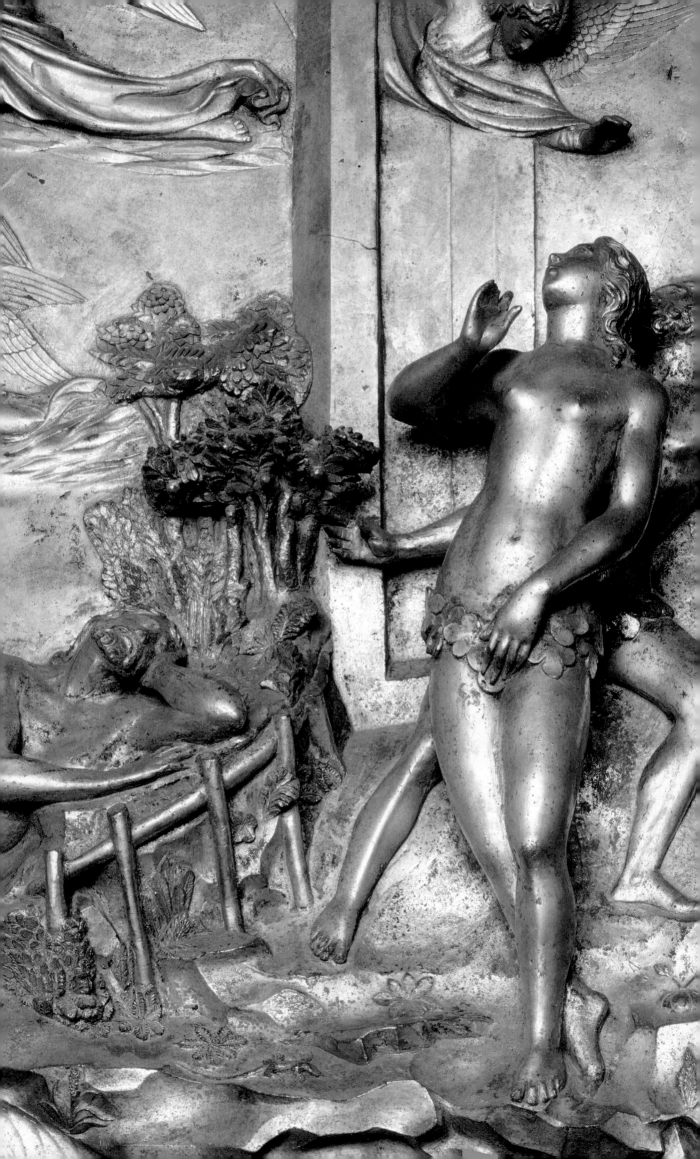

The Gates of Paradise

LORENZO GHIBERTI'S RENAISSANCE MASTERPIECE

Edited by Gary M. Radke

With contributions by Andrew Butterfield

Margaret Haines

Francesco Caglioti

Annamaria Giusti

Edilberto Formigli

Salvatore Siano

Piero Bertelli

Ferdinando Marinelli

Marcello Miccio

Francesca G. Bewer

Richard E. Stone

Shelley G. Sturman

HIGH MUSEUM OF ART, ATLANTA

YALE UNIVERSITY PRESS, NEW HAVEN AND LONDON

in association with

OPERA DI S. MARIA DEL FIORE, FLORENCE

Contents

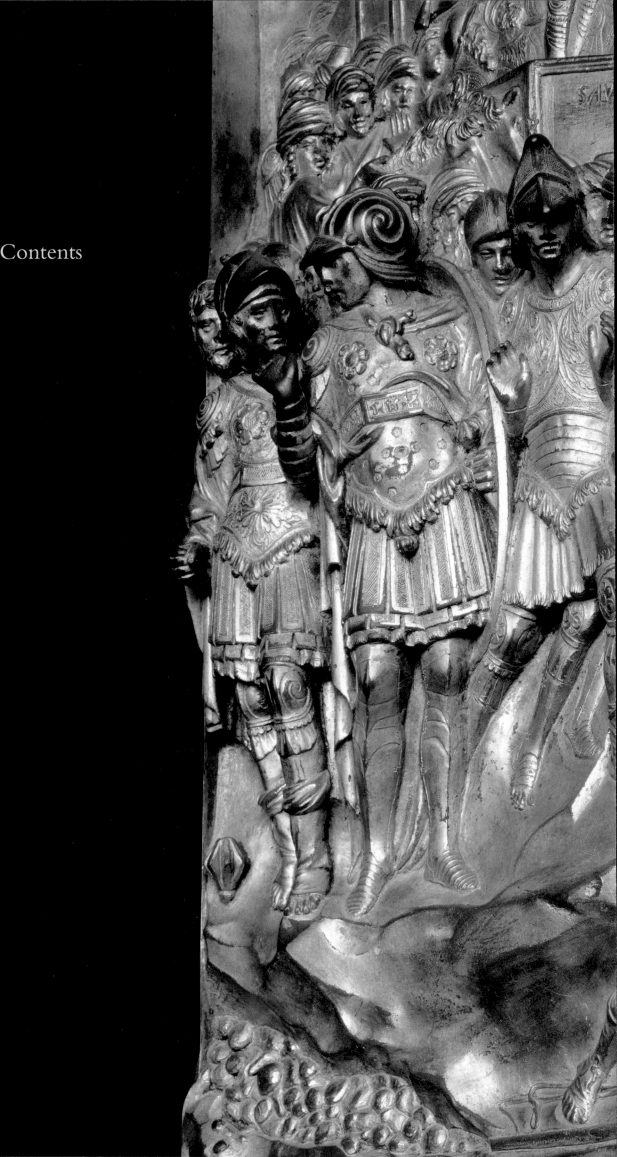

The Gates of Paradise: Lorenzo Ghiberti's Renaissance Masterpiece is organized by the High Museum of Art in collaboration with the Opera di Santa Maria del Fiore and the Opificio delle Pietre Dure in Florence, Italy.

This project is supported by an award from the National Endowment for the Arts, which believes that a great nation deserves great art, and by an indemnity from the Federal Council on the Arts and the Humanities. Additional support is provided by the Samuel H. Kress Foundation.

Regional support in Atlanta is provided by Delta Air Lines, Joan N. Whitcomb, and the Paul and Monica Hagedorn Family Foundation.

The exhibition catalogue is underwritten by a generous grant from The Andrew W. Mellon Foundation.

Published on the occasion of the exhibition
The Gates of Paradise: Lorenzo Ghiberti's Renaissance Masterpiece

High Museum of Art
Atlanta, Georgia
April 28–July 15, 2007

The Metropolitan Museum of Art
New York, New York
October 30, 2007–January 13, 2008

Art Institute of Chicago
Chicago, Illinois
July 28–October 13, 2007

Seattle Art Museum
Seattle, Washington
January 26–April 6, 2008

Director of the Restoration, 1980–1996
Loretta Dolcini, Opificio delle Pietre Dure

Director of the Restoration, 1996–present
Annamaria Giusti, Museo dell'Opificio delle Pietre Dure

Scientific Team
Salvatore Siano, Physicist, Istituto di Elettronica Quantistica, CNR, Florence
Edilberto Formigli, Director, ANTEA, Archeometria e Archeologia Sperimentale
Marcello Miccio, Radiologist, Soprintendenza per i Beni Archeologici per la Toscana
Opificio Scientists
Daniela Pinna, Director, Scientific Laboratory, Opificio delle Pietre Dure
Mauro Matteini, former director, Scientific Laboratory, Opificio delle Pietre Dure
Simone Porcinai, Chemist, Opificio delle Pietre Dure

Restorers of the Porta del Paradiso
Fabio Burrini, Head of Bronze Restoration, Opificio delle Pietre Dure
Stefania Agnoletti, Restorer, Opificio delle Pietre Dure
Annalena Brini, Restorer, Opificio delle Pietre Dure
Paolo Nencetti, Restorer, Opificio delle Pietre Dure
Ludovica Nicolai, Independent Restorer

Preface

FOR A VARIETY OF REASONS, the Board of Directors of the Opera di Santa Maria del Fiore is extremely pleased to be able to loan three of the ten panels from the Gates of Paradise, part of the San Giovanni Baptistery, to four prestigious museums in the United States. The Gates of Paradise is Lorenzo Ghiberti's masterpiece and an icon of Florentine Renaissance art.

First of all, we see this major loan as a way of expressing sincere and well-earned thanks on behalf of the Opera as well as the people of Florence to the young Americans who, forty years ago, after the damaging flood of 4 November 1966, hurried to Florence to help rescue works of art. The Gates of Paradise from the San Giovanni Baptistery was one of the more renowned victims of the water that overflowed the banks of the Arno. In 1990, it had to be removed from its site and replaced with a copy so that the original could be entrusted to the care of the experts at the Opificio delle Pietre Dure, who several years earlier had begun restoring panels that had suffered water damage.

We also consider the loan of this work a way of allowing a wider audience to view the impressive abilities of the Italian restorers who have returned Ghiberti's masterpiece to its original splendor through more than twenty-five years of painstaking and careful work. It should also be noted that the four venues of this tour in the United States will represent the last chance for the panels to be viewed outside of the Museo dell'Opera. Indeed, now that the entire door has been restored, it will be reassembled inside the museum, from which it will no longer be possible to remove it.

We are especially pleased to loan this work to four such prestigious museums. One of the purposes of the Opera di Santa Maria del Fiore is to publicize the extraordinary value of the works of art comprising the Santa Maria del Fiore complex, and we believe that this loan represents an exceptional opportunity to promote the Florentine Renaissance to an American audience. Displaying this work in these four wonderful museums will allow the public to appreciate one of the masterworks of our country's cultural patrimony. It will also serve as a very compelling invitation to visit Italy, and especially Florence, in order to further explore an artistic heritage that belongs not just to Italians, but to all humanity.

Finally, I'd like to express my gratitude to the Board of Directors of the Opera di Santa Maria del Fiore and to the directors of the four museums: Michael Shapiro of the High Museum of Art in Atlanta, James Cuno of the Art Institute of Chicago, Philippe de Montebello of The Metropolitan Museum of Art in New York, and Mimi Gates of the Seattle Art Museum. I'd also like to thank Angelica Rudenstine of The Andrew W. Mellon Foundation and Gary Radke. All have contributed with great enthusiasm and energy to the organization of an event that represents a laudable example of the impressive synergy between American and Italian cultural institutions.

Anna Mitrano
President, Opera di Santa Maria del Fiore

Foreword and Acknowledgments

AFTER MORE THAN twenty-five years of work, the restoration of Lorenzo Ghiberti's Gates of Paradise at the Opificio delle Pietre Dure in Florence is nearing completion. The results—visually splendid and of extraordinary scientific significance—are being celebrated in North America with the unprecedented exhibition of three relief panels depicting stories of Genesis, Jacob and Esau, and David, accompanied by two figurines in niches and two decorative heads from the frame. These individual elements will soon be reintegrated with the rest of the door and put on permanent display in a hermetically sealed case in the Museo dell'Opera del Duomo, never to travel again.

The essays in this catalogue reflect long engagement with Ghiberti's masterpiece. Since 1980, when restoration activities began, Italian art historians, scientists, and conservators have worked together to uncover the secrets of Ghiberti's technique and to address conservation problems. Thanks to their remarkable collegiality and generosity, scholars from around the world have enjoyed access to the work in progress. Dr. Cristina Acidini, Director of the Opificio delle Pietre Dure, and Dr. Annamaria Giusti, Director of the restoration, have been particularly generous with their time and expertise. Besides welcoming scholars throughout the restoration, in February 2006 they served as co-chairs along with Gary Radke, curator of this exhibition, of an extraordinary interdisciplinary workshop on Ghiberti's technology and creativity.

The workshop was the idea of Angelica Rudenstine, who as Program Officer for Museums and Conservation at The Andrew W. Mellon Foundation secured financial support for arranging this international gathering as well as for the publication of this catalogue, the content of which depends heavily upon research and discussions associated with the workshop. Mrs. Rudenstine also played a key role in encouraging ARTstor and its Director, James Shulman, to undertake an exhaustive photographic campaign of the doors. The results—a collaboration among Florentine photographer Antonio Quattrone and a number of art-historical advisers, chief among them Andrew Butterfield and Francesco Caglioti—allow us to see and appreciate Ghiberti's accomplishments as never before.

We extend our sincere thanks to Anna Mitrano (President) and Patrizio Osticresi (Administrative Secretary) of the Opera di Santa Maria del Fiore, and Cristina Acidini (Superintendent) and Annamaria Giusti (Director) of the Opificio delle Pietre Dure.

We are particularly indebted to Professor Gary Radke, Professor of Fine Arts at Syracuse University and the High Museum's Consulting Curator of Italian Art. Over the past six years, Professor Radke has introduced at the High Museum an impressive series of exhibitions and programs on Italian Renaissance art. His enthusiasm and commitment both to new scholarship and its accessibility are to be celebrated. Professor Radke was assisted by High Museum staff, including Philip Verre, Chief Operating Officer; David Brenneman, Director of Collections and Exhibitions; Patricia Rodewald, Eleanor McDonald Storza Chair of Education; Virginia Shearer, Associate Chair of Education; Julia Forbes, Head of Museum Interpretation; Kelly Morris, Manager of Publications; Angela Jaeger, Manager of Graphic Design; Jim Waters, Exhibition Designer; Marjorie Harvey, Manager of Exhibitions; and Amy Simon, Associate Registrar.

At the Art Institute of Chicago, the exhibition will be administered by Douglas Druick, Searle Chairman, and Bruce Boucher, Curator of Sculpture

and Earlier Decorative Arts, in the Department of Medieval to Modern European Painting and Sculpture. The following have also made valuable contributions: Dorothy Schroeder, Executive Director, Programs and Administration, and D. Samuel Quigley, Vice-President for Collections Management, Imaging and Information Technology. At the Department of Museum Education, we are grateful to: David Stark, Director of Administration and Interpretive Media; Erin Hersher, Coordinator of Education Technology Programs; and Laura Taylor, Coordinator of Communications.

At the Metropolitan Museum, where the reliefs will be installed in the Renaissance setting of the marble patio from Vélez Blanco, the exhibition is under the care of James David Draper, Henry R. Kravis Curator in European Sculpture and Decorative Arts; the department is guided by Ian Wardropper, Iris and B. Gerald Cantor Chairman. The following have also made valuable contributions: Linda Sylling, Manager for Special Exhibitions, Gallery Installations, and Design; Rebecca L. Murray, Associate Counsel; Aileen Chuk, Registrar; Michael Batista, Senior Exhibition Designer; and Richard E. Stone, Senior Museum Conservator.

At the Seattle Art Museum we would like to acknowledge Chiyo Ishikawa, Deputy Director of Art and Curator of European Painting and Sculpture, for bringing this project to the forefront and to Maryann Jordan, Senior Deputy Director, for her support and encouragement. Dr. Bruno Santi, Soprintendente per il Patrimonio Storico, Artistico, ed Etnoantropologico delle Province di Firenze, Pistoia e Prato, an esteemed friend of the Seattle Art Museum, deserves our gratitude for speaking on our behalf when the Seattle venue was proposed as a late addition to the tour. We are proud to bring this exhibition to the West Coast and are indebted to Philip Isles, Robert Lehman Foundation trustee, for immediately recognizing the wonderful opportunity to bring the masterpiece to Seattle.

Grants for the project have been awarded by the National Endowment for the Arts and the Samuel H. Kress Foundation. The exhibition catalogue is underwritten by a grant from The Andrew W. Mellon Foundation. We are indebted to these organizations and their staff for understanding the importance of this exhibition through their generous support. We also wish to acknowledge the significant support that the project has received through an Indemnity from the Federal Council on the Arts and Humanities. Finally, we wish to extend our personal and institutional gratitude to Angelica Rudenstine, Program Officer for Museums and Conservation at The Andrew W. Mellon Foundation, for her individual commitment, counsel, and participation in a series of projects over the past three years that have culminated with the exhibition *The Gates of Paradise: Lorenzo Ghiberti's Renaissance Masterpiece*.

Michael E. Shapiro
Nancy and Holcombe T. Green, Jr. Director
High Museum of Art

James Cuno
President and Eloise W. Martin Director
The Art Institute of Chicago

Philippe de Montebello
CEO and Director
The Metropolitan Museum of Art

Mimi Gates
The Illsley Ball Nordstrom Director
Seattle Art Museum

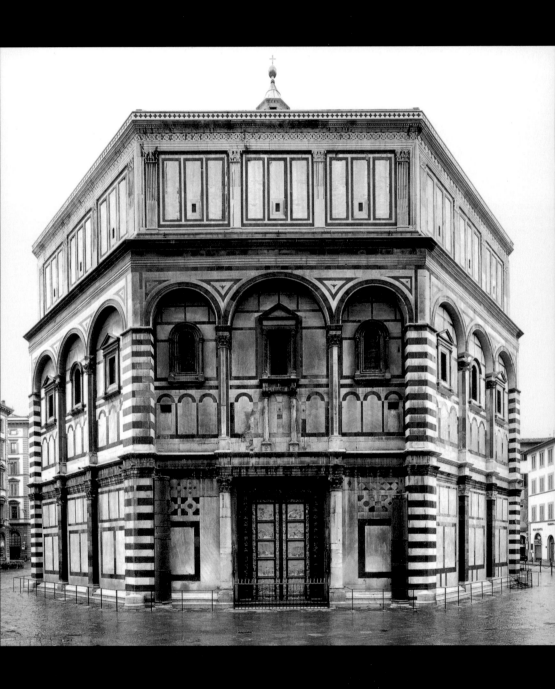

Baptistery of San Giovanni, Florence, showing the
east doors—The Gates of Paradise.

Adam and Eve

Cain and Abel

Noah

Abraham

Jacob and Esau

Joseph

Moses

Joshua

David

Solomon and Sheba

Chronology of
Lorenzo Ghiberti's Life

Aldo Galli

Professor of Art History
University of Trent

1378–1380

Lorenzo Ghiberti is born in Florence.

1400–1401

In order to escape an epidemic in Florence, Ghiberti goes to Pesaro in the company of a painter, probably Mariotto di Nardo, with whom he paints in the service of the local lord, Malatesta IV.

1401–1402

Ghiberti wins the competition to design the doors of the Baptistery in Florence.

23 NOVEMBER 1403

The Calimala (Wool Merchants Guild) signs a contract for the doors with Ghiberti and his stepfather, Bartolo di Michele.

1404

Ghiberti supplies a design for the circular stained-glass window of the Assumption on the façade of the Florence Cathedral and also designs the window frames of the Cathedral tribune.

1 JUNE 1407

A new contract for the doors is agreed upon between the Calimala and Ghiberti alone.

3 AUGUST 1409

Ghiberti matriculates as a goldsmith and metal sculptor in the Arte della Seta.

1410

Ghiberti is elected *operaio a vita* (lifelong building supervisor) for Orsanmichele and furnishes designs for the portals of the oratory, which would not be completed by stonecutters until 1420.

1412

Ghiberti furnishes designs for the rose windows depicting Saint Lawrence and Saint Stephen on the façade of the Cathedral. He receives the commission to create a bronze statue of Saint John the Baptist for the niche of the Calimala guild at Orsanmichele.

1414

Saint John the Baptist is cast; at the same time, the stonecarver Albizo di Piero works on the niche, following a design by Ghiberti (see fig. 3.6).

1417

Last touches are made to the *Saint John the Baptist* (fig. 1.1) and it is installed in its niche. On 21 May, following various contacts and at least two trips to Siena, Ghiberti receives a commission for two of the reliefs for the baptismal font of Siena Cathedral. Tommaso, the first child of Ghiberti and his wife, Marsilia, is born.

1418

Goldsmith Guariento di Giovanni realizes two silver candlesticks for Orsanmichele based on a design by Ghiberti. Ghiberti is among those who submit a model in the competition for the cupola of the Florence Cathedral. This is probably the year in which Vittorio Ghiberti is born.

1419

Ghiberti creates a miter and morse for Pope Martin V, who is staying in Florence shortly after his elevation. Ghiberti also designs the staircase of the papal apartment that is set up in the convent of Santa Maria Novella. He receives a commission from the Bankers Guild (Arte del Cambio) for a statue of Saint Matthew for the Guild's niche at Orsanmichele.

Figure 1.1 Lorenzo Ghiberti, *Saint John the Baptist,* detail of face, bronze inset with silver, 1414–1417, Orsanmichele, Florence.

1420

Ghiberti inscribes this date on the figure of *Saint Matthew*. Ghiberti is involved with the execution of wooden stalls for the Strozzi sacristy at Santa Trinita in Florence. It is highly likely that he designed the overall plan of the complex; the design of the portal and windows appears to be by his hand.

1421

Michelozzo collaborates on the casting of the *Saint Matthew*. Probably in this year Ghiberti also creates a precious silver gilt reliquary of Beata Villana on commission from Fra Sebastiano Benintendi, descendent of the holy woman and a Dominican friar at Santa Maria Novella.

1422

After a failed first attempt, the *Saint Matthew* (fig. 1.2) is cast and chased. Stonemasons Jacopo di Corso and Giovanni di Niccolò are at work on the niche, following Ghiberti's design.

1423

The door surround and architrave of Ghiberti's first doors are cast and the panels are gilded.

19 APRIL 1424

The doors are finished and mounted on the eastern side of the Baptistery, facing the Cathedral. Ghiberti immediately receives the commission for the third set of doors, for which Leonardo Bruni proposes a program. Ghiberti makes drawings for two stained-glass windows for the nave of the Cathedral. Between October and November, Ghiberti is in Venice among the entourage of ambassador Palla Strozzi.

2 JANUARY 1425

Ghiberti receives the contract for the third doors. In March, the building supervisor of the Cathedral of Siena demands the return of all the advances paid to Ghiberti for the two reliefs of the baptismal font he never finished. Ghiberti makes excuses in a letter and promises to furnish them as quickly as possible. In a second letter he thanks Giovanni di Turino, who offered to help him, and assures him that he is completing one of the reliefs while his trusted collaborator Giuliano di ser Andrea is occupied with the other. In the summer he receives the commission for a statue of Saint Stephen for the Wool Guild (Arte della Lana) niche at Orsanmichele.

1426

Ghiberti matriculates in the Stonemasons Guild (Arte dei Maestri di Pietra e Legname). In this year and the following one, he executes the tomb of Leonardo Dati at Santa Maria Novella.

1427

Ghiberti delivers the two reliefs for the Siena baptismal font. The model of *Saint Stephen* is ready and is prepared for casting. Filippo di Cristofano, following Ghiberti's design, is working on the tomb slabs of Ludovico degli Obizi and Bartolomeo Valori for the Basilica of Santa Croce in Florence.

1428

This is the probable date of the reliquary chest of the martyrs Proto, Giacinto, and Nemesio, commissioned by Cosimo and Lorenzo de' Medici for Santa Maria degli Angeli. This same year, in another de' Medici commission, Ghiberti sets in gold an antique engraved cornelian of Apollo and Marsyas.

1429

The figure of *Saint Stephen* (fig. 1.3) is completed.

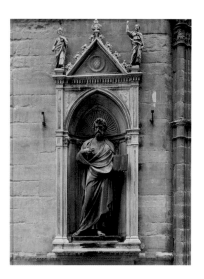

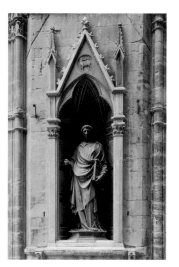

Figure 1.2 Lorenzo Ghiberti, *Saint Matthew,* bronze, 1419–1422, Orsanmichele, Florence.

Figure 1.3 Lorenzo Ghiberti, *Saint Stephen,* bronze, 1427–1429, Orsanmichele, Florence.

1432

In a competition for the furnishing of the Saint Zenobius chapel in the apse of the Cathedral, the altar is assigned to Brunelleschi and the reliquary urn to Ghiberti, who promises to complete it in three years. Ghiberti designs the frame for an altarpiece commissioned from Fra Angelico for the Linen Drapers Guild (Arte dei Linaiuoli). The marble frame is executed by stonecarvers Jacopo di Bartolo from Settignano and Simone di Nanni from Fiesole (see fig. 3.11).

1434

A design by Donatello for a stained-glass window for the central oculus of the drum of the cupola of the Florence Cathedral is preferred over a design by Ghiberti, who nonetheless furnishes other designs for the nave. He produces a miter for Pope Eugene IV.

1436

Ghiberti creates designs for the stained-glass windows in the Saint Zenobius chapel in the Cathedral.

1437

Protests and threats issue from the Opera del Duomo and the Wool Guild because the shrine of Saint Zenobius has not been delivered within the time stipulated in the contract. Vittorio Ghiberti and Michelozzo appear in these years to be the principal collaborators on the Baptistery doors that will be known as the Gates of Paradise.

1439

The reliefs for the Gates of Paradise have been cast, three have been chased, and another two are in progress.

1440

Ghiberti designs another four stained-glass windows.

1442

The shrine of Saint Zenobius is completed and delivered. New designs for stained-glass windows are made.

1443

Ghiberti designs stained-glass windows of the Ascension, Presentation in the Temple, and Agony in the Garden (fig. 1.4) for the oculi of the Cathedral. He is elected to the Dodici Buonomini, one of the two advisory councils in the government of Florence.

1444

Two anonymous denunciations accuse Ghiberti of being ineligible for service on the Dodici Buonomini because he is illegitimate. Ghiberti successfully defends his legitimacy. Vittorio Ghiberti hires Benozzo Gozzoli as a collaborator on the Gates of Paradise for three years.

1448

The Baptistery doors reach the final phase of work: framework, frame, and architrave. Ghiberti is at work on *The Commentaries,* a treatise on sculpture in which he includes an autobiography, the first ever written by a European artist.

1450

Lorenzo and Vittorio Ghiberti are paid for a door with God the Father (fig. 1.5) for a Eucharistic tabernacle in the Church of Sant'Egidio at the hospital of Santa Maria Nuova.

1452

The Gates of Paradise are completed and installed on the eastern side of the Baptistery, replacing Ghiberti's earlier doors, which are transferred to the north. Ghiberti receives a foundry and an adjacent house as final payment for his work.

1453

The workshop, now directed by Vittorio Ghiberti, receives the commission for the surrounds and architrave of the old fourteenth-century doors by Andrea Pisano on the south side of the Baptistery.

26 NOVEMBER 1455

Ghiberti makes his testament.

1 DECEMBER 1455

Lorenzo Ghiberti dies in Florence and is buried in Santa Croce.

Figure 1.4 Lorenzo Ghiberti, *Agony in the Garden,* designed 1443, stained glass executed by Bernardo di Francesco, Florence Cathedral.

Figure 1.5 Lorenzo and Vittorio Ghiberti, *God the Father,* gilt bronze, Sant'Egidio, Florence.

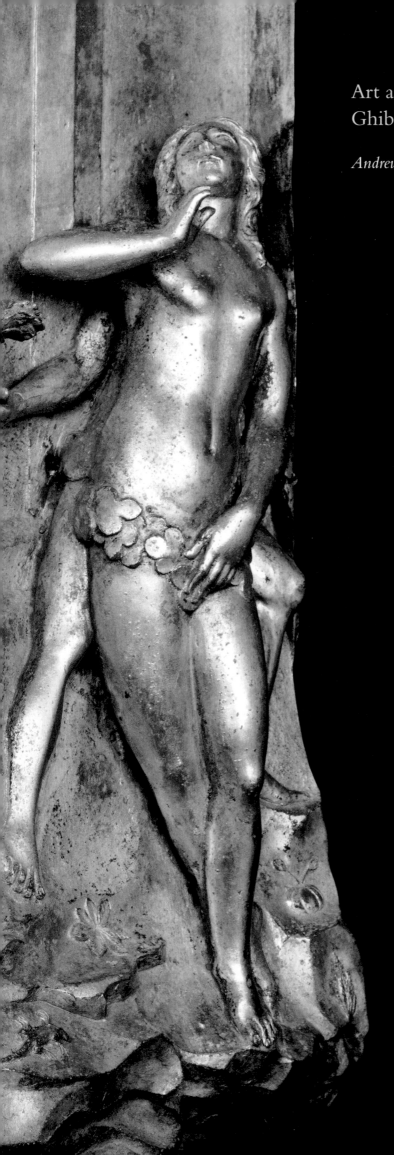

Art and Innovation in Ghiberti's Gates of Paradise

Andrew Butterfield

Condussi detta opera con grandissima diligentia e con grandissimo amore.
(I made this work with the greatest diligence and the greatest love.)
<div align="right">Lorenzo Ghiberti</div>

THE GATES OF PARADISE rank among the greatest creations of Renaissance art. Made by Lorenzo Ghiberti for the eastern portal of the Baptistery in Florence between 1425 and 1452, the two doors with their ten narrative reliefs in gilt bronze are one of the defining achievements of the period. In their combination of expressive power, convincing perspective, and sublime gracefulness, they were unlike anything ever seen before. They set a new ideal of artistic accomplishment, one that was to influence every painter and sculptor in Italy for generations to come. Such was their enduring importance that Michelangelo in the sixteenth century called them a *divinum opus*—a divine work—and it was he, too, who reportedly first gave them the name by which they are still known today, the Gates of Paradise.[1] Like Masaccio's frescoes in the Brancacci Chapel, Raphael's images in the Stanze, and Michelangelo's own paintings on the Sistine Chapel ceiling, they are works of supreme value that changed forever the course of European art.

The Gates have been admired and celebrated for nearly six hundred years, and yet in the modern era they have rarely received the careful study they deserve. This was chiefly due to the thick crust of grime that had accumulated on them over the centuries, marring the beauty and hiding the details of the sculptures. In the nineteenth and early twentieth centuries, the dirt on the reliefs was so dense and disfiguring that no one could even see the gold on their surfaces, and neither the clear projection of space nor the exact representation of emotion and anatomy in the sculptures was legible. To judge from old photographs, the Gates made a dull impression that would neither inspire nor reward close examination.

Between 1943 and 1948, the Gates were cleaned by Bruno Bearzi, and for the first time since the Renaissance it was possible to view the sculptures in all their original splendor. Unfortunately, this happy state of affairs lasted a very short while, for the doors were damaged in 1966 when several reliefs were knocked from the doors by the terrible flood of the Arno River. Following restoration, these reliefs were not returned to the Gates but instead were displayed nearby in the Museo dell'Opera del Duomo. As is discussed

in detail elsewhere (see page 98), in 1990 the two doors were moved inside and conserved at the Opificio delle Pietre Dure in order to protect them from the ravages of atmospheric pollution, which had begun to attack the surfaces of the bronzes and threatened them with ruin. The painstaking operation of cleaning the Gates has made it necessary to keep them off public view for nearly twenty years. A copy has stood in their place at the Baptistery, and individual relief panels have been put on exhibition at the Museo dell'Opera del Duomo as their cleaning was completed. But it has not been possible to make a comprehensive or systematic study of the Gates in this period.

In 1956, soon after Bearzi's restoration, Richard Krautheimer published a book on Ghiberti that is widely regarded as one of the finest studies of a Renaissance artist ever written.[2] The virtues of this extraordinary book are considerable; nearly every page displays profound learning and penetrating insight, and the tone of presentation is authoritative and magisterial. The book makes such a daunting impression that few scholars in the last fifty years have been willing to question Krautheimer's methods or results.[3] It has thus had the unintended effect of bringing serious study of Ghiberti to a near halt. This is especially sad since the deterrence of new research occurred during the only time in the last several centuries when it was possible to see the Gates of Paradise as Ghiberti had planned.

Another problem has clouded understanding of the Gates of Paradise: the prejudicial notion that Ghiberti was in essence a Gothic and conservative artist.[4] In this view, the innovations of the Gates of Paradise must be at least partly the result of someone else's thought or influence, such as Ambrogio Traversari's or Leon Battista Alberti's.[5] Hypotheses of this kind are without foundation, and yet they were common among scholars born in the earlier years of the twentieth century, and they have impeded more in-depth analyses of the Gates' artistic character.

Fortunately, the current restoration campaign now nears its magnificent conclusion, and the results are of such dazzling brilliance that it inspires the beholder to take a fresh, close look at the Gates of Paradise. Everywhere one gazes on the sculptures now, there is so much to dwell on and marvel over that it is as if one had never seen them before. The sense of discovery and surprise will be especially vivid for anyone who knows the reliefs primarily from older photographs, such as the pictures in Krautheimer's book, which uniformly fail to capture the subtlety of the details, the clarity of the space, and the majesty of the designs. The cleaning of the Gates thus provides a new basis and a new beginning in the study of Lorenzo Ghiberti and Renaissance art.

Before examining the reliefs closely it is necessary to consider some main points in the documentary chronology of the Gates, which is discussed in the essay by Margaret Haines and Francesco Caglioti (see page 80). The first set of bronze doors for the Baptistery in Florence was made in the 1330s by Andrea Pisano and depicts scenes from the life of St. John the Baptist (fig. 2.1); these doors grace the southern portal of the building. Around 1400 the Calimala guild, the mercantile body that enjoyed the patronage rights of the Baptistery, decided to erect a second set of bronze doors with scenes from the New Testament (fig. 2.2). In 1401 the guild held a competition that was won by Lorenzo Ghiberti against six other artists, most notably Filippo Brunelleschi. Ghiberti at that time was a very young man, and it was his first important commission. He worked on these doors from 1403 until their completion in 1424. The doors were originally set up in the eastern portal,

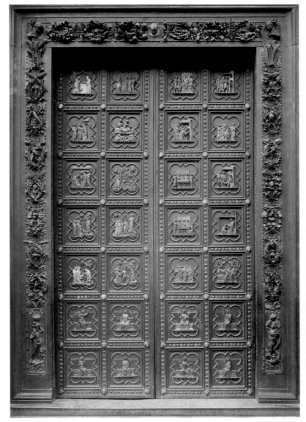

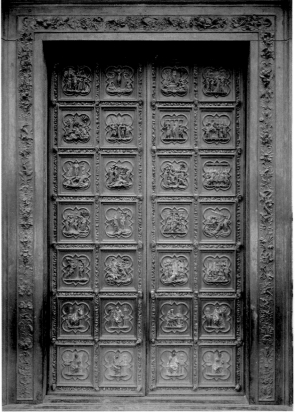

but in 1452 they were moved to the northern portal of the Baptistery, and they stand there still.

Even before the conclusion of the second set of doors, the Calimala guild had begun to plan a commission for a third set, representing events from the Old Testament. Mention of this project is first recorded in a letter written by the eminent humanist Leonardo Bruni to the Calimala guild, sometime before 21 June 1424. Seemingly composed in response to a request from the guild, Bruni's letter features a proposal for a narrative program for the doors. Just a few months later, on 2 January 1425, Ghiberti signed a contract to create the third set of doors. When he actually began the long preparatory phase of making drawings and models for the sculptures is unknown, but his biennial tax returns in 1427, 1429, 1431, and 1433 state that he was working on the doors in those years.

The design and modeling of the sculptures must have been concluded sometime before April of 1436 or 1437, since a document of that time says that all ten narrative panels have been cast and that the laborious process of chasing, filing, and finishing the reliefs has begun. According to a record of 4 July 1439, between 1438 and that date the chasing of three reliefs—the panels of *Cain and Abel, Moses,* and *Jacob and Esau*—had been completely or nearly finished; the chasing of one relief—the *Joseph* panel—had been half-finished; and the chasing of one relief—*Solomon and Sheba*—had been partly finished. A document of 1443 states that four reliefs remained to be completed, but does not indicate which four. Presumably, it refers to four of the five reliefs not mentioned in the document of 1439—the panels for *Noah, Abraham, Joshua, David,* and *Adam and Eve.* Of this group the one that differs most from the others is the *Adam and Eve* panel; I therefore think its chasing must have been finished before 1443, and the other four completed after that year.[6] (Whether the chasing of the *Adam and Eve* relief is to be dated between 1436/37 and 1438 or between 1439 and 1443 cannot be determined, but I believe the earlier period is the more likely.) In

Figure 2.1 Andrea Pisano, south doors, 1330s, gilt bronze, Baptistery of San Giovanni, Florence.

Figure 2.2 Lorenzo Ghiberti, first doors (east, then north), 1424, Baptistery of San Giovanni, Florence.

How the Lord creates the heavens and the stars	The Lord makes man and woman	Adam and Eve flanking the tree, eating the apple	How they are driven from Paradise by the angel
Cain kills his brother Abel	Every kind of animal enters into Noah's Ark	Abraham is willing to sacrifice Isaac, according to the commandment of the Lord	Isaac gives his blessing to Jacob believing him to be Esau
The brethren of Joseph sell him out of envy	The Pharaoh's dream of the seven kine and seven ears of corn	Joseph recognizes his brethren who have come to Egypt for grain	Moses sees the Lord in the burning thorns
Moses speaks to the Pharaoh and performs miraculous signs	The Sea divided and the people of the Lord passing through	The laws given by the Lord to Moses on the burning mountain, the trumpet sounding	Aaron makes sacrifice on the altar, dressed in priestly habit with bells and pomegranates around his robes
The people of the Lord pass the river Jordan and enter the land of promise with the ark of the covenant	David kills Goliath in the presence of King Saul	David made king amid the cheers of the people	Solomon passes judgment on two women over the question of the child
Prophet Samuel	Prophet Nathan	Prophet Elias	Prophet Elisha
Prophet Isaiah	Prophet Jeremiah	Prophet Ezekiel	Prophet Daniel

Figure 2.3 Leonardo Bruni's proposed scheme for Ghiberti's second doors, 1424.

any event, work on all ten narrative panels had been finished by August of 1447. A document of January 1448 indicates what remained to be completed at that time: 1) the chasing of the twenty-four pieces of the frame that surround the panels; 2) the modeling and casting of the heads in roundels in the frame; and 3) the bronze architrave, cornice, jambs, and threshold of the doorframe. All elements were finished by the beginning of 1452, and payments for gilding them were made in the spring. In summer the Gates of Paradise were judged to be so beautiful that the Calimala guild decided to move the second set of doors with the scenes from the New Testament to the north portal and to place the Gates of Paradise in the eastern portal, where they were inaugurated in September of that year.

According to the plan described in Bruni's letter of 1424, the initial scheme for the Gates (fig. 2.3) called for twenty-eight reliefs, arranged in four columns of seven reliefs, two columns per door. This plan followed the format that had already been used on both the first and second sets of doors at the Baptistery. In Bruni's program, these reliefs were to depict eight prophets and twenty narrative scenes from the Old Testament, beginning with the Creation of the Heavens and ending with the Judgment of Solomon.

As made, however, the Gates of Paradise have only ten relief panels, arranged in two columns of five panels, one column per door. In the program that Ghiberti actually used, there are no panels depicting prophets; instead, the prophets appear only in the framing elements around the narrative scenes. The cycle still begins with Creation and ends with Solomon;

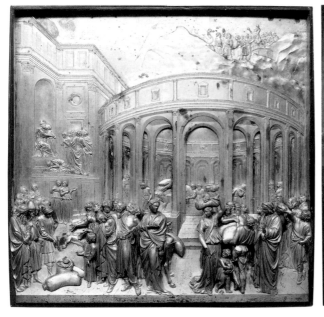

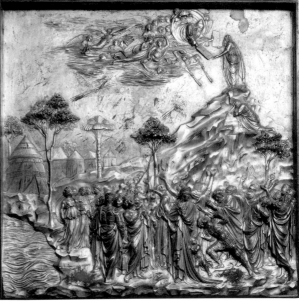

but to reduce the number of narrative reliefs from twenty to ten required extensive condensing and editing by Ghiberti, presumably in collaboration with a humanist advisor, either Bruni or someone else. Bruni had proposed four panels depicting five scenes from Creation and the story of Adam and Eve; four of the five scenes he suggested are present in the final work, but Ghiberti combined them into one relief. Similarly, Bruni imagined three scenes from the story of Joseph, two of which actually appear in one panel (fig. 2.4) on Ghiberti's sculpture. In another case, Ghiberti was more radical in pruning. Bruni had planned to have five panels tell the story of Moses; in his relief (fig. 2.5) Ghiberti eliminated all but one of these scenes (although perhaps he hints at a second). Moreover, Ghiberti cut out the panel of the story of Aaron projected by Bruni and replaced it with the story of Joshua (fig. 2.6); this is completely new—there is no reference to Joshua in Bruni's

Figure 2.4 *Joseph* panel.

Figure 2.5 *Moses* panel.

Figure 2.6 *Joshua* panel.

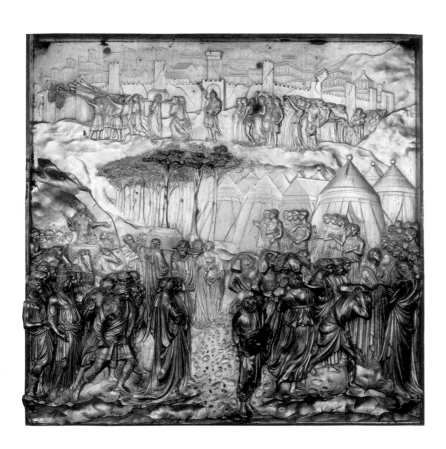

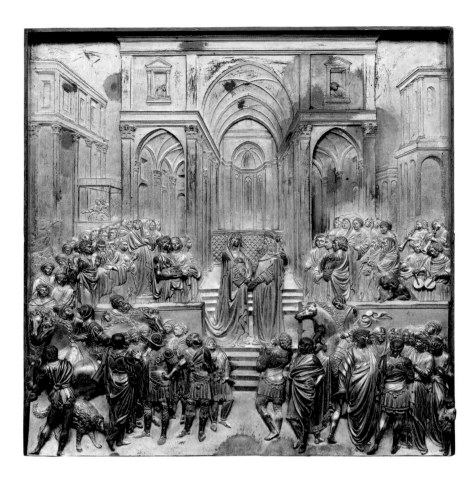

Figure 2.7 *Solomon and Sheba* panel.

plan. And for the last relief in the cycle (fig. 2.7), Ghiberti substituted the Meeting of Solomon and Sheba for the Judgment of Solomon that Bruni had recommended.

We cannot be sure how or when these changes came about, nor can we ascertain the degree of authority Bruni's plan may have originally enjoyed either with the members of the Calimala guild or with Ghiberti himself. Krautheimer argued that Bruni's scheme was reworked by Ambrogio Traversari, the theologian and humanist who headed Santa Maria degli Angeli, the Camaldolite monastery in Florence.[7] This is a brilliant theory, but fifty years after its first publication it remains unsubstantiated. Krautheimer also believed that the plan for ten narrative panels was only decided in the late 1420s and that serious work on the designs of the sculptures did not begin until around 1429 or 1430.[8]

Krautheimer thought this for two reasons. He theorized that Ghiberti, in reducing Bruni's plan, initially decided to make twenty-four reliefs, rather than ten. Krautheimer thus had to allow for a period of some years in which Ghiberti first developed and then rejected this intermediate arrangement. However, Krautheimer's evidence for this hypothetical phase in planning the doors has now been disproved (see pages 86–97). Krautheimer also wanted to assign a relatively late date for the inception of work on the reliefs because he imagined that Alberti must have deeply influenced their design, and Alberti and Ghiberti could not have met before 1429. This hypothesis was motivated by Krautheimer's overvaluation of Alberti's primacy in the development of two key aspects of early Renaissance art: rational depiction of space and emphasis on narrative force. To be sure, Alberti gave great importance to both elements in his innovative book *On Painting,* which was written around 1435. But as will become clear in the discussion below, Ghiberti's exploration of these matters in the Gates of Paradise was so varied, complex,

and sophisticated that it vastly outstripped the recommendations in Alberti's text. The flow of influence must have run mainly from Ghiberti to Alberti, not the other way around; Alberti thus has little bearing on reconstructing the chronology of work on the Gates' designs.

In his book *I Commentarii,* written in the 1440s, Ghiberti says that he worked on the Gates of Paradise "with the greatest diligence and the greatest love."[9] This extraordinary remark, perhaps the first of its kind to survive in the history of art, suggests that the design of the narrative panels took considerable time. A work of such complexity and ingenuity as the Gates of Paradise is the result of a long process of imagination, elaboration, and revision. Indeed, given the intricacy of detail, the multiplicity of figures, and the originality of invention, Ghiberti must have made hundreds of preparatory drawings and sketch models for the reliefs. Yet it is idle to speculate how many years this effort required. We know the design phase began sometime around 1425 and ended sometime around 1435, but there is almost no artistic or documentary evidence that allows us to be more specific. It is also mistaken, I believe, to imagine that one can detect the sequence in which Ghiberti created the individual panels. The Gates of Paradise were conceived and executed as an artistic unity, and the differences in treatment between the reliefs at the top and the bottom were fully intentional, not simply the result of Ghiberti's stylistic development.

This is evident when we examine one of the most celebrated features of the Gates of Paradise, the vivid illusion of space in the reliefs. Both Donatello and Ghiberti had already begun to explore effects of this kind in works such as their bronze reliefs for the Baptistery font in Siena (figs. 2.8 and 2.9) or Donatello's marble relief of St. George and the Dragon for Orsanmichele in Florence. But the Gates of Paradise were by far the most extensive, original, and effective experiment in the representation of deep space in sculpture created up to that time. In ambition and achievement they surpass anything made before, even in Classical antiquity.

Figure 2.8 Donatello, *The Feast of Herod,* Baptistery font, Siena.

Earlier attempts to understand the spatial qualities of the reliefs have concentrated almost exclusively on the *Jacob and Esau* and *Joseph* panels.[10] These two sculptures, set in the middle tier of the Gates, seemingly come

Figure 2.9 Ghiberti, *The Arrest of John the Baptist,* Baptistery font, Siena.

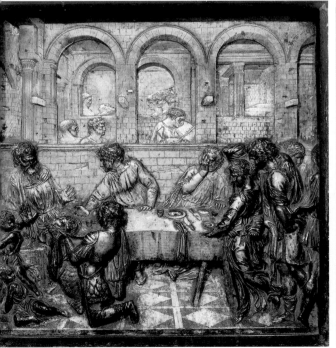

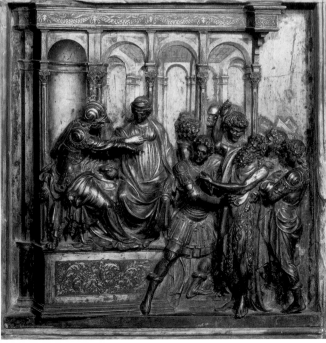

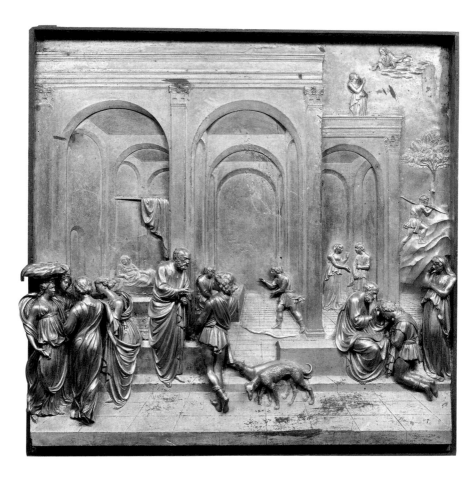

Figure 2.10 *Jacob and Esau* panel.

the closest to the principles of single-point perspective in painting, which had initially been conceived by Filippo Brunelleschi and later formulated by Alberti in *On Painting*. For example, as summarized by Krautheimer, the *Jacob and Esau* panel (fig. 2.10) contains the following elements typical of single-point perspective:

> . . . the position of the vanishing point in the center of the panel; the division of the picture base into a number of equal sections; the relation of these sections to the height of the figures in a proportion of one to three; the tile floor used as a network of coordinates for the exact placing of each object; the convergence of all diagonals toward a "quasi-distance point"; and lastly, the architectural setting as a proportionate frame for these figures, the principal agent both in creating an intelligible space for their actions, and in giving the entire scene a wholly measurable depth and height.[11]

Yet the other eight panels on the Gates of Paradise seem to differ significantly from the *Joseph* and the *Jacob and Esau* reliefs and, with the exception of the *Solomon and Sheba*, appear to exemplify few of the principles of single-point perspective. Scholars have been unsure how to analyze their spatial qualities, which they have rarely studied with attention; nor have they been able to provide a convincing explanation for the variety in the depiction of space in the ten panels.

For instance, although reaching contrary conclusions, both Krautheimer and John Pope-Hennessy thought the differences among the reliefs were due to changes in Ghiberti's level of interest in and understanding of single-point perspective. According to Krautheimer, Ghiberti did not know the new system of perspective when he made the panels in the top two tiers of the Gates, mastered it briefly under Alberti's tutelage while creating the panels in the middle tier, and then essentially forgot how it worked when designing

the reliefs in the bottom two tiers.[12] Pope-Hennessy took the opposite view: he argued that Ghiberti, in composing the sculptures, started at the bottom and worked his way up the Gates and that it is the reliefs at the top which show the most complete command of perspective.[13] On the other hand, according to Alessandro Parronchi, the differences were planned from the beginning and were made to accommodate the projection of space from one ideal vantage point somewhere in the piazza in front of the Gates.[14]

Such theories share several misleading assumptions. Krautheimer and others have analyzed the use of single-point perspective in relief sculpture as if reliefs, like paintings, were flat, and this tendency has been exacerbated by the reliance on photographs, and drawings made from photographs, as the basis for their analyses. Yet there is an inherent difficulty in the application of single-point perspective to relief. Single-point perspective is a system intended for the projection of space on a two-dimensional surface. But relief sculptures are three-dimensional and have complex surfaces. One basic problem is that figures in a relief must have real three-dimensional volume, and consequently there must also be a projection at the bottom of the relief for them to stand on. In non-perspectival relief sculpture, such as the bronze doors of Andrea Pisano, the artist simply attaches a shelf at the bottom of the relief field as a support (fig. 2.11). But in perspectival reliefs, such as the panels on the Gates of Paradise, the artist must demonstrate the continuity of the real space of the shelf on which the figures stand in the foreground with the fictive space depicted in lower relief or on the surface of the bronze in the background. To do so, the artist must sharply tilt downward the shelf on which the figures stand. He must also control the

Figure 2.11 Andrea Pisano, *The Visitation* panel, south doors, Baptistery of San Giovanni, Florence.

degree of the real three-dimensional volume of all the figures in the relief, so that the figures decrease in volume as they recede into depth. This is exceedingly difficult, and yet it is obligatory, especially if one wants to create a single, unified volume of continuously receding space as in the *Joseph* and the *Jacob and Esau* panels.

In addition, earlier analyses of the use of perspective on the Gates have routinely ignored the requirements of narrative and setting that Ghiberti faced; scholars have examined the space in the reliefs as if the artist had been free to design them any way he pleased, regardless of what stories he had to tell. But two issues must have been integral to Ghiberti's planning of the spatial effects of his sculptures from the very start. One basic consideration was that, according to the dictates of the Biblical narrative, only three of the scenes could take place in architectural settings; the other seven had to be set outdoors in non-urban landscapes. For example, no matter what Ghiberti thought about single-point perspective, he could not have placed the story of *Cain and Abel* (fig. 2.12) in a building or piazza with a Classical arcade and a tiled floor, as in an Albertian painting. This poses a serious problem for the application of single-point perspective because that system depended on a network of lines, typically derived from an architectural setting, to create the illusion of measurable space, receding at a regular pace into the distance.

Another major issue Ghiberti had to take into account was that the scenes from Genesis in the first six panels involve the direct confrontation of small numbers of figures, usually two at a time, whereas the scenes from Exodus and the Historical Books of the Old Testament in the bottom four panels are events in the history of a nation or people, the Israelites, and necessarily entail the depiction of large groups of figures. In other words, the desire to narrate with clarity and force the stories of all ten panels placed very different demands on Ghiberti as a designer. In the upper six panels, he had

Figure 2.12 *Cain and Abel* panel.

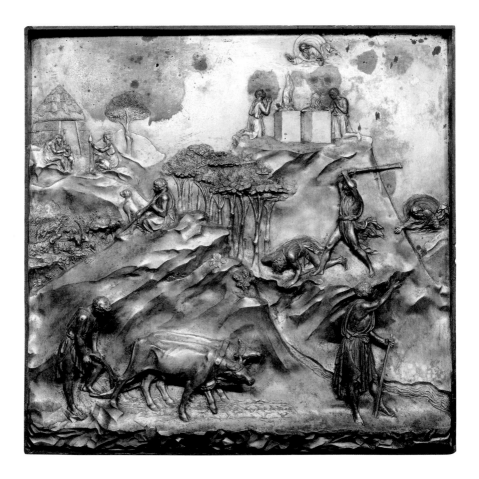

to create settings that enabled him to divide the visual field into a number of different sections of comparably moderate depth, while maintaining overall coherence and visual plausibility within the relief. On the other hand, in the lower four panels, he had to imagine ample surroundings that could accommodate multitudinous crowds, distant vistas, and large changes in scale and yet still provide a focal point in which to situate the hero. Ghiberti's concerns as a narrator and expositor of Biblical narrative simply outweighed his interests in single-point perspective, and he used or adapted that system for the depiction of space only as it served his needs.

Legibility must have been another primary concern for Ghiberti. Indeed, the desire for greater clarity was almost certainly a motive in the decision to have ten panels on the Gates of Paradise rather than twenty-eight as on the other doors of the Baptistery. Furthermore, two new observations arising from the recent cleaning reveal with special strength how Ghiberti's desire for clarity affected the designs of the reliefs. One is that the surfaces of the panels in the bottom two tiers are extensively worked with goldsmith punches, while the panels in the upper three tiers have relatively few such markings. This difference must have been planned from the start since the panels were not chased in sequence (see the essay by Formigli, page 118). The second is that, seen in profile, the ten reliefs can be readily divided into three groups, and these groups correspond generally to the panels' height on the Gates. Both observations indicate that basic considerations in planning the spatial effects of the reliefs were the height and distance from which they were to be seen. Ghiberti did not design the ten panels from one fixed vantage-point; he knew this was impractical in a work of art that would be seen by many viewers from a multiplicity of points as they walked past or stood in front of the Gates. But Ghiberti did regard distance and height as general factors to consider in designing all ten reliefs.

It is possible, I believe, to show that in terms of their spatial effects the ten panels divide into four groups: (1) *Adam and Eve*; (2) the other three panels in the upper two tiers of the Gates; (3) all three scenes in architectural settings (*Jacob and Esau, Joseph,* and *Solomon and Sheba*); and (4) the other three panels in the bottom two tiers of the Gates. Let us take a closer look at the reliefs, beginning with the last of these groups.

With the exception of the *Solomon and Sheba,* the panels of the bottom two tiers—*Moses, Joshua,* and *David* (see pages 110–117)—are very similar in profile. (The reason for the difference of the *Solomon and Sheba* panel is simply that it is one of the narratives in an architectural setting, which have specific requirements.) In these three reliefs, the figures in the foreground at the bottom of each sculpture project a minimal degree beyond the integral bronze frame that surrounds the panel (fig. 2.13). Likewise, the shelf of ground below the figures projects beyond the frame a small amount, if at all. Furthermore, the figures are in a plane that is both parallel to the side edges of the bronze frame and perpendicular to the bottom edge of the frame. The low relief and planar disposition of the figures were intended to accommodate the placement of these panels in the bottom section of the door and thus below the vantage-point of many viewers. Another common trait is that the figures in all three panels are elaborately and minutely detailed and extensively chased with goldsmith tools, such as the rosette punch and lunette punch. (*Solomon and Sheba* is also decorated in this manner.)

In all three panels the visual field is divided into a series of large compartments of space separated by planes established by big groups of figures or prominent features of the landscape, such as hills or trees. By my count, in

Figure 2.13 *David* panel in profile.

28

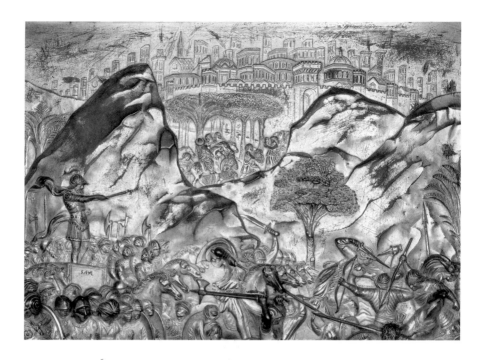

Figure 2.14 *David* panel, detail.

Figure 2.15 *Jacob and Esau*
panel in profile.

the *Joshua* panel there are nine such divisions, in the *David* seven, and in the *Moses* four. These compartments rise up the face of the bronze as they go back into the distance. In nearly every compartment, the recession in depth is further indicated by a succession of other markers, such as figures, trees, and tents (fig. 2.14), which through a combination of overlapping and diminution show their relative and intermediate positions within the compartment. This creates an extremely effective illusion of deep space. Indeed, as an attempt to depict a profound and complex field of vision, these reliefs have few points of comparison in contemporary Florentine painting and sculpture.

The three scenes represented in architectural settings are likewise highly similar in profile. In each case there is a thin, tall, triangular wedge that projects beyond the integral frame at the bottom of the relief (fig. 2.15). A steeply inclined plane forms the upper surface of this wedge; the angle of this incline is approximately eighty degrees. Seen from the front, this incline makes a continuous plane with the ground or floor as it recedes into the fictive depths of the scene. The steep incline was necessary to approximate the effects of single-point perspective in painting; if the incline were less sheer in pitch, the elements represented in the relief would have to overlap more, making them harder to read, and the front ledge would have to project much farther beyond the integral frame of the relief. The figures in the foreground of the relief stand on this severe incline. Ghiberti took great care to hide the incline and to make the figures' stances look natural. The means of disguise are various: swaddling the feet in the drapery of the robes, posing the figures with the front leg bent at the knee, depicting one foot modeled in high relief and the other foot foreshortened in low relief, and so on (fig. 2.16 and pages 74–75). All of these effects are found in all three panels, and yet they are integrated with the design of the reliefs in such a natural manner that they never draw the viewer's attention.[15]

As already noted, the architectural elements of these reliefs appear to diminish as they recede into depth, approximating the rules of single-point perspective. Scholars have routinely suggested that the *Solomon and Sheba* relief is inferior in its spatial planning to the *Joseph* and *Jacob and Esau* panels. In part this is owing to the lower quality of its chasing, but it is also the result

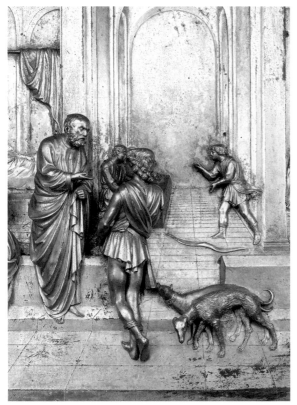

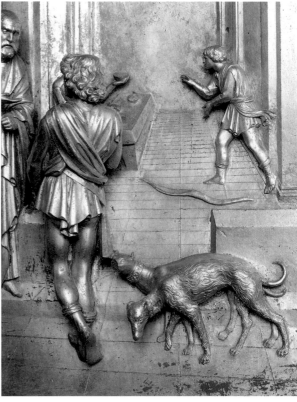

of studying this relief either in photographs or from a position in the piazza a few feet from the Gates, which distorts the perspective. In his *Commentarii* Ghiberti remarks that the illusion of space in the reliefs works when the viewer stands at a distance.[16] This is certainly true of the *Solomon and Sheba* panel (see fig. 2.7), whose spatial qualities are more effective when the sculpture is seen from the middle of the piazza or from the steps of the Duomo. It is even possible that the panel represents a correction by Ghiberti of certain elements in the other two architectural panels. Krautheimer believed that the absence of a tiled floor showed a waning of interest on Ghiberti's part. But perhaps the artist actually wanted to avoid the degree of specificity in measurement that the tiles imposed. In the *Jacob and Esau* panel (fig. 2.17), the length of the table at the center of the relief is calculable from the tiles on the floor before it: it is approximately twelve tiles long, or roughly four times the height of Esau standing in the center foreground. That would make the table oddly long—something like twenty to twenty-four feet in length—and make the bread at the far end of the table exceptionally large. Without a regular unit of measurement visible throughout the relief, the *Solomon and Sheba* panel does not call attention to problems in spatial planning. Furthermore, this panel is the only one of the three architectural scenes that features a continuity of attention and regard across its planes: figures in the foreground look into the background and figures in the background look into the foreground. This does not happen in the *Joseph* or the *Jacob and Esau* panels, where all exchanges occur laterally within the separate and successive units of depth. In the *Solomon and Sheba* panel, it is even conceivable that the figure on horseback who is looking up in the left foreground is attempting to see the falcon about to be released in the middle distance. If so, Ghiberti was imagining the entire three-dimensional volume of space depicted in the relief to be a continuous entity. Given the emphasis on the two-dimensional plane of the floor typical in single-point perspective, this would be especially striking.

Figure 2.16 *Jacob and Esau* panel, detail.

Figure 2.17 *Jacob and Esau* panel, detail.

The four panels in the upper two tiers of the Gates are similar in profile. The bottom section tends to project farther than it does in the other six reliefs. The underside of this projection is more curved and more elaborately worked than in the other panels, and its upper side is much less steeply inclined (fig. 2.18). The figures in the foreground of the upper reliefs tend to be larger in scale and more widely separated from each other. In some cases—most notably Cain behind his plow (fig. 2.19)—the figures bend from the waist outward toward the viewer. The strong inclination of the body is well-disguised; it is not apparent in photographs or even to someone standing in front of the reliefs. The trees and rocks of the landscape are also in higher relief than the corresponding elements in the panels lower on the Gates. The reliefs in the upper two tiers of the Gates are approximately eight to thirteen feet above the viewer's head, and all these changes appear to have been intended to augment their visibility and legibility to the beholder below.

These stories are told in the Bible almost entirely in a succession of momentous and dramatic exchanges among a small number of figures, often no more than two. Of course, the most significant and charged of these encounters are those between man and God. Given the nature of the stories, Ghiberti was able to arrange these reliefs as a series of separate encounters, which he dispersed in a continuous narrative across the field of the composition, using the rocky and irregular forms of the landscape as a multi-level platform for staging the different scenes of the drama. The elements of the landscape are arranged both to create visual unity and to keep the different moments of the story clearly separate. This visual unity includes continuity of space, but the continuity is generalized: one cannot measure with precision the relative distances of the figures.

Within the four reliefs of the top two tiers, the *Adam and Eve* panel stands out—so much so that it requires special attention. Unlike the other three panels, it is symmetrical and centralized. The figures in the foreground at either end project the closest to the viewer, and the area near the center of the panel, above God's and Eve's heads and below the semicircle of angels, is the deepest point in the projection of space. The relief is notable, too, for its complexity. Ghiberti divided the visual field into four components, one for each of the events of the Creation myth. He also interwove these components, making them overlap one another and joining them inextricably into one visual whole. Perhaps no other relief on the Gates is so carefully and artfully composed.

Figure 2.18 *Adam and Eve* panel in profile.

Figure 2.19 *Cain and Abel* panel, detail.

Figure 2.20 *Adam and Eve* panel, detail.

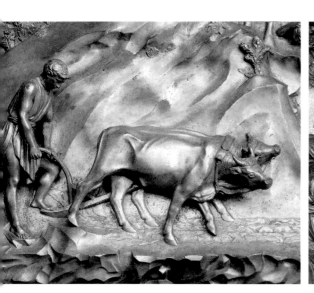

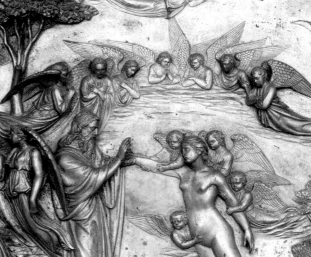

There is another remarkable feature of the representation of space in the *Adam and Eve* panel: the use of a foreshortened circle—formed by the heads and arms of God and Eve and the crescent of angels near the center of the relief—as a means for making the recession into depth more discernible and legible (fig. 2.20). (The illusion of deep space in this part of the relief is especially strong when the panel is seen from below.) Although the depiction of a foreshortened torus was soon to become a demonstration of the mastery of perspective for painters such as Uccello, it had been uncommon in the pioneering works of single-point perspective by Donatello, Masaccio, and others. In those images, as in Alberti's *On Painting,* the emphasis tended to be on the representation of quadrilateral, rather than circular, shapes in perspective.

Only one artist before Ghiberti regularly used circles of overlapping figures to indicate the relative position of figures in space in a convincing way, and that was the painter Fra Angelico. Indeed, the closest points of comparison for the circle of figures in the *Adam and Eve* panel are the circles of figures in Angelico's *Coronation of the Virgin* in the Uffizi (fig. 2.21), and his *Assumption of the Virgin* in Boston, both works of the early 1430s. The two artists collaborated on the Linaiuoli tabernacle in 1431 (see fig. 3.12), and it has been suggested by Ulrich Middeldorf and others that Ghiberti influenced Fra Angelico.[17] But around 1430 the Dominican friar was the most progressive painter in Florence, and his dazzlingly original compositions —such as the Strozzi altarpiece (fig. 2.22), completed in 1432, with its deep perspective and vast sky—were unlike anything seen before in Italian painting. These pictures must have fascinated Ghiberti, and it could be that the painter inspired the sculptor, just as the sculptor influenced the painter. Surely the walled city in the background and the overlapping trees marking the distance in the middle ground of the Strozzi altarpiece are similar to corresponding elements on the Gates of Paradise.

One of the most original and important features of the Gates is the extraordinary subtlety with which Ghiberti described the mental, emotional, and physical states of the figures. In their vivid and precise depiction

Figure 2.21 Fra Angelico, *The Coronation of the Virgin,* ca. 1434–1435, Galleria degli Uffizi, Florence.

Figure 2.22 Fra Angelico, *The (Strozzi) Deposition,* ca. 1430–1432, Museo di San Marco, Florence.

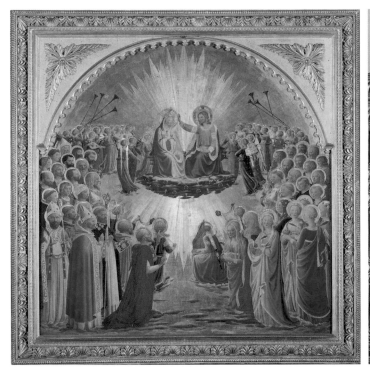

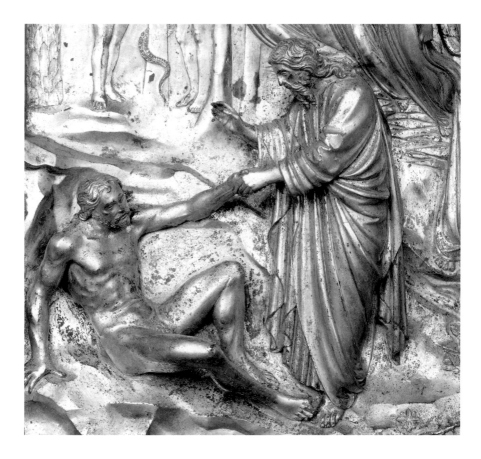

Figure 2.23 *Adam and Eve* panel, detail.

of a wide range of psychological and somatic conditions, these sculptures are almost without precedent in the history of European art. It is commonly remarked that the Renaissance is the period when painters and sculptors first regularly sought to represent the "motions of the mind." Perhaps more than any other artist in early Renaissance Florence, Ghiberti discovered and explored this new realm of representation.

Let us begin to examine this aspect of Ghiberti's genius by looking at the way he depicts Adam in the scene of the making of Adam in the lower left corner of the *Adam and Eve* panel. Unmistakably, Adam is shown in a state of semi-consciousness, as if waking from a profound slumber (fig. 2.23 and pages 44–45). The muscles in his face are slack with sleep, his eyes are still half-closed, and his mouth hangs partly open, as if not yet fully under his control. Yet there is a sense of rising energy around the figure. The veins of his left arm pulse with life in response to the touch of God's hand, and his beard and hair undulate as if flowing with an irresistible force. Ghiberti has represented Adam in this way not merely to show off his virtuosity in naturalistic description. Rather, he has sought to depict, in an emotionally and physically convincing manner, the moral heart of the Biblical account of the creation of Man. The specific line depicted in this scene is Genesis 2:7; in the King James version it reads: "And the Lord God formed man of the dust of the ground, and breathed into his nostril the breath of life; and man became a living soul." (The third clause of this line is especially vivid in the Latin Vulgate Bible that Ghiberti would have read: *et factus est homo in animam viventem.*) Like other artists before him, Ghiberti concentrated on the first and third clauses of the sentence and chose to show God giving life by the touch of his hand rather than the breath of his nostrils. Yet Ghiberti was the first to imagine that the common and natural state of rousing from sleep could serve as the physical and visual analog for this moment of transcendent importance in sacred history. Watching Adam wake, we watch his spirit inhabit his body; we watch man become "a living soul."

Ghiberti not only made observations of physical and emotional states with compelling accuracy and force, he also combined these observations to articulate and to amplify the emotional content implicit in the narratives he portrayed. We can see this, for example, in the group of angels hovering behind God in the creation of Adam scene. Decorum may have prevented Ghiberti from depicting the Lord's expressions and gestures to represent His infinite love for mankind. But Ghiberti could use the angels to show this love. By the attitudes of their bodies, the poses of their arms, and the looks on their faces as they glance one to another, it is clear that the angels are reverential, tender, and loving; as they watch the creation of Adam they are filled with hope for man and awe for the compassion and omnipotence of the Lord God.

Another example of Ghiberti's detailed description of emotion is the group of figures in the lower left foreground in the *Joseph* panel (fig. 2.24). This scene depicts the moment in the story when the cup that Joseph has had planted in his brothers' sack of grain is discovered, leading to their arrest. The Old Testament is famously elliptical and enigmatic in its narrative style, and the scene of the cup's discovery is described in the Bible in very few words. The King James translation (Genesis 44:11–14) reads: "Then they speedily took down every man his sack to the ground and opened every man his sack. And he searched, and began at the eldest and left at the youngest and the cup was found in Benjamin's sack. Then they rent their clothes, and laded every man his ass, and returned to the city." From this account, Ghiberti chose to depict just one clause: "having rent their clothes"—it is only two words, *scissis vestibus,* in the Latin Bible that Ghiberti would have read—and yet on this thin basis he has depicted a moment of the highest drama and the most intense feeling. In Ghiberti's relief, we see Benjamin and his brothers overwhelmed by fear and consternation as they look at the cup and at their accusers. One brother tears his garments in

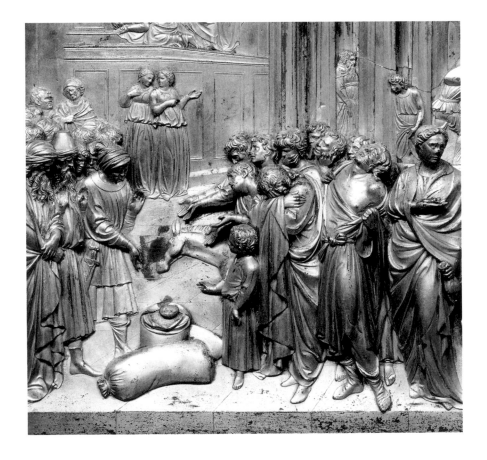

Figure 2.24 *Joseph* panel, detail.

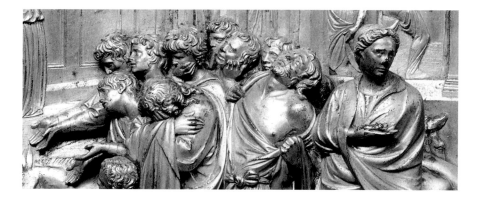

anxiety and grief, a second hides his face in despair, a third stares in disbelief, another begs for mercy, and so on (fig. 2.25). In the Bible the words *scissis vestibus* describe a moment in passing, yet Ghiberti has imagined the scene as a moment of climax and deep emotion.

In the middle distance at the left in the *Joseph* panel, immediately above and beyond the figures in the foreground, we see the recognition scene where Joseph reveals himself to his brothers (fig. 2.26). This is the next chapter in the narrative and the dramatic culmination of the Joseph story (Genesis 45:2–15). It is a scene fraught with feelings of ineffable profundity and complexity: overwrought by love for his brothers, Joseph is moved to forgive them, even though they had cast him into a well and sold him into slavery; under arrest and in fright for their lives, the brothers initially are confused and unable to respond. It is characteristic of Ghiberti's genius that in depicting the story he chose to concentrate on just three lines of the Biblical text (Genesis 45:3 and Genesis 45:14–15): "And his brethren could not answer him; for they were troubled at his presence.... And [Joseph] fell upon his brother Benjamin's neck, and wept; and Benjamin wept upon his neck. Moreover he kissed all his brethren, and wept upon them: and after that his brethren talked with him." From these lines Ghiberti composed a scene showing the transitional moment when Joseph embraces one brother and reaches out to the others, and the brothers, still in fear, begin to understand the full significance of the events taking place before them. By their gestures and expressions, Joseph and his brothers display a wide range of

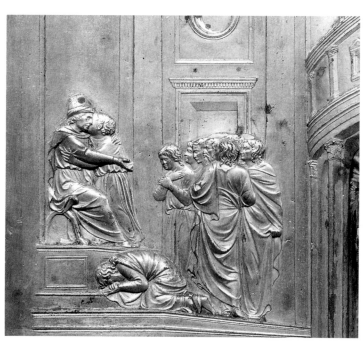

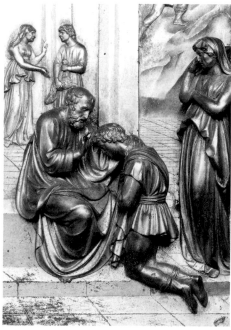

different reactions—shock, fear, shame, relief, love, remorse—that together express the implicit essence of the drama.

Likewise in another story of fraternal conflict, in the *Jacob and Esau* panel, Ghiberti brings to light the deep and conflicting sentiments of the narrative, from jealousy and anger to humility and affection. Especially touching is the scene in the right foreground where Isaac, blind and infirm, gives his blessing to Jacob, who kneels with deep humility and reverence before his father (fig. 2.27). Ghiberti's emphasis on thought and feeling is evident throughout the panels of the Gates of Paradise. The *Cain and Abel, Abraham,* and *Moses* panels are also especially noteworthy for the diversity, intensity, and meticulousness in the depiction of the figures' states of mind.

There are few parallels in early Renaissance art for the subtlety and verism of Ghiberti's account of the emotions.[18] To be sure, ever since Giotto at the beginning of the fourteenth century, leading Italian artists had regularly created deeply affecting figures who appeared animate with inner life. But for all the expressive power and convincing vitality of human figures in early Renaissance art, the depiction of the emotional and psychological conditions of these figures was often generalized rather than specific. Figures may seem intensely alive, but only rarely are their individual and distinct states of mind and sentiment indicated. The major exceptions to this rule are scenes of tragedy, especially events from the Passion of Christ, such as the Deposition and Lamentation, wherein it was common to show figures in attitudes of profound shock and wrenching grief. Yet other than the grand rhetoric of gesture and expression in such scenes, the representation of emotions tended to be limited in scope and detail; rarely did it ever attain the particularity that Ghiberti sought and achieved.

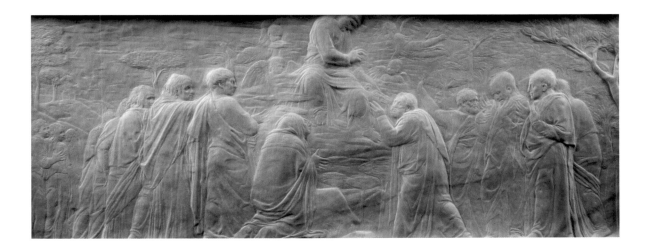

To get a better sense of Ghiberti's accomplishment, we can look at works by two other leading Florentine artists of the 1430s, Fra Angelico and Donatello. Fra Angelico, in works such as the Strozzi altarpiece, made paintings that suggest great depths of feeling. Yet he focused on the representation of an ideal state of spiritual grace: the figures in his paintings have interior lives, but they are saintly ones. In this regard Angelico's account of human sentiment is vastly different from that of Ghiberti, who depicts a wider and more complex range of feeling. The other contemporary artist to whom one must compare Ghiberti is the sculptor Donatello. In the twentieth century it was common to view Donatello as the more powerful and naturalistic of the two in the representation of human nature. Certainly, Donatello created

Figure 2.28 Donatello, *Ascension with Christ Giving the Keys to St. Peter,* 1428–1430, marble relief, Victoria and Albert Museum, 7629-1861.

images of incomparable intensity and vividness. But for all their animation and suggestiveness, Donatello's narrative sculptures rarely describe the emotional and psychological states of the figures they depict with the subtlety, the precision, and the realism of Ghiberti's. For example, the specificity in the depiction of thought and feeling seen in the Gates of Paradise is nowhere found in Donatello's reliefs for the bronze altar in Padua or in his marble panels such as the *Ascension with Christ Giving the Keys to St. Peter* (fig. 2.28) and *The Assumption of the Virgin;* the figures in these tend to give a general sense of excitement, agitation, and *gravitas* rather than represent distinct human motives and reactions. In *The Feast of Herod* (see fig. 2.8), Donatello conveys the horror and shock of the scene with great power. In the *Joseph* panel and the *Jacob and Esau* panel, Ghiberti represents a wider range of sentiments and depicts them with more finely modulated shades of distinction. This observation is not to claim that one artist is better than the other, just that their interests and talents in the portrayal of visual narratives were markedly different.

At about the time that Ghiberti was finishing the models for the Gates, Alberti wrote *On Painting.* In Book Two of this text, Alberti famously recommended that an "*istoria* will move the soul of the beholder when each man painted there clearly shows the movements of his own soul."[19] Alberti gives a few examples of emotions an artist might portray—anxiety, melancholy, anger, happiness—and he cites Giotto's mosaic in Old St. Peter's Basilica of Christ walking on the water—the so-called *Navicella*—as a model of an *istoria.* In that picture, Alberti says, "each figure expresses with his face

Figure 2.29 Ghiberti, *John the Evangelist* panel, north doors, Baptistery of San Giovanni, Florence.

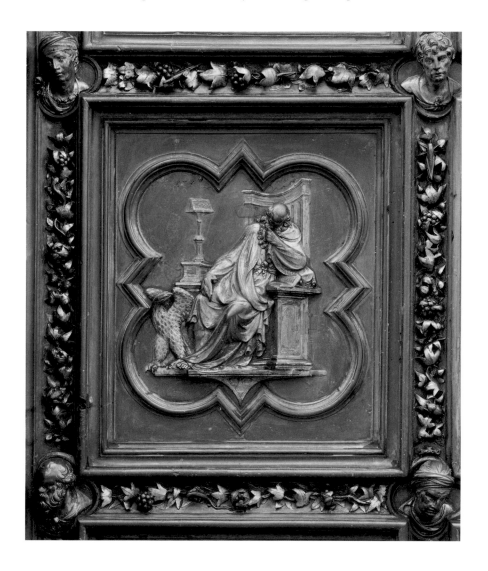

and gesture a clear indication of a disturbed soul in such a way that there are different movements and positions in each one." Krautheimer argued that Alberti's ideals of composition influenced Ghiberti. But Alberti's remarks are too brief and general to account for the complexity and originality of Ghiberti's style of narration in the Gates of Paradise. Moreover, from the very beginning of his career, with the *Sacrifice of Isaac* panel (see fig. 3.4), Ghiberti had displayed the greatest attention to depicting the emotional states of his figures in the most pointed and emphatic manner. Already on the first set of bronze doors he made for the Baptistery, Ghiberti had created sculptures that showed the motions of the mind. To give just one example from the reliefs, as Vasari and many others have noted, the sculptures in the bottom tier of these doors depict the four Evangelists in the middle of mental activities (fig. 2.29); to quote Vasari's succinct description of these men, "one is writing, another is reading, others are in contemplation."[20]

If any one artist helped especially to inspire Ghiberti's careful description of a wide range of human states, it was not Alberti, but Ambrogio Lorenzetti, the fourteenth-century Sienese painter. He was among Ghiberti's favorite artists; in *I Commentarii* the sculptor gives a long account of Ambrogio's work and calls him "a most perfect maestro, and a man of great genius."[21] Ghiberti singled out for praise a fresco cycle Ambrogio made for the church of San Francesco in Siena. Those pictures have been destroyed, but there are two other frescoes by Ambrogio in the church, and they suggest aspects of Ambrogio's art that Ghiberti must have found so attractive. Of these pictures, one shows the martyrdom of Franciscan missionaries (fig. 2.30); a similar scene had also been depicted in the now lost cycle described by Ghiberti. In the surviving picture the grim anxiety of the friars awaiting death and the rapt fascination and visceral shock on the faces of the pagans watching the massacre are described by Ambrogio with vivid detail; there is

Figure 2.30 Ambrogio Lorenzetti, *Martyrdom of Franciscan Missionaries,* ca. 1326, San Francesco, Siena.

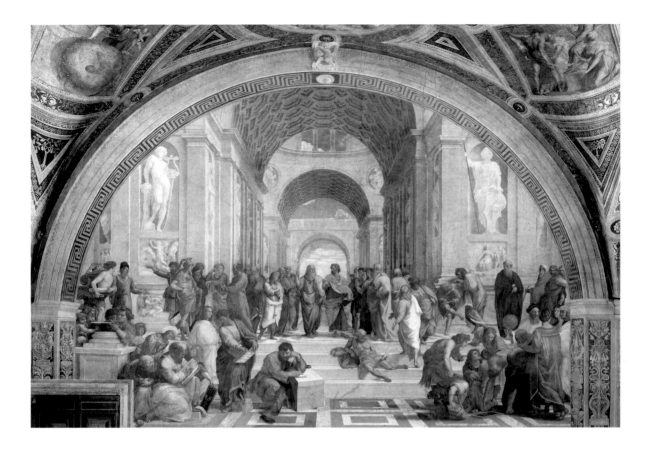

Figure 2.31 Raphael, *The School of Athens,* 1509, fresco, 25¼ feet wide, Stanza della Segnatura, Palazzi Pontifici, Vatican, Rome.

nothing conventional, rhetorical, or generalized about Ambrogio's depiction. Similarly, Lorenzetti took great pains to represent with accuracy and variety the mental states of the figures in the fresco *Saint Louis Taking Leave of Boniface VIII,* in which the assembled friars look on, pondering the significance of the event as Saint Louis kneels with humility before the pope. Unmistakably, they are shown to be thinking, thinking in response to the specific historical event they are witnessing.[22] This degree of subtle description was rare in fourteenth- and early-fifteenth-century painting. It is exactly the kind of accuracy that Ghiberti strove to create in his own relief sculptures.

Although Ghiberti was interested in an attentive and particularized description of emotions, he also sought to join these observations with an elevated style of idealized grace appropriate to his subject, the sacred history of mankind. This may seem to be a surprising combination, especially since realism and idealism are sometimes thought to be contrary poles in aesthetic expression. Yet it was Ghiberti's goal to strike a balance between the two, a balance that became characteristic of Italian Renaissance art. In their sublimity of form as well as their realism of psychological detail, the Gates of Paradise were unlike anything seen before. The harmony of the figures' proportions, the elegance of the poses of the bodies, the fluidity of the draperies, and the dancing rhythmical lines of the compositions reach a level of unearthly refinement that was all but unprecedented in Italian art.

Of the Gates of Paradise, Vasari wrote, "And it may be said, in truth, that this work is in every way perfect and that it is the most beautiful work which has ever been seen in the world, whether ancient or modern."[23] Certainly, in its innovative use of perspective, its rich depiction of human emotions, and its breathtaking embodiment of idealized grace, it was an achievement of dazzling originality. As a work of imagination and sublimity, the Gates were not to be equaled until Raphael's *School of Athens* (fig. 2.31) and the High Renaissance it did so much to inspire. Thanks to their recent

cleaning, we can again see the vision of heavenly beauty that once excited Vasari, Michelangelo, and every other beholder blessed enough to view the Gates in their original brilliance and grandeur.

NOTES

1. In the Middle Ages baptistery doors were frequently referred to as "Gates of Paradise"; Michelangelo, therefore, did not coin the name but rather insisted that Ghiberti's doors were truly worthy of the title. On earlier uses of the term, see M. English Frazer, "Church Doors and the Gates of Paradise: Byzantine Bronze Doors in Italy," *Dumbarton Oaks Papers* 27 (1973), pp. 145–162.

2. R. Krautheimer, *Lorenzo Ghiberti,* Princeton: Princeton University Press, 1956.

3. More recent publications on the Gates of Paradise include E. M. Angiola, "Gates of Paradise and the Florentine Baptistery," *The Art Bulletin* 60 (1978), pp. 242–248; F. Hartt, "Lucerna ardens et lucens: Il significato della Porta del Paradiso," in *Lorenzo Ghiberti nel suo tempo,* Florence: L. S. Olschki, 1980, pp. 27–57; U. Mielke, "Zum Programm der Paradiestür," *Zeitschrift für Kunstgeschichte* 34 (1971), pp. 115–134; and the two chapters on the Gates in W. Prinz and I. Marzik, *Die storia oder die Kunst des Erzählens in der italienischen Malerei und Plastik des späten Mittelalters und der Frührenaissance 1260–1460,* Mainz: P. von Zabern, 2000, pp. 229–258, 259–400.

4. J. Pope-Hennessy, *Italian Gothic Sculpture,* 3rd ed., New York: Phaidon, 1986, pp. 32–33, for example, discusses Ghiberti among Gothic sculptors since, in his opinion, the artist's work does not "reveal the fully rational thought-process of Renaissance Art." See also J. White's comments in "Developments in Renaissance Perspective," in *Studies in Renaissance Art,* London: Pindar Press, 1983, pp. 68–131.

5. E.g.: "Many details in the narrative treatment of the door, as well as its more classical style, must reflect the intervention of Bruni, Traversari, and other learned men" (Pope-Hennessy 1986, p. 35). This prejudice also runs throughout Krautheimer's book, causing him confidently and tendentiously to dismiss or reinterpret any evidence that does not fit the theory that Ghiberti was less progressive than some other artists, specifically Brunelleschi, Donatello, Masaccio, and Alberti. For example, regarding Vasari's explicit statement that Michelangelo called the Gates of Paradise by that name and said they were a *divinum opus,* Krautheimer, p. 18, states: "That Michelangelo was the author is unlikely. Hardly would he have stared in wonder at a door before which he had played hide-and-seek as a child; aside from which, both taste and training drew him more toward Donatello's stone figures than toward Ghiberti's melodious bronze reliefs." Krautheimer gives no evidence for his claim that Michelangelo preferred Donatello to Ghiberti, nor does he explain why he feels free to disallow a statement by Vasari, someone who knew Michelangelo. The opposition of Ghiberti and Donatello, and the claim that Donatello is the more modern of the two, is a common assumption in twentieth-century scholarship. Other scholars who have credited Alberti, Traversari, etc. for the innovative elements on the doors include: S. Edgerton, *Renaissance Discovery of Linear Perspective,* New York: Basic Books, 1975; F. Hartt, *History of Italian Renaissance Art,* New York: H. N. Abrams, 1969, pp. 239–242; and most recently, F. Camerota, "Le premesse ottiche: Lorenzo Ghiberti," in *La prospettiva del Rinascimento: Arte, architettura, scienza,* Milan: Electa, 2006, pp. 82–86.

6. In my opinion, the *Adam and Eve* panel is the most exquisitely chased of all the reliefs. Details of anatomy and naturalistic description—such as the trees and the birds in the trees—are of a degree of delicacy and refinement virtually unprecedented in Italian sculpture or goldsmith work. It is of such outstanding quality that I assume it received special attention from Lorenzo Ghiberti in some manner, including the possibility he chased it first to set the standard for all the other panels. It is worth stating here that the division of labor in chasing the panels is entirely a matter of speculation. We do not know exactly how it was organized. The document of 4 July 1438 might be read to imply that the workshop was divided into three teams of chasers: one led by Lorenzo Ghiberti, one by his son Vittorio, and one by Michelozzo. But even if we make that assumption, we cannot be sure what the division of work might have been. (Moreover, it is possible that the division of labor within the studio changed after 1443.) Did they divide the panels among the three teams, or did each team specialize in some feature of the chasing? Further study on this point might reveal the answer.

7. Krautheimer, pp. 169–188. On Traversari, see also G. Clarke, "Ambrogio Traversari: Artistic Advisor in Early Fifteenth-Century Florence," *Renaissance Studies* 11 (1997), pp. 161–178; and P. Castelli, "*Lux Italiae:* Ambrogio Traversari Monaco Camaldolese: Idee e immagini nel Quattrocento fiorentino," *Atti e memorie dell'Accademia Toscana di scienze e lettere 'La Colombaria'* 47 (1982), pp. 39–90, and "Marmi policromi e bianchi screziati: In margine alle valutazioni estetiche del Traversari," in *Ambrogio Traversari nel VI centenario della nascita,* Florence: L.S. Olschki, 1988, pp. 211–224.

8. Krautheimer, pp. 162–163, 328–329.

9. L. Ghiberti, *I Commentarii,* ed. L. Bartoli, Florence: Giunti, 1998, p. 95.

10. On Ghiberti's use of single-point perspective in these two panels and in general, see J. White, *The Birth and Rebirth of Pictorial Space,* London and Boston: Faber & Faber, 1987, pp. 160–164; F. Camerota 2006; L. Vagnetti, "Ghiberti prospettico," in *Lorenzo Ghiberti nel suo tempo,* Florence: L. S. Olschki, 1980, pp. 421–436; L. Andrews, *Story and Space in Renaissance Art: The Rebirth of Continuous Narrative,* Cambridge: Cambridge University Press, 1995; D. D. Kane, "Science in the Art of the Italian Renaissance: Ghiberti's Gates of Paradise, Linear Perspective, and Space," *Ohio Journal of Science* 102 (2002), pp. 110–112; and C. Seymour Jr., *Sculpture in Italy 1400–1500,* Harmondsworth: Penguin, 1966, pp. 106–115.

11. Krautheimer, p. 250.

12. See Krautheimer, pp. 229–253, esp. 253: "After all, [Ghiberti's] mind had never run along theoretical lines, and almost unaware he slipped out of Alberti's perspective system as suddenly as he had slipped into it."

13. J. Pope-Hennessy, "The Sixth Centenary of Ghiberti," in *The Study and Criticism of Italian Sculpture,* New York: Metropolitan Museum of Art, 1980, pp. 51–62.

14. Parronchi, "Le misure dell'occhio secondo il Ghiberti," in *Studi su la dolce prospettiva,* Milan: Aldo Martello, 1964, pp. 331–348.

15. The earlier use of an inclined foreground in relief, and Ghiberti's knowledge of it, requires further investigation. It was a practice going back at least to the early thirteenth century; for example, see the overdoor reliefs in the doorway of the south transept at Chartres Cathedral, from ca. 1215–1230 (for an illustration, see P. Williamson, *Gothic Sculpture, 1140–1300,* New Haven and London: Yale University Press, 1995, p. 45). It was also known in Florence, for example, in the reliefs on the Silver Altar of the Baptistery, a project with which Ghiberti was intimately familiar and on which both Michelozzo and Vittorio Ghiberti were to work. However, these inclines are not coordinated with the perspective of the space in the background, as in Ghiberti, and earlier artists do not seem to have been concerned about the need to disguise the incline by adapting the placement of the figures' feet.

16. Ghiberti, p. 95, "Furono istorie dieci tutti in casamenti, colla ragione che l'ochio gli misure e veri in modo tale *stando remoti* da essi appariscono rilevati" (emphasis added).

17. U. Middeldorf, "L'Angelico e la scultura," *Rinascimento* 6:2 (1955), pp. 179–194; J. Pope-Hennessy 1980, pp. 56–57. It is worth noting that Michelozzo and Benozzo Gozzoli worked closely with both Angelico and Ghiberti.

18. The representation of emotion in late medieval and Renaissance art is a vast and crucial subject, but one that has received very little concentrated attention from scholars. The remarks I make here are, of course, entirely preliminary, and it is to be hoped that others will take up and examine this subject with the care and sensitivity that Erich Auerbach in *Mimesis* brought to the subject of the depiction of reality in Western literature. It is my belief that scholars have not often given close thought to the differences between, on the one hand, power and credibility in the depiction of emotions and, on the other hand, specificity and particularization in their description. It may be that the conditions and functions of visual narrative in the late Middle Ages and Renaissance created a strong need for power but not particularization in the representation of the emotions. Nor did the nature of the narratives that artists were asked to make require such particularization: after all, most visual narratives were intended to portray either exemplary and/or miraculous deeds or heroic suffering. The kind of psychological complexity so strongly implicit in the stories of Genesis was exceedingly uncommon among the myths and legends that artists generally had to represent. It is striking that Ghiberti was the artist to respond to this aspect of the stories. One might also consider the decorum incumbent on artists: the need for dignity and majesty in the representation of God, Jesus, and the saints may have disallowed the emphasis on emotion, except in moments clearly established by tradition, such as the Passion of Christ. One should also note the suspicion of the human passions, which were regarded as

something negative in the Christian Stoic tradition that was so dominant in the early Renaissance. According to this view, blessedness and happiness were states beyond the transitory fluctuations of the emotions, and enlightened understanding entailed a nearly complete degree of self-control. (Is this related to why saints appear so placid in images of their martyrdom?) The question of what constituted the Renaissance concept(s) of psychology and how this would have affected the understanding and depiction of various states of mind and feeling is another that one might wish to ask.

19. L. B. Alberti, *On Painting,* trans. J. R. Spencer, Westport, Connecticut: Greenwood Press, 1976, p. 77.

20. G. Vasari, *Lives of the Painters, Sculptors and Architects,* trans. G. du C. de Vere, New York: A. A. Knopf, 1996, I: 294. Vasari's descriptions of both the north doors and the Gates of Paradise emphasize the complexity, profundity, and accuracy of Ghiberti's depiction of the emotional and psychological states of the figures portrayed in the narrative reliefs.

21. Ghiberti, pp. 87–89.

22. We can be certain that Ghiberti was interested in Ambrogio's capacity to depict thought. In the *Commentarii,* he opens his description of the fresco cycle in San Francesco by saying that the first scene in the cycle shows "come uno giovane deliberò essere frate": how a youth *deliberated* to become a friar. See Ghiberti, p. 7.

23. Vasari, p. 304.

Adam *and* Eve

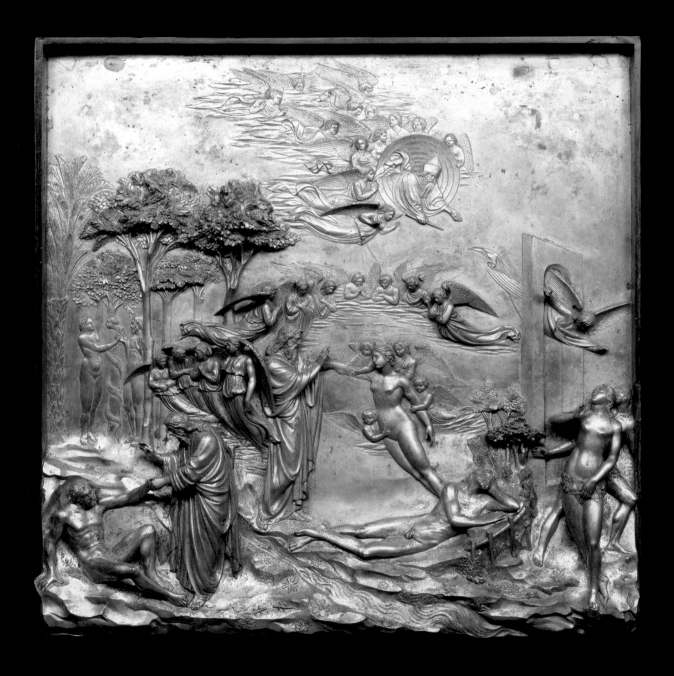

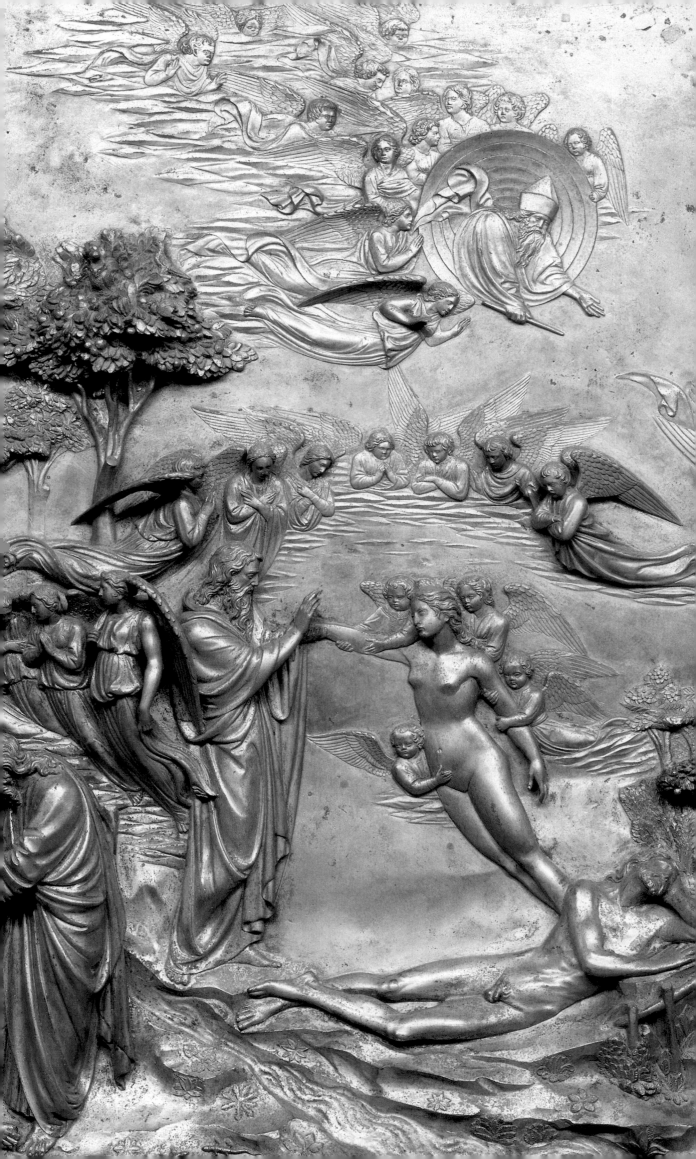

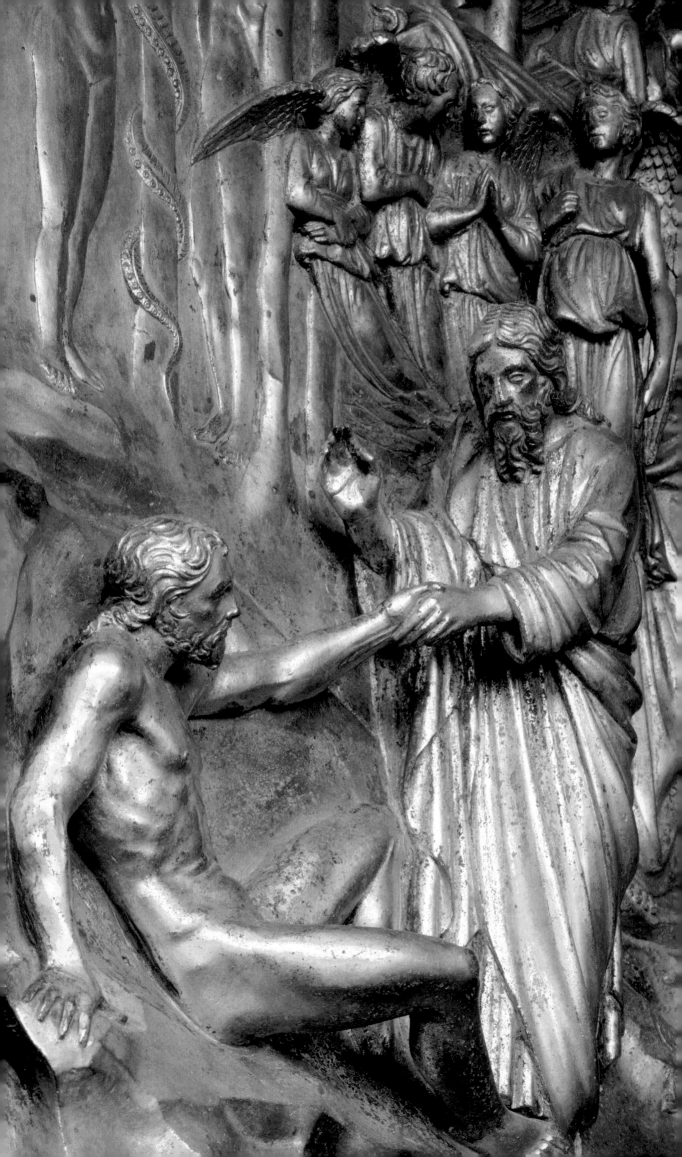

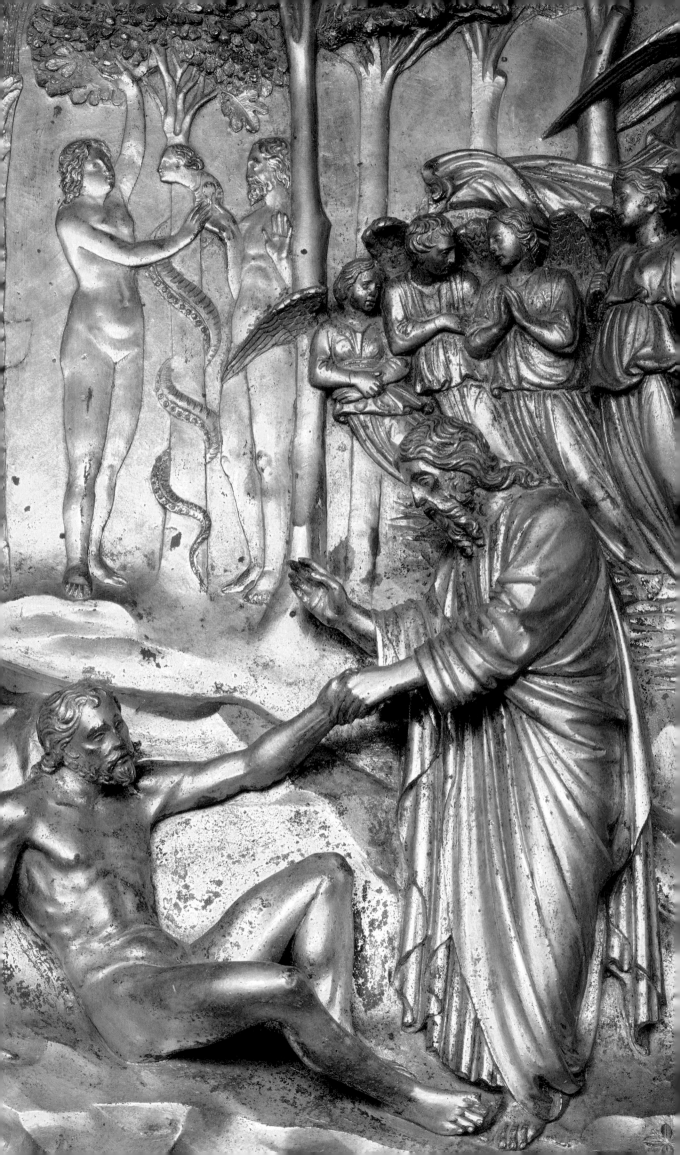

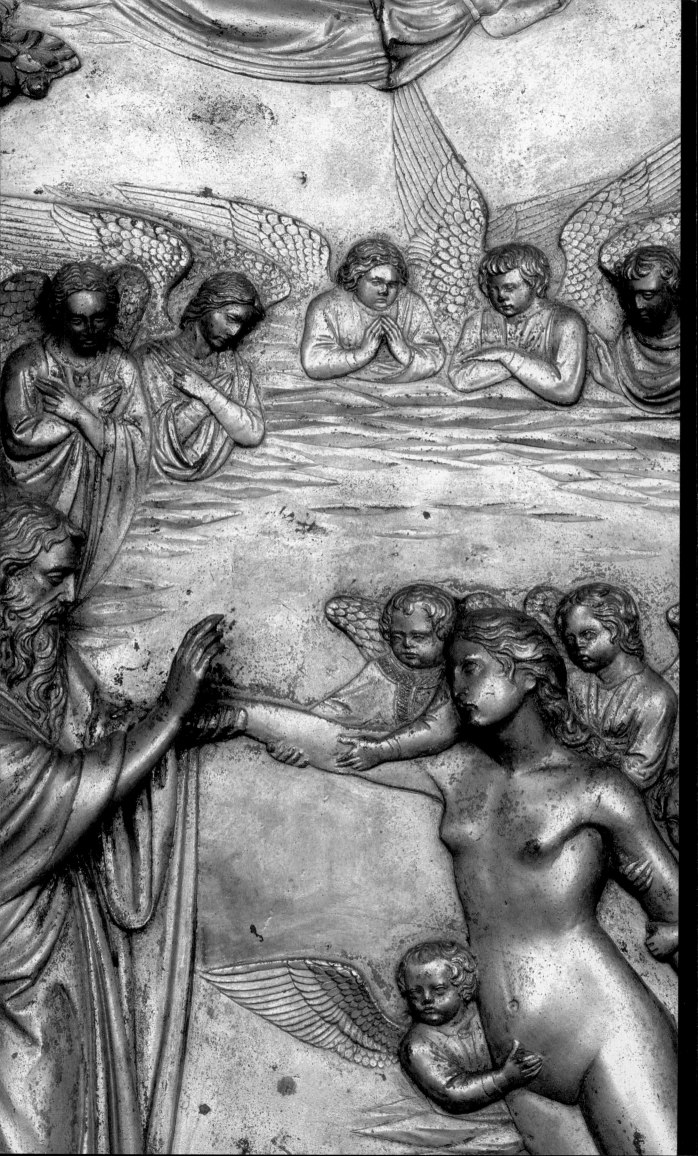

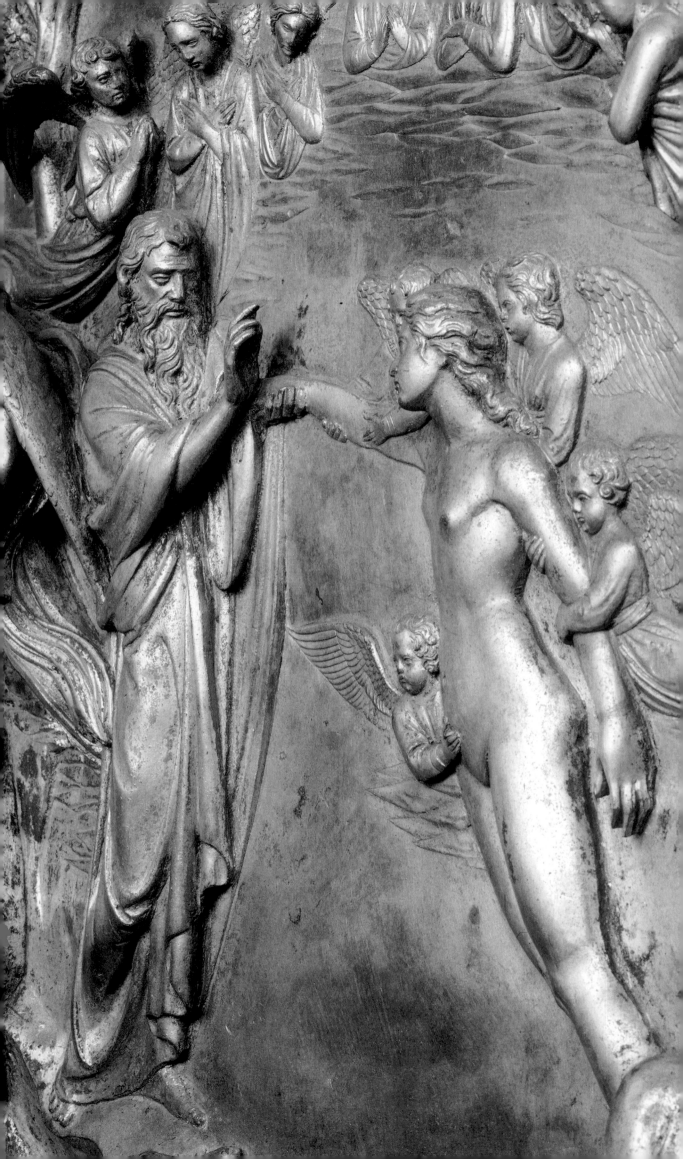

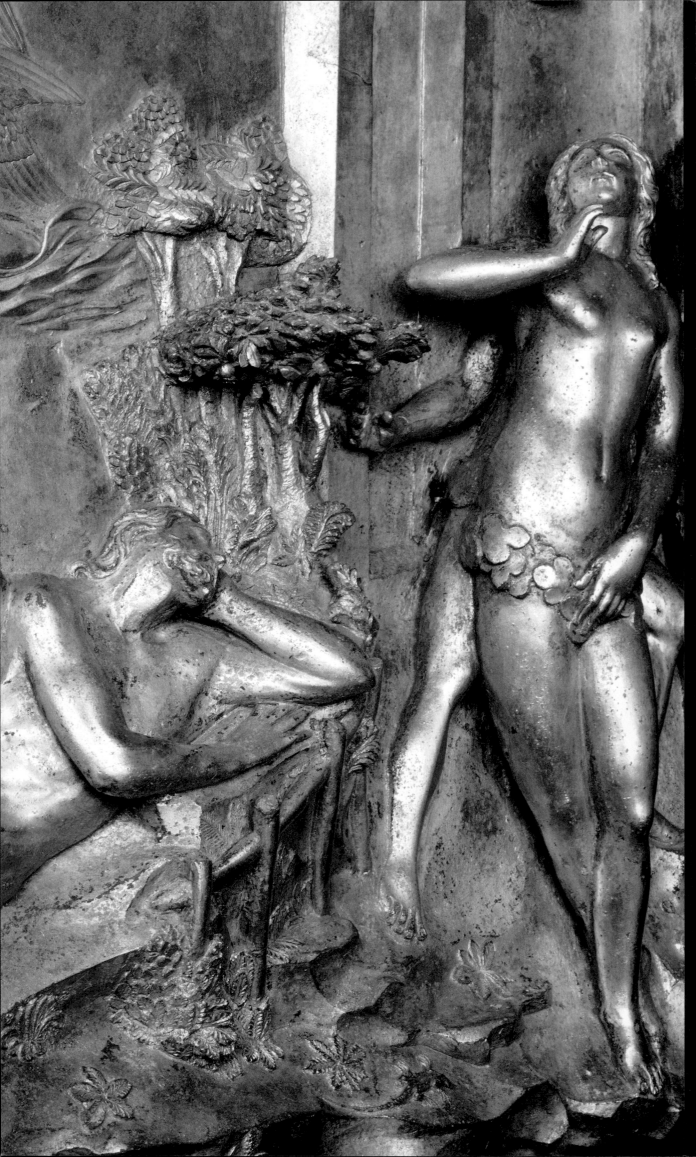

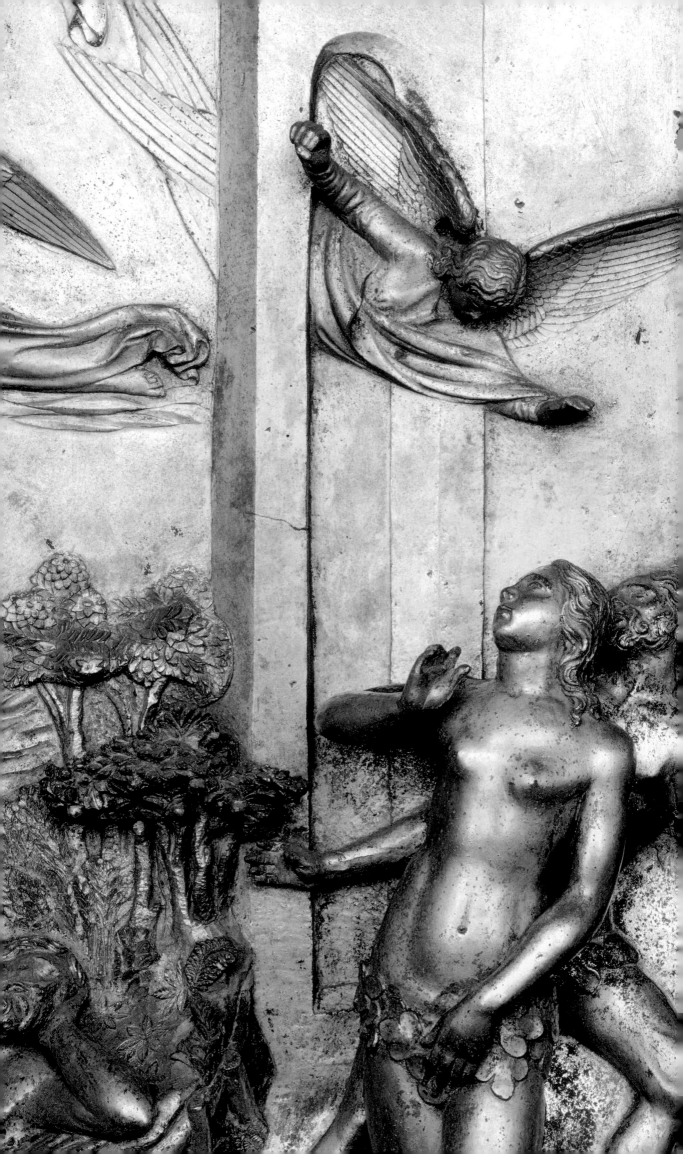

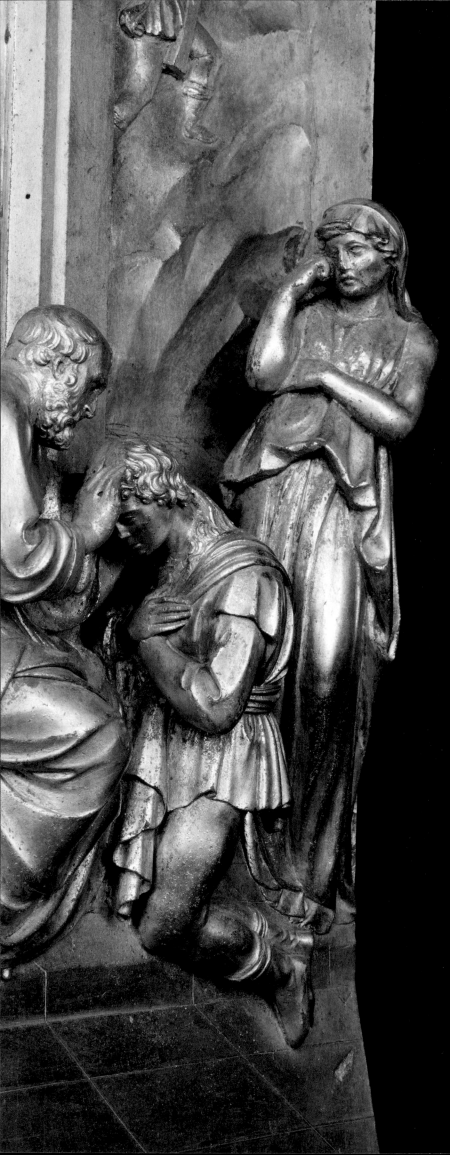

Lorenzo Ghiberti:
Master Collaborator

Gary M. Radke

Dean's Professor of the Humanities
Syracuse University

and

Consulting Curator of Italian Art
High Museum of Art

IN THE WINTER OF 1400–1401 Lorenzo Ghiberti entered the competition for a new set of bronze doors for the Florentine Baptistery. The rivalry among the seven finalists must have been intense.[1] Ghiberti later described the event in his autobiography—the first ever written by a modern artist—as both a test and battle (*pruova et combattimento*), and he called the participants not just competitors but combatants (*combattenti*).[2] Under such circumstances we can fully appreciate his triumphant boast upon winning the competition: "To me was universally conceded the glory without any exception."[3] But a counter-version of the same events, told by partisans of Filippo Brunelleschi (1377–1446), who lost the competition and went on to become the period's most famous architect, claimed that members of the selection committee were evenly divided and that at first they offered the commission jointly to both artists.[4] Brunelleschi is said to have stormed off, insulted by the idea of collaboration, but the reality is that collaboration, not just competition and rivalry, was the norm in fifteenth-century Florence. As we shall see, Brunelleschi himself shared the commission for his famous dome on Florence Cathedral with none other than Lorenzo Ghiberti.

Powerful corporate sensibilities and social structures tempered Renaissance genius and individuality. In large part, Renaissance Florence was run by committee. Florentines lived in large extended families, the city's leading businesses were often run by teams of brothers, partnerships were common, trades were organized around workshops that necessarily included assistants and trainees, and one of the most popular means of addressing complex governmental issues was to appoint a *balia*, a broadly representative investigative panel. On the artistic front, as early as 1367 a plebiscite of hundreds of ordinary as well as powerful citizens reviewed plans for the city's enormous cathedral.[5] In 1401 thirty-four judges from both Florence and its surrounding territories participated in the selection of Ghiberti for the Baptistery commission, and in 1504 a committee of both artists and governmental officials determined the placement of Michelangelo's *David*.[6] Even commissions that today strike us as largely individual—those associated with Cosimo il Vecchio de' Medici, for example—recently have been shown to have been undertaken in concert with others.[7] What is more, both artists and patrons expected works to be produced with assistants; otherwise, it is hard to make sense of contractual stipulations that urge the master to devote

his attention to difficult details.[8] Savvy patrons knew that the master would be delegating much of his work.

The question then is not whether Ghiberti and his fellow artists collaborated with others—they all had intimate dealings with patrons and with committees that selected, supervised, and evaluated artists, as well as with suppliers, assistants, and one another.[9] Instead, the key distinction lies in how individual masters negotiated these complex relationships. Ghiberti stands apart in fifteenth-century Florence for his skills as an impresario within his own shop and for his canny ability to work well with others. In his workshop, he was extremely successful at forging the contributions of his assistants and collaborators into a single, coherent whole. Tellingly, while art historians have been able to discern multiple hands in the works of contemporary painters, Ghiberti's complex narrative compositions on both sets of bronze doors for the Florentine Baptistery have so far resisted such dissection. Part of this may be due to the nature of producing bronze sculpture, which allowed Ghiberti to return over and over to his works during the lengthy production process. But given the large number of Ghiberti's collaborators on the doors—eleven assistants are documented in 1407 and twenty-one are listed in further documents for the first set of doors[10]—it is remarkable that Ghiberti was able to exercise such a strong controlling hand. He was, as payment documents for his monumental bronze statue of *Saint Matthew* for the Bankers Guild at Orsanmichele put it, the conductor (*conductore*) of the work, making and having others help him make the statue (fig. 3.1).[11] While it would be anachronistic to equate this role with the conductor of the modern symphony orchestra—Renaissance and Baroque musicians did not expect such control over their performances—the term may be interpreted broadly to mean the creative leader and coordinator of a collaborative enterprise, the man who was responsible for supervising every aspect of the work and bringing it to a successful conclusion.

Outside his own shop Ghiberti efficiently marshaled the services of cart drivers, day laborers, and suppliers to keep his workshop running smoothly. He was both charming and well-organized, which appealed to patrons, even though they must have been frustrated by the overly optimistic cost-and-time estimates he provided them. Ghiberti seems to have found it hard to say no to the rich and powerful, profiting enormously by accepting multiple overlapping salaries. The Ghiberti touch was so in demand that he also provided designs for numerous other artists to execute in media other than bronze, his specialty. What is more, he had architectural ambitions, which led to his working with Brunelleschi on the tribunes and dome of Florence Cathedral, another collaboration that must have been fraught with difficulties but of which he was particularly proud.[12]

It may seem surprising, then, to learn that Ghiberti composed his autobiography nearly entirely in the first-person singular—the only time he used the plural or spoke of a collaborator was when he discussed working alongside Brunelleschi on the dome. His ego was not diminished by working with and for others; instead, collaboration allowed him to be even more productive than he might otherwise have been. In the end, his was the controlling, synthesizing vision, and he was ultimately responsible for the works that issued from his shop. It was he who faced patrons and explained away complications, failures, and delays. Again, to cite a modern parallel, he created his works of art the way a modern architect "builds" a building, attending obsessively to detail even though it was not possible for him to accomplish the work with his own hands. When Ghiberti says, "I produced the statue

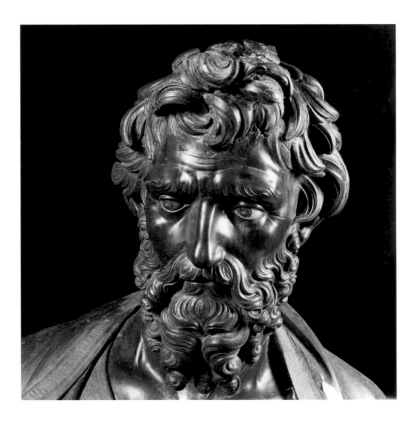

Figure 3.1 Lorenzo Ghiberti, *St. Matthew* (detail), bronze, 1419–1422, Orsanmichele, Florence.

of Saint Matthew by my hand,"[13] he means that he was responsible for the work, not that he labored alone.[14] He makes clear his principal role in the creative process when he boasts toward the end of his autobiography, "There are few important things in our land [Florence] that were not designed and given order (*disegnate et ordinate*) by my hand."[15] Designing in the broadest sense of the word—from actually drawing and modeling to more generally articulating an aesthetic vision—along with giving order to complex tasks: these were the skills that made Ghiberti a master collaborator.

In some cases, the word "collaboration" may strike readers as overly inclusive, especially as I use it both to describe Ghiberti's longterm interactions with actual collaborators like Brunelleschi as well as to characterize other more perfunctory exchanges. I am hard put to find another word, however, that so powerfully indicates the interconnectedness of all Renaissance artmaking. In some cases, collaboration may have occurred by default and even remote control—one person exploiting the work, ideas, or financing of the other without much personal interaction. However, most of this exchange took place knowingly: Ghiberti's suppliers, for example, were well aware of the kinds of fine-quality materials he required, and Ghiberti was attentive to the media into which some of his designs were to be translated. Copyright, of course, did not exist, and there was little reliance on single, individual genius. Collaboration was the order of the day.

In this essay I explore three realms of collaboration in Ghiberti's work. First, I address the surprising amount of interaction that took place by default within the formal competitive process surrounding most public commissions. Second, I examine Ghiberti's skillful—one might even say manipulative—relations with his patrons, to whom he paid due attention even while furthering his own best interests. Finally, I review his work with and for fellow artists outside as well as within his workshop. I hope to provide a richer and more complicated view of Ghiberti, a man who experienced his share of competitions and rivalries but who was also a master collaborator.

I. Collaboration within Artistic Competitions

Competitions were integral to the commissioning of public art and architecture in Renaissance Florence. With huge expenditures at stake, not to mention political and ideological concerns, commissioners needed to be confident that they were investing in the best and most appropriate designs possible. But competitions were burdensome as well. Ghiberti must have sighed with relief when he received the commission for his second set of bronze doors for the Baptistery, the Gates of Paradise, without having to jump through the usual hoops, allowing him to begin the second set of doors very shortly after he completed the first. Even the great Filippo Brunelleschi, however, was not so fortunate. Once the dome of Florence Cathedral was completely vaulted in 1436—thanks to Filippo's ingenious design of bricks laid in herringbone patterns without the assistance of any wooden centering—he still had to participate in a competition for the design of the lantern that closes and crowns the dome (fig. 3.2). One of his competitors was Lorenzo Ghiberti, along with three others.[16] A careful reading of the documents surrounding the competition allows us to appreciate what the commissioners hoped to gain from Ghiberti's and other artists' involvement in both the competition and in the construction that followed.

After a thorough vetting process, which included review by masters of sacred theology, doctors of secular sciences, builders, masters of other arts, and knowledgeable laymen, followed by written reports given by three juries, each of which contained two architects, two painters, two goldsmiths, a mathematician, and two citizens knowledgeable in the art of architecture, as well as further review by a special committee including Cosimo de' Medici—the entire process testifying to the collaborative and consensual nature of commissioning public art and architecture—Brunelleschi's design for the lantern carried the day. Deemed superior in strength and lightness as well as imperviousness to rain, the design was nonetheless required to be modified in light of the other submissions, as we learn from the official pronouncement, which insisted

> that said lantern be made and constructed following the model made by said Filippo and that it be guided and brought to execution by the same Filippo; but with these modifications, namely: that the consuls and *operai* by virtue of their office have Filippo meet with them; and that they use such words with him concerning the preceding as may be required, in order that he might put aside all rancour remaining in him and correct and improve the part which requires correction in his model, whatever that may be judged to be, however insignificant, that seems in need of correction and that which appears good and useful in other models, let him take it and put it into his, so that said lantern may be perfect in all of its parts: let the preceding weigh on his conscience.[17]

In other words, the competitive process both allowed multiple ideas to come forward and left open the possibility that good ideas from losing entries could be incorporated into the finished work. Commissioners were, in essence, interested in collaboration by default, caring little about the artistic integrity or singularity of any one design. While Brunelleschi was surely resistant to such a practice, as evidenced by references in the document to the "rancour remaining in him" and by the commissioners' exasperated appeal to his conscience, there was broad consensus that the crowning element of the city's cathedral was to incorporate the ideas of multiple designers.

Figure 3.2 Filippo Brunelleschi, Lantern, Florence Cathedral, marble, designed 1436, built by Michelozzo Michelozzi, possibly incorporating elements suggested by Lorenzo Ghiberti.

Figure 3.3 Lorenzo Ghiberti, Sacristy, Santa Trinita, Florence, 1418–1423.

It might be worth reconsidering, then, what Ghiberti may have contributed to the lantern as we see it today, even if his ideas were subsumed into Brunelleschi's overall conception and further masked and/or altered by other masters who completed the construction after Brunelleschi's death—all of whom, it should be noted, are likely to have been aware of and sympathetic to Ghiberti's ideas.[18] Architectural historians have long noted the lantern's rich decorative quality and its singularity in Brunelleschi's oeuvre, more reminiscent of goldsmith's work and reliquaries than his more sober and restrained architecture. Giannozzo Manetti openly complained that the stilted arches over the windows and the decorations under the scrolls were not as Brunelleschi intended them, prompting Howard Saalman to wonder whether the rosettes and peapods under the scrolls and even the pilaster capitals might have been "inspired additions by Michelozzo."[19] Or could it be that here we are seeing vestiges or recollections of the lantern design by Ghiberti, who is likely to have put a premium on decoration and was not at all uncomfortable stilting or pointing arches, even in classicizing designs such as his niche for *Saint Matthew* at Orsanmichele? Similar rosettes appear in the spandrels of the lancet windows he designed for Filippo Strozzi at the sacristy of Santa Trinita (fig. 3.3), and lush peapods and other foliage enliven the frames of his Baptistery doors. Or might Ghiberti's design have been

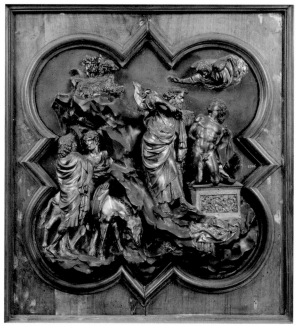

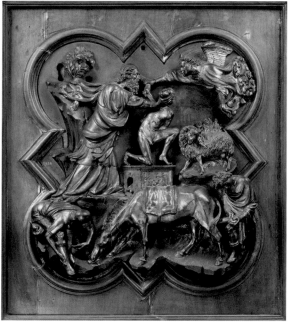

Figure 3.4 Lorenzo Ghiberti, *Sacrifice of Isaac,* bronze, 1401–1402, competition panel, Museo Nazionale del Bargello, Florence.

Figure 3.5 Filippo Brunelleschi, *Sacrifice of Isaac,* bronze, 1401–1402, competition panel, Museo Nazionale del Bargello, Florence.

more thoroughly Gothic, pushing Brunelleschi himself to devise a classical equivalent of crockets and spires in the turned candelabra-like forms, topped by gilded balls, that punctuate the base of the lantern's roof? We are not likely ever to know, but clearly the lantern that we see today does not reflect Brunelleschi's ideas alone. It necessarily fused various design proposals.

Artistic exchange, whether intentional or by default, started at the very beginning of the design process. Artists attempted to sneak looks at one another's work, and Ghiberti seems to have been especially savvy about soliciting opinions from numerous critics and incorporating them into his work. At least that is how Manetti explained the striking differences between the Baptistery competition panels by Ghiberti and Brunelleschi (figs. 3.4 and 3.5). Brunelleschi, he said, worked quickly and completely on his own to prepare his competition panel for the Florentine Baptistery, while Ghiberti constantly sought the advice "of all the people he esteemed who, being goldsmiths, painters, sculptors, etc. and knowledgeable men, had to do the judging."[20] While Manetti chalked this up to Ghiberti's supposedly shifty personality and feelings of inadequacy toward Brunelleschi, the mode of working that he describes corresponds closely to the meticulous work we see in all of Ghiberti's narrative reliefs. Manetti says Ghiberti "unmade and remade the whole and sections of it without sparing effort, just as often as the majority of experts in discussing it judged that he should. The *operai* and officials of the church were advised by the very people Lorenzo had singled out. They were in fact the best informed and had been around Lorenzo's work many times: perhaps there was no one else [to consult]."[21]

Manetti's parting shot, "perhaps there was no one else," may have been intended as a diplomatic disclaimer, but the number and variety of people whose opinions were solicited for major public commissions were considerable and could well have led to lobbying and jockeying by the competing artists—something the smooth-talking Ghiberti would have found very agreeable, unlike the more taciturn and at times irascible Brunelleschi. Along the way, competitors were sometimes even called upon to critique one another's work. In 1366 three teams of designers not only commented on their own submissions for the Cathedral but were asked to indicate which of the designs struck them as "the most beautiful or functional and secure."[22]

Their diplomatic replies reveal that they well understood the principle of collaboration within competition.

II. Collaboration with Patrons

Given the prestige and costliness of the materials with which Ghiberti worked (largely bronze and gold),[23] his patrons were necessarily the rich and powerful: members of guilds such as the Lana (wool masters), Calimala (wool merchants), and Cambio (bankers), including Palla Strozzi and Cosimo de' Medici, as well as officers of the Opera del Duomo (itself overseen by the Arte della Lana). His one major commission outside Florence was for panels for the font in the Baptistery in Siena (see fig. 2.9), again overseen by a highly prestigious public entity.

Ghiberti's relationships with his patrons can be described charitably as inventive, at times dismissive, and frequently self-interested. He never played exactly by the rules, which meant that he needed to renegotiate contracts, ask for extensions, and generally talk himself out of some tight corners. While he occasionally must have angered his patrons—he hardly ever met a deadline—Ghiberti knew how to smooth feathers and keep the process moving forward. Patrons probably indulged him both because he possessed remarkable diplomatic skills and because he basically cornered the market on Florentine bronze production in the first half of the fifteenth century. His sometime assistants Donatello and Michelozzo also worked in the medium, but Ghiberti was Florence's bronze modeler, caster, and finisher par excellence. Novel but accessible, his works appealed to a broad audience, unlike the highly inventive but often impressionistic, less well-crafted, and psychologically challenging works produced by Donatello.[24] None of Ghiberti's patrons ever expressed disappointment with his finished work.[25]

From the beginning of his career, Ghiberti extracted unusual terms from his patrons, putting much more of the financial risk and burden on them than on himself. While most artists agreed to contracts that provided them advances from which they paid assistants and purchased materials,[26] Ghiberti's contract of 23 November 1403 for his first set of doors at the Florentine Baptistery provided the sizable annual salary of 200 florins to be shared by him and his stepfather (who must have been acting as legal guarantor since Ghiberti did not matriculate in the pertinent goldsmith's guild until 1409). In addition, all material and other labor costs were to be borne separately by the guild.[27] When on 1 June 1407 Ghiberti had not met the conditions of annually producing three reliefs, he and officers of the Calimala guild renegotiated his contract. They had agreed to work together and needed to work out a mutually satisfactory solution for their continuing collaboration. The commissioners put pressure on Ghiberti to work more diligently and not take other commissions (a condition he always agreed to but often disregarded); at the same time, they increased his personal salary to 200 florins annually, no longer requiring him to share it with his stepfather. Between the lines of these contracts one can almost hear Ghiberti explaining how complicated his work was, how much he wanted it to be of the very best quality, and how the commissioners' patience and indulgence would be well rewarded—though neither he nor they probably ever imagined that the production of a set of bronze doors like those that had taken Andrea Pisano six years to complete in the fourteenth century (1330–1336) would stretch over two decades.

Part of the complication lay in distractions caused by the Calimala guild itself, which around 1414 commissioned an over-life-size bronze sculpture

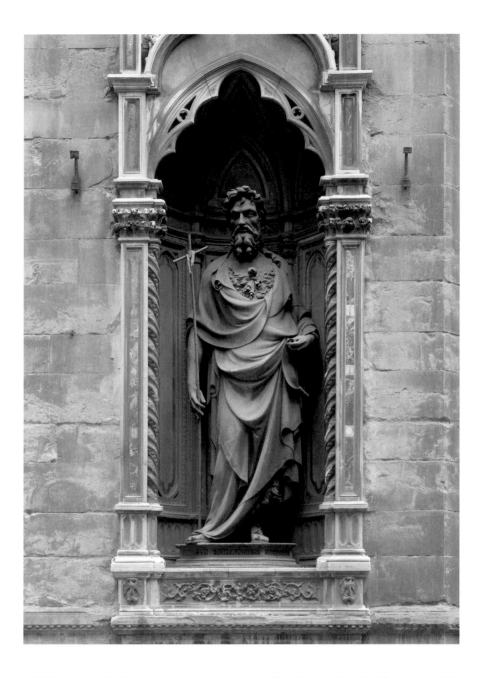

Figure 3.6 Lorenzo Ghiberti, *Saint John the Baptist,* bronze, 1414–1417, Orsanmichele, Florence.

of Saint John the Baptist, their patron saint, for Orsanmichele (fig. 3.6) while the artist was in the midst of work on the doors. And when he installed the statue in 1417 but still had not completed the doors, Ghiberti took on a commission the same year to create two reliefs for the Siena Baptistery font.[28] Tellingly, the Sienese project dragged on for a decade, over the course of which the treasurer of the Siena Opera came personally to Florence in 1420 to urge Ghiberti to complete the reliefs.[29] Sienese solicitations notwithstanding, Ghiberti still had not completed the work in March 1425, and the Opera demanded that he return all the advances he had received for the uncompleted works. Ghiberti wrote an apologetic letter on 16 April 1425 to his Sienese colleague Giovanni Turini, saying the work had been delayed by the outbreak of plague and loss of his assistants[30]—a white lie of sorts, insofar as Ghiberti had recently been on a diplomatic mission to Venice with Palla Strozzi,[31] another sign of the high regard in which he was held in Florence—and it might reasonably be assumed that Michelozzo, his chief collaborator on the first doors, had probably left the shop to create a partnership with Donatello upon the completion of the first set of doors on 19 April 1424, unaware that the commission for the second set would be made without a time-consuming competition.[32] Ghiberti rejected Turini's

offer of assistance in completing the reliefs, saying that they were in the hands of other assistants, nearly finished, but once again Ghiberti was prevaricating, for the panels were not delivered to Siena until 1427. Patience and skepticism were virtues in collaborating with Ghiberti.

The shrewd members of the Arte del Cambio had more success in getting Ghiberti to work in a timely manner on their niche statue *Saint Matthew* for Orsanmichele (see fig. 3.1), which Ghiberti agreed to begin in 1419, again while still working on the bronze doors. They refused to be bound by the conditions that Ghiberti had secured from the Calimala for the Baptistery doors and his *Saint John the Baptist*. Instead, the good bankers, led by Cosimo de' Medici, insisted on the more usual practice of having the work evaluated when it was completed,[33] providing advances and paying reasonable costs for the artist's materials. Perhaps wary of Ghiberti's expectations, they inserted a statement into the contract, written for Ghiberti to sign in the first-person singular, in which he agreed to the process.[34] For once Ghiberti nearly met the official deadline of three years for the work, though there were substantial casting problems along the way and the final evaluation of the work stipulated that he would be compensated a total of 650 florins on the condition that he also recast the base and attach the figure to it.[35] In the end, however, the bankers paid Ghiberti 120 florins more than the Calimala had compensated him for their statue of *Saint John the Baptist,* an indication not only that the *Saint Matthew* was somewhat larger and more artistically advanced than the *Saint John the Baptist* but that the working relationship had turned out to be very positive.

During this process Ghiberti developed an intimate relationship with Palla Strozzi, the richest man in Florence and a leading member of the Arte del Cambio. Ghiberti and Palla had already become acquainted with one another when the banker served as one of the syndics for Ghiberti's first set of Baptistery doors in 1403.[36] On 7 August 1420 the Strozzi Bank loaned Ghiberti the substantial sum of 600 florins for purchasing two farms from the Capitani of Orsanmichele.[37] Our artist seems to have had a great talent for taking advantage of and enjoying his well-placed connections. The loan came with the extraordinary condition that it not be recalled until Ghiberti was ready to pay. As we have noted, Ghiberti also joined Palla in Venice in October and November 1424 as part of a diplomatic mission that was discussing a possible joint response to military threats from Milan.[38] Had the Strozzi family been able to avoid being sent into exile by the Medici in 1434, Ghiberti's collaboration with the family and other artists and builders who regularly worked for them might well have been even more extensive.

Ghiberti continued to work for the Calimala on the bronze doors for the Baptistery for nearly two more decades, during which time he came to know his patrons and their financial situation intimately. While he again received an annual salary and went through multiple contracts for the Gates of Paradise,[39] he twice advanced the guild money.[40] Whether Ghiberti actually loaned money to the guild[41] or merely assisted their cash flow by not requiring payment of certain funds that were owed him is not clear from his *catasto* declaration. He also eased their financial stress by taking his final payment for the Gates of Paradise in the form of the house and workshop where he had produced the doors, in lieu of cash.[42] The man cooperated with his patrons, but he also knew how to strike a good deal.

Just the same, Ghiberti's preferred mode of payment remained an annual retainer, underscoring the rather high-handed ways in which he sometimes treated his patrons. In 1432 he secured very favorable conditions from the

Opera del Duomo for the production of a bronze shrine for the relics of Saint Zenobius (fig. 3.7).[43] In what sounds like an act of desperation—Ghiberti was fully engaged with modeling and casting the large panels of the Gates of Paradise for the Arte della Calimala—the Opera agreed to pay him fifteen florins a month (180 a year, nearly equal to his annual 200-florin salary for the doors), whether he worked on the commission or not. If officials thought that such generous terms would distract Ghiberti from his work for the Calimala, they were mistaken. Five years later, little or no work seems to have been accomplished, and the Opera completely canceled the contract in April 1437 as work on the doors reached an even higher pitch.[44] By March 1439 tempers had cooled and Ghiberti was back on the cathedral payroll, committing, without blinking an eye, to finish the shrine by January 1440.[45] The work was not done until 30 August 1442, two and a half years after the deadline.[46]

The Operai should have been well aware of Ghiberti's willful behavior. They had already rejected his design for the choir enclosure of the cathedral in November 1435, in part because he had not followed their instructions to place a lectern, not the high altar, at the center of the design.[47] It is clear, then, that being what I have termed a "master collaborator" did not always mean being completely cooperative, timely, or forthcoming; rather, Ghiberti pushed his patrons to achieve what he believed would yield the best results. The judgment of history has proven him correct.

Figure 3.7 Lorenzo Ghiberti, *Shrine of Saint Zenobius,* bronze, 1432–1442, Florence Cathedral.

III. Collaboration Inside and Outside Ghiberti's Workshop

Running a large workshop and bronze foundry brought Ghiberti into contact with dozens of persons whose cooperation and collaboration were essential to his success. Unfortunately, we know frustratingly little about the actual workings and day-to-day relations among Ghiberti and his assistants in the workshop. Until new documentation is found or art historians make major breakthroughs in untangling the participation of these assistants in modeling and finishing his works, we are left primarily with names, the most recognizable being his two sons, Tommaso and Vittorio Ghiberti, long-time assistant Giuliano di ser Andrea,[48] the young Donatello, Paolo Uccello, Michelozzo, Bernardo Ciuffagni, Bernardo Cennini, Michele da Firenze, and Benozzo Gozzoli—the last of whom was hired for three years, with escalating terms of compensation, just at the moment when the workshop moved into high gear chasing the panels of the Gates of Paradise.[49] As Ulrich Middeldorf has shown, Ghiberti had close dealings with Fra Angelico,[50] so our sculptor probably had occasion to meet the young painter in Angelico's shop and assess his work, but it is not at all clear what duties Gozzoli was

assigned. He could have been engaged in chasing the last four narrative panels, complete at the end of his contract in 1447,[51] though this seems a most curious assignment for a former painter's assistant.

Thanks to the survival of the Arte del Cambio's financial records for Ghiberti's *Saint Matthew*, we can catch a more precise glimpse of Ghiberti dealing with his suppliers and those with whom he collaborated on a more casual basis. The guild's so-called Libro del Pilastro ("Book of the Pier"—in other words, of the pier and niche where their statue was located at Orsanmichele) contains detailed reimbursements to Ghiberti for acquiring materials, hiring day laborers, and paying for the materials and construction of the furnace and framework necessary to produce an over-life-size sculpture in bronze.[52] In a series of reimbursements throughout July and August 1419 and again on 29 January 1421, Ghiberti moved step by step through the process of assembling materials for the sculpture. First came payments to the day laborer Macteo da Pergamo for digging and then lining the trench in his yard where the figure would be cast.[53] Ghiberti then individually paid Jacopo the woodworker for wood to make the platform on which he worked,[54] Romolo the ironworker for iron reinforcement under the base of the figure, Andrea di Gioia and Stefano di Gioia for clay, Mariano the cart driver to deliver the clay, Sandro the blacksmith to make copper tools to work the clay, Biagio the clipper for cloth clippings to mix with the clay, and Agnolino the day laborer to beat the clay and mix it with clippings. Ghiberti also paid the same Agnolino for wax, as he did the pharmacist Lorenzo di Stagio Barducci (for a special Romanian variety), as well as six ounces of *pegola* (pitch) and a libra and four ounces of turpentine, all materials he must have used in modeling the outer shell of his model. The purpose of his purchase of an ounce of quicksilver from an unnamed pharmacist is not clear, though it, too, probably served this preliminary work (see page 181, note 57). Checcho da Monteregghi supplied him charcoal.

By 9 May 1421 Ghiberti had also secured ironwork, bricks, mortar, wood, and other things for creating his furnace.[55] Work proceeded apace throughout the second half of the year, judging from the fact that on 29 January 1422 Ghiberti received reimbursements for money he had paid to Nicolo di Domenico da Fiesole for making a *pietra morta* ladle for the furnace, Andrea di Giovanni for copper, Piero d'Antonio for part of his work in constructing the furnace, Manectino di Bruogio for stone for the furnace, stonemasons Papi di Piero and Taddeo di Nanni, presumably for working that stone, goldsmith Giovanni di Bartolo for plane tree wood, Checcho di Domenico for other wood and charcoal, cart driver Martino di Lapo for delivering wood, Piero di Graziano for copper, cart driver Giunta di Francescho for delivering brass, and blacksmith Romolo di Lorenzo for ironwork for clamping around the model of the statue. He also compensated workers: Giovanni di Bartolo, who delivered bread and wine, day laborer Tommaso di Lambertino, Michelozzo, Michelozzo's assistant Pagolo, Jacopo di Brando, and Jacopo di Piero for their salaries as well as Francesco di Niccolo for help in casting. Unfortunately, at this point the guild reimbursement records become much more generic, perhaps a sign of the trust the financial officers developed in Ghiberti's detailed record-keeping.[56] Were his own account books ever to surface, they would certainly provide a treasure trove of information about the numerous individuals who contributed to his works.

Outside his immediate shop, Ghiberti's most famous—and yet regularly ignored—artistic collaboration was with Filippo Brunelleschi. Even in the two artists' lifetimes, public credit for the construction of the Duomo's

Figure 3.8 Lorenzo Ghiberti, marble window frames and revetment designs, ca. 1410, Florence Cathedral.

Figure 3.9 Lorenzo Ghiberti, *Saint Zenobius Enthroned,* stained glass, designed 1436, Florence Cathedral.

cupola was given exclusively to Brunelleschi. However, financial records of the Opera del Duomo confirm most of what Ghiberti asserts in his autobiography: that he and Brunelleschi worked on the cathedral project together for eighteen years.[57] If we are to understand Ghiberti's contribution, it is important to note from the outset that he scrupulously avoided the use of the word *cupola,* instead selecting the broader term *tribuna,* which more accurately reflects the fact that he was engaged in a large number of projects around the entire east end of the cathedral, including marble revetments on the exterior (fig. 3.8), stained-glass designs for most of the chapels (fig. 3.9), and the bronze shrine of Saint Zenobius (see fig. 3.7).

At the design stage for the cupola in 1418, Ghiberti and Brunelleschi were the leading contenders. Unlike the other aspirants, both artists were assigned workspace on Opera property, and the Opera paid for masons and carpenters to help them build their models.[58] Brunelleschi's design was selected, but, as we have seen, he would have been instructed to take into account outstanding features of the other models.[59] What is more, Brunelleschi was named as just one of three *provisores operis cupole.*[60] The other two supervisors were Ghiberti and Battista d'Antonio, who was largely responsible for day-to-day construction. Ghiberti received an annual salary of 100 florins for the next six years with only minor interruptions—compensated, as he reported in his autobiography and is confirmed by payment records, at the same rate as Brunelleschi. However, in February 1426, when Ghiberti began work on the Gates of Paradise and actual construction began to put Brunelleschi's novel vaulting ideas to the test, Ghiberti's salary was reduced to three florins per month.[61]

Still, subsequent design decisions continued to be issued in the name of all three *provisores,* including the design of the masonry chain that resists the dome's outward expansion at its haunches.[62] And when it came time in 1432 to build a wooden model for the ring of the lantern, a commission allotted to all three artists, Ghiberti alone was compensated for the work.[63] We should hardly imagine that Ghiberti built it with his own hands, however; assistants certainly would have supplied the labor.

If we are to identify anything about the dome that is Ghibertian, it probably should be stylistic, not structural: the elegant curve and ribbing of the dome, for example, are unparalleled in Brunelleschi's other works. Indeed, Ghiberti's fine hand has been recognized by architectural historians in the crisply detailed lancets in the tribunes (fig. 3.8) that were constructed earlier (ca. 1410).[64] The stylishly thin tracery and swaying broken-arched pediment are framed by a combination of tightly twisting colonettes and flat-paneled spires that reappeared in Ghiberti's niche design for his *Saint John the Baptist* at Orsanmichele in 1414 (see fig. 3.6). In that case, we know the name of the stonemason who realized Ghiberti's design: Albizo di Piero. Ghiberti also collaborated with other artists on the project. The pediment once included an image of God the Father inlaid in mosaic by Frate Bernardo di Stefano from a design by Giuliano d'Arrigo, called Pesello.[65] Why Ghiberti himself did not provide the design is unclear. Perhaps the collaboration attests to Ghiberti's very busy schedule and his use of assistants to design components of his work.

Ghiberti also provided designs in a similar style for the main portals of Orsanmichele (fig. 3.10).[66] Very respectful of the pre-existing fourteenth-century tracery in the other openings of the buildings, Ghiberti varied his models only slightly, tightening the lateral bays to provide a larger central opening and consequently giving himself a very stylish (for ca. 1410) series of tightly pointed arches inscribed within the intersection of two round-headed arches. Although much of the exterior detail in the very soft limestone has been degraded by the elements, fleshy flowers and leaves still run around the capitals on the interior, so different from the dry, repetitive forms of Ghiberti's predecessors. To obtain such fine results both here and on the capitals of his *Saint John the Baptist* tabernacle (see fig. 3.6), Ghiberti must have provided three-dimensional models to the carvers rather than drawings, as he indicates in his autobiography: "... to many painters, sculptors, and statue makers I earned the greatest honors in their works, having made extremely many models (*prouedimenti*) in wax and clay."[67] Also distinctly Ghibertian are the neatly chamfered panels that frame the doors themselves and the bands that reach across the lintels to the side panels. Their simple forms provide a cool, clean contrast to the fluorescence of decorative forms

Figure 3.10 Lorenzo Ghiberti, northwest portal, Orsanmichele, Florence, designed ca. 1410.

above. Within an elaborate late-Gothic framework, Ghiberti was already beginning to work out more sober elements that he would use to great effect in subsequent architectural commissions, most notably his niche for the Arte del Cambio's statue of *Saint Matthew* located immediately to the left of the portals (see fig. 1.2). This, the first classicizing niche at Orsanmichele, was built by the stonemason team of Jacopo di Corso and Giovanni di Niccolo[68] and demonstrates Ghiberti's rare gift for what might be termed, in the context of this essay, *stylistic* collaboration: his uncanny ability to combine and balance Gothic and Renaissance forms. Neither Gothic crockets nor a pointed, arched shell and niche look out of place in this composition, so carefully are they coordinated both with the proportions of the niche itself and with the Gothic composition of the adjacent portals.[69]

The new vocabulary of Ghiberti's niche seems to have been especially appealing to Palla Strozzi. As Ghiberti began work on the *Saint Matthew*, he and several other artists were also supervising the woodwork for the new sacristy building at Santa Trinita, which functioned as the family's burial chapel.[70] The portal and the lancet windows (see fig. 3.3) derive from Ghiberti's designs,[71] as did Palla's new coat of arms.[72] The construction was all

Figure 3.11 Lorenzo Ghiberti, marble tabernacle for Linaiuoli Altarpiece by Fra Angelico, 1432, Museo di San Marco, Florence.

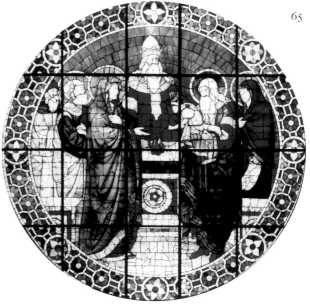

supervised by Filippo di Giovanni, who also worked on the staircase at the papal apartment in Santa Maria Novella, for which Ghiberti had provided a design,[73] and who was one of eight construction supervisors at the dome. Collaboration was natural in a world this small.

Throughout the 1420s and 1430s Ghiberti was also providing designs for other artists to carve in marble. Filippo di Cristofano carved two floor tombs in Santa Croce from Ghiberti's drawings, and there may have been others as well.[74] In 1432 Ghiberti provided drawings for a large marble-and-wood tabernacle for the Arte dei Linaiuoli (fig. 3.11).[75] Middeldorf has suggested that Ghiberti may also have assisted Angelico with the design of the large figures on the tabernacle's wings,[76] in keeping with Ghiberti's statement in his autobiography that he had developed a special system for enlarging figures that he shared with painters.[77] Ghiberti's relations with painters were especially cordial. He began his career assisting a painter, probably Mariotto di Nardo.[78]

Mariotto also designed stained glass,[79] which may have provided the impetus for Ghiberti's own prolific career in this medium. In Italy it was common practice for painters and sculptors to provide designs for stained glass that were then executed by others.[80] Ghiberti proudly reports in his autobiography that he designed the *Assumption of the Virgin* window (fig. 3.12) and many others in the cathedral.[81] Of necessity, his collaborators in this medium were numerous,[82] though only occasionally do we get a clear sense of how the designers and glaziers worked together.[83] In 1424, Bernardo di Stefano, a glazier and Dominican monk from Santa Maria Novella, was advanced money for the windows on which he and Ghiberti were working, and Ghiberti had to seek payment for his cartoons directly from Bernardo.[84] Many of these designs were probably on a small scale—in 1438 Ghiberti was paid only three lire ten soldi per figure for windows in the Duomo[85]—but in at least one famous case the drawing was extremely large. The competitors for the *Coronation of the Virgin* window for the central oculus of the drum of the cathedral cupola were paid the extraordinary sums of between fifteen and eighteen florins for full-scale cartoons, which were hoisted into place to judge their effect.[86] Though Donatello won this particular commission, Ghiberti went on to design an *Ascension, Agony in the Garden* (see fig. 1.5), and *Presentation in the Temple* (fig. 3.13) for the drum. Each of the drum windows seems to follow its Ghibertian model quite closely, unlike

Figure 3.12 Lorenzo Ghiberti, *Assumption of the Virgin,* stained glass, designed 1404, glazed by Niccolo di Piero, Florence Cathedral.

Figure 3.13 Lorenzo Ghiberti, *Presentation in the Temple,* stained glass, designed 1443–1445, glazed by Bernardo di Francesco, Florence Cathedral.

some of the other windows, where the glaziers merrily strewed flowers and decorative motifs over and around Ghiberti's figures (see, for example, the quatrefoil designs on the Virgin's mantle in the *Assumption* window). Glaziers felt free to "enhance" his and other artists' designs according to their own aesthetic traditions.

Was this also the case for designs Ghiberti provided to goldsmiths? In 1418 the Opera of Orsanmichele commissioned Guariente di Giovanni Guariento to create two silver and enameled candelabra for the altar of Saint Anne following a design by Ghiberti.[87] The sort of detail Ghiberti may have provided can be imagined from a workshop drawing of a female saint standing in the niche of what appears to be a reliquary (fig. 3.14).[88] The architectural framework of the reliquary of San Jacopo in Pistoia Cathedral (fig. 3.15),[89] the only surviving goldsmith's work that can convincingly be linked to Ghiberti himself, could have been created from such a drawing, but the angels, highly reminiscent of the heavenly beings surrounding the Madonna in the *Assumption* window Ghiberti designed for the Duomo three years earlier, would have required a three-dimensional model. Either Ghiberti provided such models, or works following his designs varied more considerably from his intentions than we might have imagined.

We also need to consider that many works showing Ghiberti's influence would have been produced without his authorization. In 1426 he asked Giovanni Turini to return a drawing he had lent him but which had now gotten into the hands of a woodworker in Siena.[90] Most of Ghiberti's works stood in public places, where they could be freely studied and copied. Keeping this in mind, do the numerous Madonna and Child reliefs that have been associated with his shop (fig. 3.16, for example, with the reclining figure on its base taken from the Eve on the frame of the Gates of Paradise[91]) indicate that Ghiberti told an assistant to adapt one of his models into a marketable, over-the-counter commodity, or do such objects suggest that other less-inventive artists were impressed by Ghiberti's work and hoped to cash in on his reputation? Or both?

The Collaborative Mindset

As we have seen in this essay, collaboration in the Renaissance could be by default as well as intentional, patrons telling artists to incorporate the good ideas of others into their works or artists and patrons working closely with one another for decades. Artists like Ghiberti worked in a very open environment where ideas were shared and criticism was common. Donatello is famously said to have been glad to return to Florence after ten years working in Padua because he was tired of receiving only praise instead of the constructive criticism on which Florentine artists thrived. In a world where the Medici sought to be "the first among equals," individuality was tempered by a sense of community and collaboration. Producing Renaissance art was necessarily a corporate activity. At the very least, assistants prepared materials and took on repetitive and/or low-skill tasks. But as this essay has shown, the Renaissance workshop was hardly self-contained. Artists competed with one another and learned from one another; they negotiated with patrons over payments and completion schedules; they depended on a large number of suppliers and day laborers to provide, deliver, and prepare materials; and they even provided explicit designs for others to build, carve, paint, cast, or transform into stained glass. They were creative geniuses, certainly, but many of the most successful—Ghiberti certainly stands at the head of this list—were keen businessmen, entrepreneurs, impresarios, negotiators, and contractors. Working with and depending on others did not diminish the pride they took in their work. Instead, it seems to have enhanced it, allowing Ghiberti accurately and proudly to declare in his autobiography that "few things of importance were made in our city that were not designed and given order by my hand."

Figure 3.16 Lorenzo Ghiberti, *Madonna and Child,* polychromed terra-cotta, ca. 1450, Cleveland Museum of Art, Coralie Walker Hanna Memorial Collection, 39.161.

NOTES

1. For this and nearly all aspects of Ghiberti's life and work, see the classic monograph by R. Krautheimer in collaboration with T. Krautheimer-Hess, *Lorenzo Ghiberti,* 2 vols., Princeton: Princeton University Press, 1970. Recently, A. Galli has reframed Ghiberti's work in two succinct but very important studies: "Nel Segno di Ghiberti," in *La bottega dell'artista: Tra Medioevo e Rinascimento,* Milan: Jaca Book, 1998, pp. 87–108; and *Lorenzo Ghiberti,* Rome: Gruppo Editoriale Espresso, 2005. For rivalry and competition, see R. Goffen, *Renaissance Rivals: Michelangelo, Leonardo, Raphael, Titian,* New Haven and London: Yale University Press, 2002. On the nature of Renaissance competitions and their actual origins in the Middle Ages, see A. Middeldorf Kosegarten, "The Origins of Artistic Competitions in Italy," in *Lorenzo Ghiberti nel Suo Tempo, Atti del Convegno Internazionale di Studi (Firenze, 18–21 ottobre 1978),* vol. 1, Florence: Leo S. Olschki, 1980, pp. 167–186. In a series of recent presentations E. Holman has also begun to relate artistic competitions to the widespread practice of literary competitions.

2. J. von Schlosser, *Lorenzo Ghibertis Denkwürdigkeiten (I Commentarii),* Berlin: Julius Bard, 1912, pp. 45–51, esp. 46.

3. "*Universalmente mi fu conceduta la gloria sança alcuna exceptione.*" Schlosser, p. 46. Ghiberti repeats the assertion later with the words: "*da tutti fu dato in mio fauore la soscriptione della uictoria.*"

4. Most famously recounted by the highly partisan A. di Tuccio Manetti, *The Life of Brunelleschi,* ed. H. Saalman, trans. C. Enggass, University Park and London: Pennsylvania State University Press, 1970, pp. 46–50.

5. H. Saalman, *Filippo Brunelleschi, The Cupola of Santa Maria del Fiore,* London: A. Zwemmer, 1980, p. 53.

6. Ghiberti gives the number of judges in his autobiography (Schlosser, p. 46). For the *David,* see S. Levine, "The Location of Michelangelo's *David*: The Meeting of January 25, 1504," *Art Bulletin* 56 (1974), pp. 31–49.

7. J. Paoletti has highlighted evidence of Cosimo's frequent collaboration with his brother Lorenzo and the familial rather than individual nature of many of his commissions. See his "Fraternal Piety and Family Power: The Artistic Patronage of Cosimo and Lorenzo de' Medici," in *Cosimo "il Vecchio" de' Medici, 1389–1464,* ed. F. Ames-Lewis, Oxford, 1992, pp. 195–219; and "Donatello's Bronze Doors for the Old Sacristy of San Lorenzo," *Artibus et historiae* 11 (1990), pp. 39–69. See also W. Sheard and J. Paoletti, eds., *Collaboration in Italian Renaissance Art,* New Haven and London: Yale University Press, 1978.

8. Ghiberti's contract of 23 November 1403 (Krautheimer, Doc. 26) called for him to attend to figures, trees, and similar things ("*le figure, alberi e simili cose*"), rephrased on 1 June 1407 to include hair, nudes, and similar things ("*massimamente in su quelle parti che sono di piu perfezione come capelli, ignudi, e simili*").

9. Particularly well discussed by P. Rubin and A. Wright, eds., *Renaissance Florence: The Art of the 1470s,* London: London National Gallery Publications, 1999. Also exemplary is A. Thomas, *The Painter's Practice in Renaissance Tuscany,* Cambridge: Cambridge University Press, 1995.

10. Krautheimer, Docs. 27, 31.

11. A. Doren, "Das Aktenbuch für Ghibertis Matthäus-Statue an Or San Michele zu Florenz," *Italienische Forschungen* 1 (1906), pp. 1–58, esp. 30, reimbursement of 26 August 1419 to "*Lorenzo di Bartoluccio, orafo, conductore della detta fighura.*" His original contract stipulated: "*Ancora [Ghiberti] promise la detta fighura lavorare et lavorare fare per buoni et sufficienti maestri intendenti delle dette cose et del ditto lavorio.*"

12. According to his autobiography, he intended to write a treatise about his experiences but never did.

13. "*Produssi di mia mano la staua di sancto Matteo.*" Schlosser, p. 47.

14. Charles Seymour recognized the meaning of this turn of phrase in his astute examination of a drawing of the Fonte Gaia commissioned from Jacopo della Quercia but not likely to have been executed by the artist himself. See C. Seymour, Jr., "'Fatto di sua mano': Another Look at the Fonte Gaia Drawing Fragments in London and New York," *Festschrift Ulrich Middeldorf,* ed. A. Kosegarten and P. Tigler, Berlin: Walter de Gruyter & Co., 1968, pp. 93–105.

15. "*Poche cose si sono fatte d'importanza nella nostra terra non sieno state disegnate et ordinate di mia mano.*" Schlosser, p. 51.

16. Antonio Manetti Ciaccheri, Bruno di Ser Lapo Mazzei, and the lead worker Domenico.

17. Trans. Saalman, p. 139; Latin original, Doc. 262.8, p. 272.

18. Intriguingly, the first master to supervise the construction of the lantern after Brunelleschi's death was Michelozzo,

who had worked for extended periods in Ghiberti's shop. He was replaced in August 1452 by Antonio Manetti Ciaccheri, one of Ghiberti's fellow participants in the lantern competition. Bernardo Rossellino, whom V. Coonin has recently suggested played a major role in working with Vittorio Ghiberti on the frames of Andrea Pisano's bronze doors, served next, followed by Bruno di ser Lapo Mazzei, who had also been a participant in the lantern competition. See Saalman, pp. 142–144.

19. Saalman, pp. 140–141, citing Manetti, lines 1399–1406.

20. Manetti, pp. 48–49.

21. Ibid.

22. Recorded in Saalman, p. 47: "*quale . . . gli pare piu bello o piu utile e piu sichuro.*"

23. See the exhaustive study by F. Caglioti and D. Gasparotto, "Lorenzo Ghiberti, il 'Sigillo di Nerone' e le origini della placchetta 'antiquaria,'" *Prospettiva* 85 (1997), pp. 2–38, esp. 3–4. When the Florentines hosted Pope Martin V in the early 1420s and Eugenius IV two decades later, they called upon Ghiberti to create sumptuous gold work for each. Archbishop Alvise Trevisan (1437–1439) even had Ghiberti surround an antique carnelian in gold with a classical inscription amidst gold dragons and ivy leaves. Ghiberti describes the gold miter for Martin V as being created from fifteen libre of gold and five and a half libre of gems, valued at 38,000 florins—nearly twice the cost of the 22,000 florins Ghiberti reports for his first set of bronze doors. On the front he fashioned an enthroned God the Father surrounded by angels, on the back a similar image of the Madonna, all accompanied by four evangelists and a host of angels on the frieze running around its base. In his autobiography Ghiberti also gives a detailed description of a morse he created for Martin V: "*uno bottone d'uno piuale nel quale feci otto meze figure d'oro et nel bottone feci una figura d'uno Nostro signore che segna*" (Schlosser, p. 47).

24. It has long been noted that Donatello's bronzes are technically much less sophisticated than Ghiberti's. His *Saint Louis of Toulouse* for the Mercanzia niche at Orsanmichele, for example, was cast in numerous pieces that do not all join neatly, unlike Ghiberti's *Saint John the Baptist* and *Saint Stephen,* which are single casts, and his *Saint Matthew,* which was cast in two pieces. There are numerous uncorrected casting flaws in the abdomen and leg of Donatello's bronze *David* for the Medici.

25. Again in contrast to Donatello, whose relief for the tabernacle door of the Siena Baptistery was rejected.

26. For a systematic overview of contract possibilities, see H. Glasser, *Artist Contracts of the Early Renaissance,* New York: Garland Publications, 1977.

27. See Krautheimer, Dig. 8.

28. Ibid., no. 44.

29. Ibid., no. 80.

30. Ibid., nos. 399–400; English translation in C. Gilbert, *Italian Art 1400–1500 Sources and Documents,* Englewood Cliffs, New Jersey: Prentice Hall, 1980, p. 3.

31. See M. Haines, "Ghiberti's Trip to Venice," in L. Jones and L. Matthew, eds., *Coming About . . . A Festschrift for John Shearman,* Cambridge, Massachusetts: Harvard University Art Museums, 2001, pp. 57–63, esp. 63.

32. On the other hand, Ghiberti's contract with the Calimala had left open the possibility of another commission within a year of completing the doors, should the guild members be so inclined.

33. See Krautheimer, Dig. 71, and Doren, pp. 25–30. For a private commission from the Medici to Ghiberti, see S. Cornelison, "Lorenzo Ghiberti and the Renaissance Reliquary: The *Shrine of the Three Martyrs* from Santa Maria degli Angeli, Florence," in R. Bork, ed., *De Re Mettallica, The Uses of Metal in the Middle Ages,* Aldershot: Ashgate, 2004, pp. 163–179.

34. "*Solamente sono contento per mio salario et de' detti maestri avere solamente quella quantità di danari et quello prezzo, come et in che modo sarà una volta et più proveduto et deliberato pe' consoli della detta arte. . . .*" Doren, p. 27.

35. Krautheimer, Dig. 97.

36. Krautheimer, Doc. 26, and R. Jones, "Documenti e precisazioni per Lorenzo Ghiberti, Palla Strozzi e la Sagrestia di Santa Trinita," in *Lorenzo Ghiberti nel Suo Tempo, Atti del Convegno Internazionale di Studi (Firenze, 18–21 ottobre 1978),* vol. 2, Florence: Leo S. Olschki, 1980, p. 507. See also his extensive study "Palla Strozzi e la sagrestia di Santa Trinita," *Rivista d'arte* 37 (1984), pp. 7–106.

37. See J. Russell Sale, "Palla Strozzi and Lorenzo Ghiberti: New Documents," *Mitteilungen des Kunsthistoriches Institutes in Florenz* 22 (1978), pp. 355–358.

38. See Haines, esp. p. 63.

39. 2 January 1425; 4 July 1439; 24 June 1443; and 24 January 1448, renewed on 5 or 16 January 1451.

40. Krautheimer, Dig. 162, 179.

41. Amy Bloch explored this possibility in a paper she presented at the Provo/Athens sculpture conference at the University of Georgia in 2004.

42. Krautheimer, Dig. 287.

43. Krautheimer, Dig. 166. The most recent extended study of this work is A. Bloch's "Ritual, Use, Space, and Ghiberti's Shrine of Saint Zenobius," Ph.D. dissertation, Rutgers University, 2004.

44. Krautheimer, Dig. 199.

45. Krautheimer, Dig. 204.

46. Krautheimer, Dig. 236.

47. G. Poggi, *Il Duomo di Firenze, Documenti sulla decorazione della chiesa e del campanile tratti dall'Archivio dell'Opera,* 2 vols., ed. M. Haines, Florence: Edizioni Medicea, 1988, n. 1176. See also L. Waldman, "From the Middle Ages to the Counter-Reformation: The Choirs of S. Maria del Fiore," in *Sotto il cielo della Cupola, Il coro di Santa Maria del Fiore dal Rinascimento al 2000,* Milan: Electa, 1997, pp. 37–68, esp. 40.

48. First documented in 1405 as a *discepolo* (Krautheimer, Dig. 17) and later described by Ghiberti as finishing one of his two reliefs for the Siena baptismal font (see Ghiberti's letter of 16 April 1425, text in Krautheimer, Docs. 399–400).

49. Krautheimer, Dig. 246, 24 January 1444.

50. U. Middeldorf, "L'Angelico e la scultura," in *Raccolta di Scritti: That Is, Collected Writings, II, 1939–1973,* Florence: SPES, 1980, pp. 183–199.

51. Krautheimer, Docs. 20, 42; Dig. 259. Krautheimer, Doc. 44 of 24 January 1448, shows that the twenty-four long thin panels surrounding the narrative reliefs (the *spiagge*) had yet to be chased and that the twenty-four heads that protrude from their intersections, the cornice above the door, the sill, and other parts of the surround had not yet been modeled in wax, so these tasks could not have been Gozzoli's.

52. For what follows, see Doren, pp. 30–33.

53. "*Per fare la fossa dove si debba mettere la forma della figura di San Macteo*" and "*per murare la fossa a secchio.*" Doren, p. 30.

54. "*Per fare il ponte, sul quale si lavora.*" Ibid.

55. Ibid., p. 34.

56. The guild officers spent increasingly large amounts of their time keeping track of the forced contributions each member was making to this very expensive project. See Doren, 45f.

57. Schlosser, p. 51: "... *nella edificatione della tribuna fumo concorrenti Filippo et io anni diciotto a uno medesimo salario: tanto noi conducemo detta tribuna. Faremo uno trattato d'architettura et tratteremo d'essa materia.*"

58. See Saalman, pp. 61–62. For Ghiberti's payments, which at 300 lire were just ten lire shy of Brunelleschi's, see Krautheimer, Dig. 61.

59. Saalman, pp. 68–70.

60. An alternate was also chosen for each —in Ghiberti's case, the cranky Giovanni di Gherardo da Prato, who reappears later in the documents pushing his own earlier plan. See Saalman, pp. 65–66.

61. Krautheimer, Dig. 124.

62. Krautheimer, Dig. 153, 7 January 1429. The document specifically states that Brunelleschi and Battista were to build the chain according to the design of Brunelleschi, Ghiberti, and Battista.

63. Krautheimer, Dig. 171, 175.

64. G. Marchini, *Ghiberti architetto,* Florence: La Nuova Italia, 1978, pp. 17–18; and Saalman, pp. 57, 246–247. Ghiberti was paid three florins for his window designs in 1409.

65. Krautheimer, Doc. 3; Dig. 34.

66. Marchini, *Ghiberti architetto,* p. 18, and D. Zervas, "Lorenzo Monaco, Lorenzo Ghiberti, and Orsanmichele, Part I," *Burlington Magazine* 133 (1991), pp. 747–759, esp. 758, docs. 5–7.

67. Schlosser, pp. 50–51: "... *a molti pictori et scultori et statuarij ò fatto grandissimi honori ne' loro lauorij, fatto moltissimi prouedimenti di cera et di creta....*"

68. See agreement of 2 May 1422 in Doren, pp. 46–47.

69. For the proportional scheme of the statue and niche, see D. Zervas, "Ghiberti's *Saint Matthew* Ensemble at Orsanmichele: Symbolism in Proportion," *Art Bulletin* 58 (1976), pp. 36–44.

70. Krautheimer, Dig. 73a.

71. Marchini, *Ghiberti architetto,* pp. 22–23, places construction between July 1418 and 1423, when Gentile da Fabriano's Adoration of the Magi altarpiece (now Uffizi, Florence) was placed in the chapel. U. Middeldorf, "Additions to Lorenzo Ghiberti's Work," in *Raccolta di Scritti,* pp. 315–316, has also suggested that Onofrio Strozzi's tomb, but not its framing arch, derives from a design by Ghiberti.

72. Suggestively proposed by Jones, 1980, p. 510 and fig. 1, as being the basis of a roundel displayed on the Santa Trinita Sacristy façade in Via del Parione.

73. See F. Quinterio, "Filippo di Giovanni: Quattro cantieri col Ghiberti," in *Lorenzo Ghiberti nel Suo Tempo, Atti del Convegno*

Internazionale di Studi (Firenze, 18–21 ottobre 1978), vol. 2, Florence: Leo S. Olschki, 1980, pp. 643–664.

74. See Middeldorf, "Additions": Ludovico degli Obizi (died 1424) and Bartolomeo Valori (died 1427). Middeldorf also attributes the design of the tombs of Barduccio di Chierechino Barducci at S. Felicita, Pietro Lenzi at Ognissanti, John Ketterick at S. Croce, and Maso degli Albizzi at S. Paolino to Ghiberti.

75. Carved by Simone di Nanni da Fiesole and Jacopo di Bartolo da Settignano. Krautheimer, Dig. 174, prior to 24 October 1432.

76. Middeldorf, "Angelico e la scultura," p. 187. For the practice in general, see L. Fusco, "The Use of Sculptural Models by Painters in Fifteenth-Century Italy," *Art Bulletin* 64 (1982), pp. 175–194.

77. Schlosser, p. 51: *"Etiando chi auesse auute a ffare figure grandi fuori de la naturale forma, dato le regole a condurle con perfetta misura."*

78. M. Salmi, "Lorenzo Ghiberti e Mariotto di Nardo," *Rivista d'arte* 30, ser. 3.5 (1955), pp. 147–152, and Salmi, "Lorenzo Ghiberti e la pittura," in *Scritti di Storia dell'Arte in onore di Lionello Venturi,* vol. 1, Rome: De Luca, 1956, pp. 223–237.

79. A stained-glass window in San Domenico, Perugia, carries Mariotto's name and the date 1404.

80. R. Burnam, "Stained Glass Practice in Medieval Florence: The Case of Orsanmichele," *Journal of Glass Studies* 30 (1988), pp. 77–93. Burman notes that treatises encouraged painters to put letters on their drawings indicating color choices.

81. Schlosser, p. 51: *"Disegnai nella faccia di sancta Maria del Fiore nell'occhio di mezzo l'assumptione di Nostra Donna et disegnai gl'altri sono da llato."*

82. See Marchini, "Ghiberti pittore di vetrate," in *Ghiberti e la sua arte nella Firenze del '3–'400,* Florence: Edizioni Città di Vita, 1979, pp. 139–157; M. Bacci, "Le vetrate del tamburo della cupola," in *Lorenzo Ghiberti 'materia e ragionamenti,'* Florence: Centro Di, 1978, pp. 245–257; and F. Martin, "'Eidem Dabitur Designum' La realizzazione degli occhi e la loro disposizione nel Duomo di Firenze," in T. Verdon and A. Innocenti, *La cattedrale e la città, Saggi sul Duomo di Firenze, Atti del convegno internazionale di studi, Firenze, 16–21 giugno 1997,* vol. 1, Florence: Edifir, 2001, pp. 551–567.

83. Marchini has noted the curious situation that windows executed by the same glazier and designed by the same artist do not always have the same tonalities and that windows by different glaziers can be strikingly similar to one another. *Italian Stained Glass,* New York: Abrams, 1957, p. 148. This topic deserves intensive study.

84. F. Martin, *Le vetrate di San Francesco in Assisi,* Assisi: Case Editrice Francescana, 1998, p. 126.

85. Noted in Martin 1998, p. 131. Specifically recorded in the documents are figures of Saints Barnabas, Anthony Abbot, Matthew, Thomas, James Minor, John the Evangelist, Zenobius, Peter, Paul, Andrew, Bartholomew, Stephen, James Major, and Matthew, as well as earlier designs for Saint Stephen, Saint Lawrence, Joachim Driven from the Temple, and the Death of the Virgin. See Poggi, vol. I, part IV, pp. lxxviii–xciii.

86. Martin 1998, pp. 131–133.

87. Krautheimer, Doc. 119.

88. G. Brunetti ambitiously attributed the drawing and the reliquary of Saint Andrew in Città di Castello to Ghiberti himself. "Ghiberti Orafo," in *Lorenzo Ghiberti nel Suo Tempo, Atti del Convegno Internazionale di Studi (Firenze, 18–21 ottobre 1978),* vol. 1, Florence: Leo S. Olschki, 1980, pp. 223–244. Though the design of the Saint Andrew reliquary does indeed include some distinctively Ghibertian motifs—including little dragons that recall the motifs Ghiberti said he included in his setting of an antique cornelian—the attribution of the reliquary is not completely convincing.

89. Most recently and convincingly discussed by Galli, 1998, p. 91, and *Lorenzo Ghiberti,* p. 60.

90. Krautheimer, Docs. 399–400.

91. See A. Darr, ed., *Italian Renaissance Sculpture in the Time of Donatello,* Detroit: Founders Society, Detroit Institute of Arts, 1985, pp. 90–91.

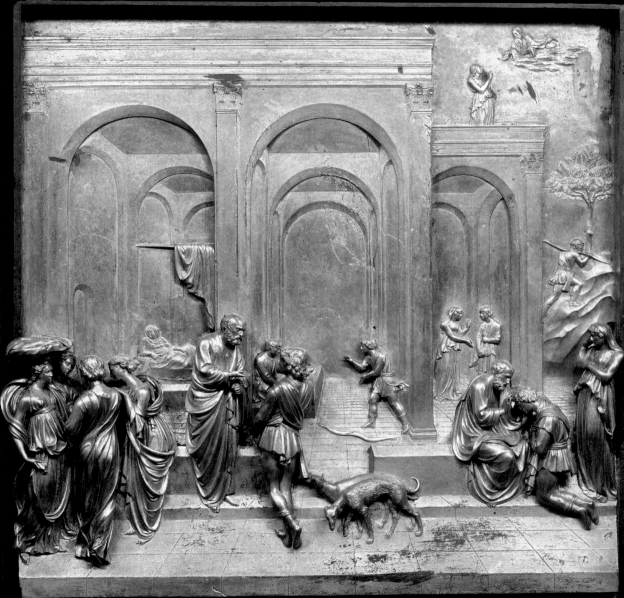

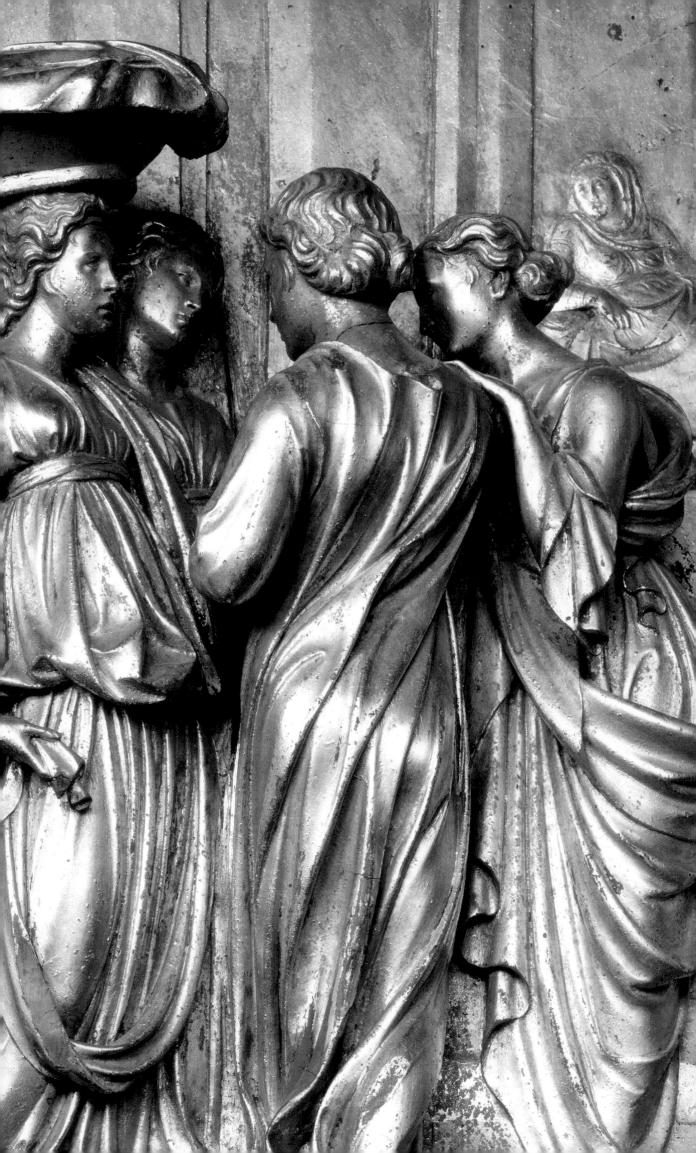

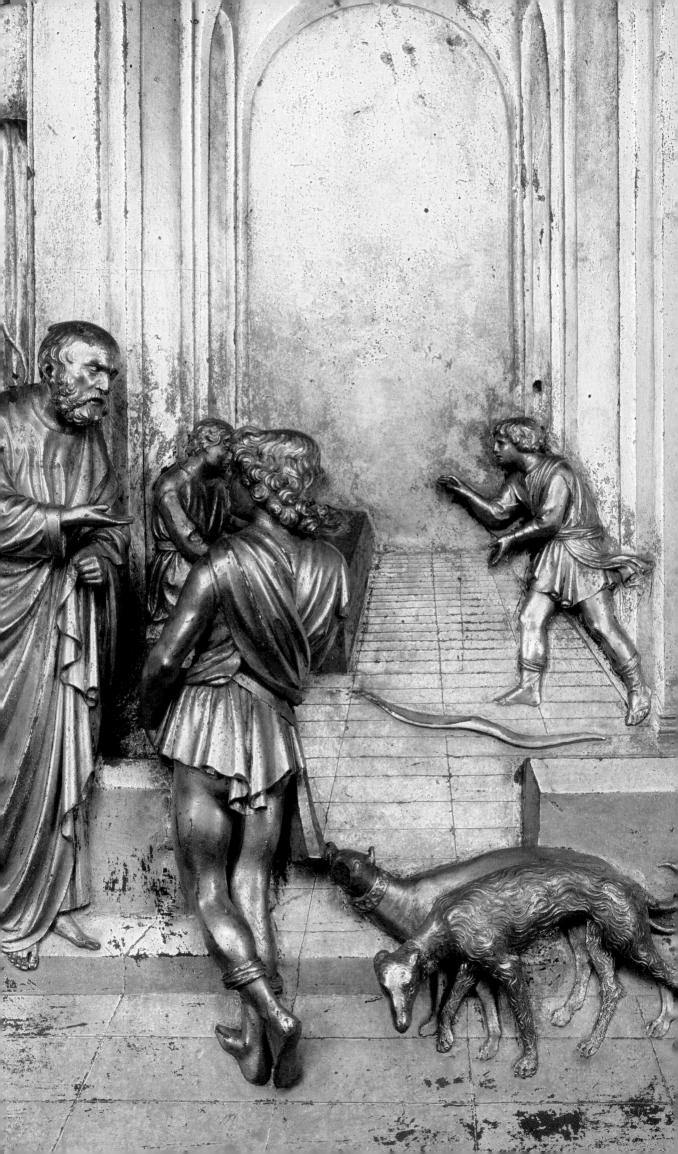

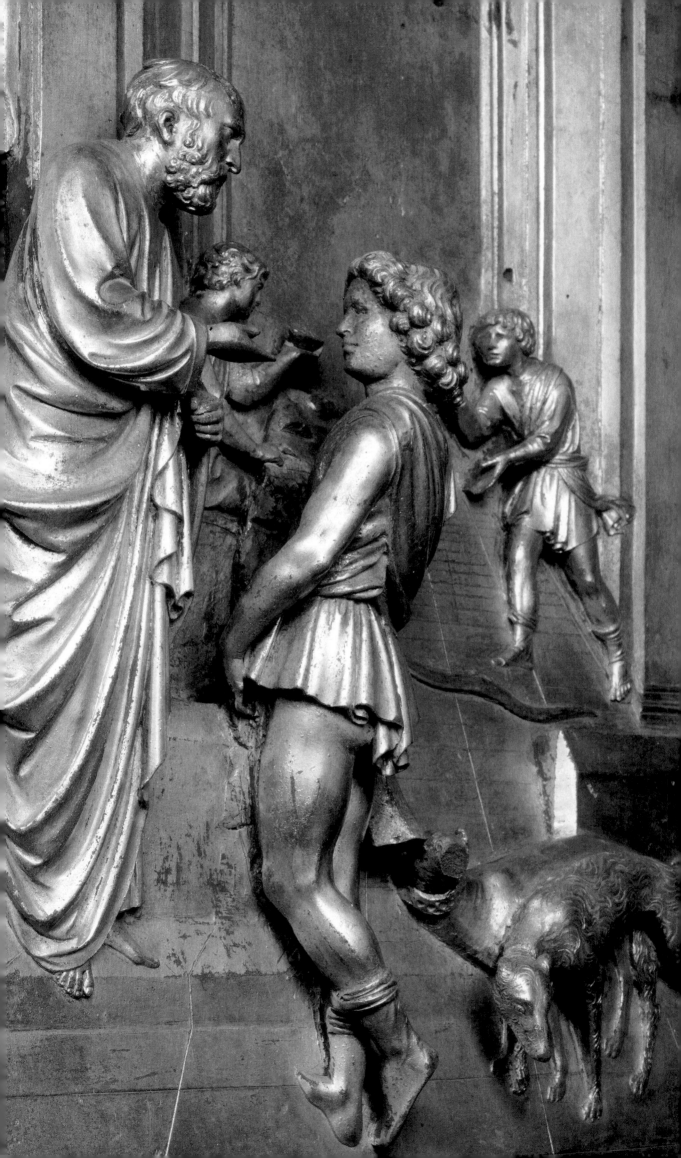

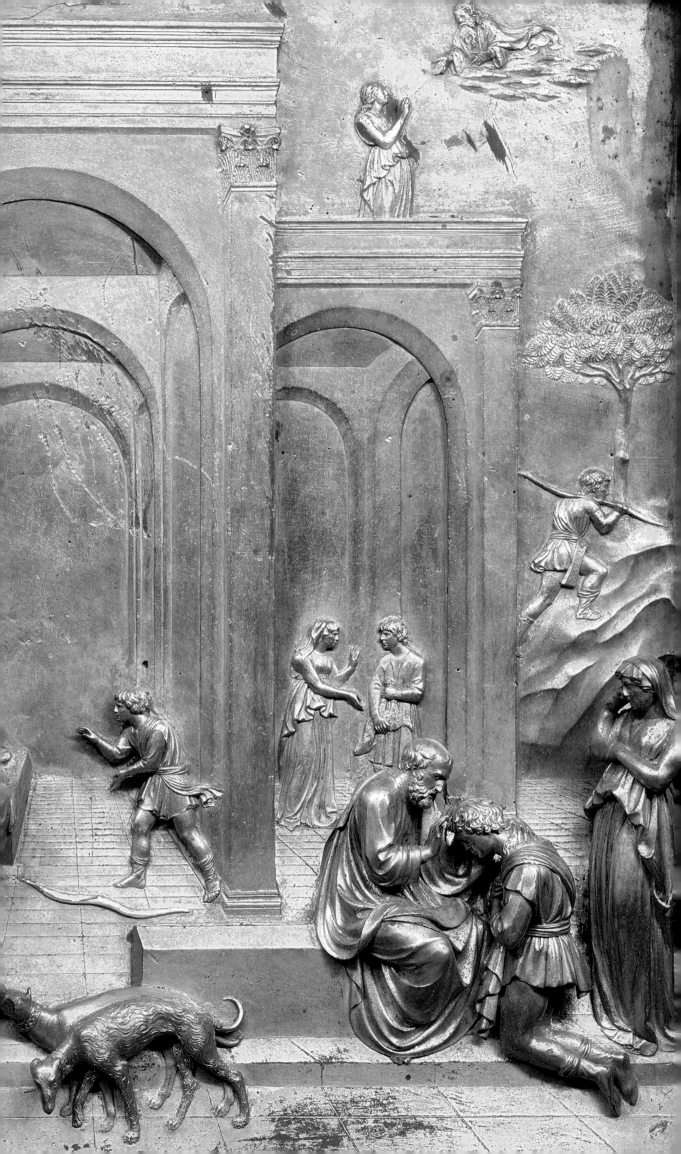

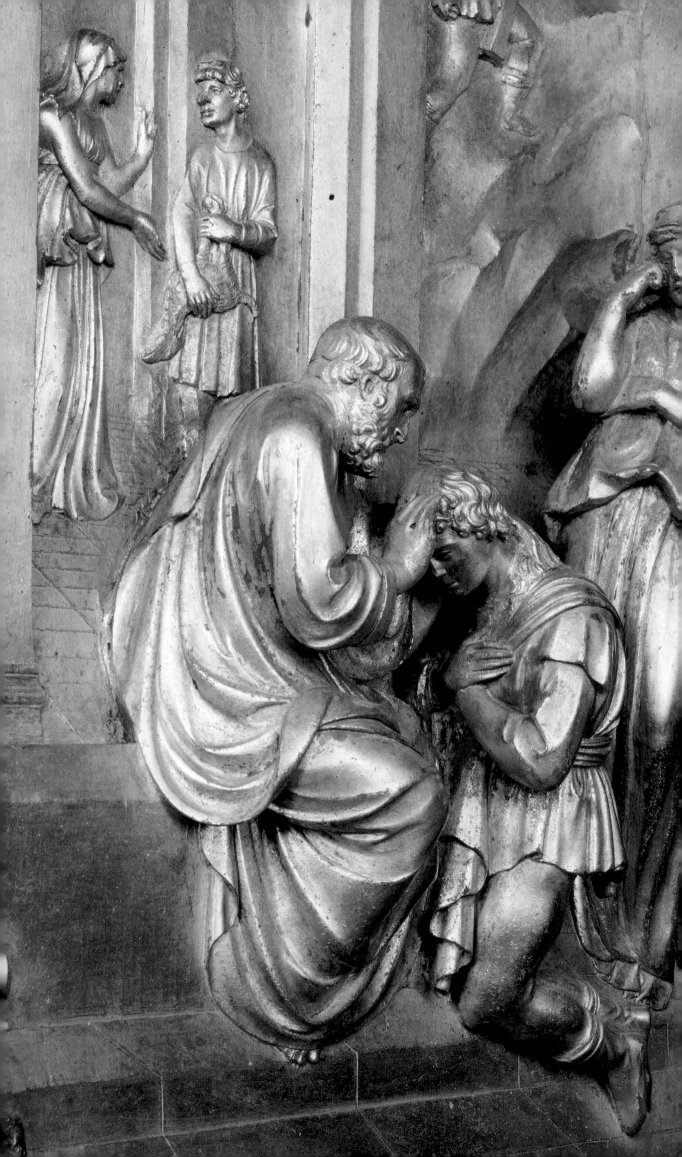

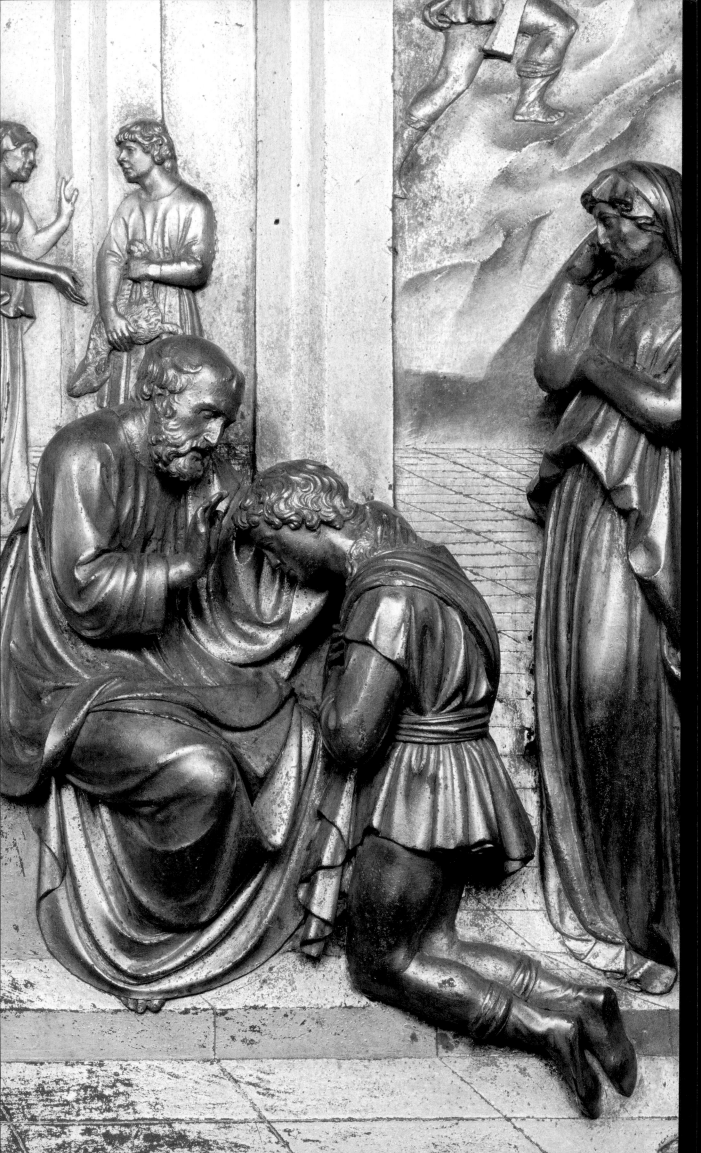

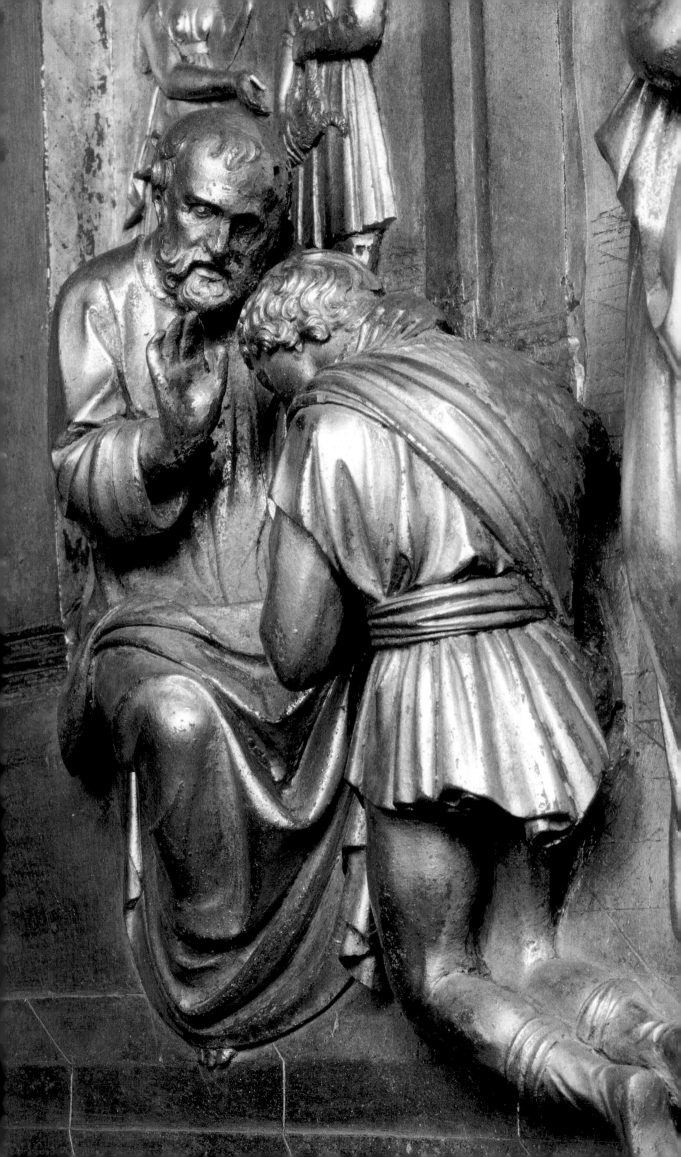

Documenting the Gates of Paradise

Margaret Haines

Senior Research Associate
The Harvard University Center
for Italian Renaissance Studies, Villa I Tatti

Francesco Caglioti

Professor of Art History
Università degli Studi "Federico II" di Napoli

Documentation on the Gates of Paradise:
Through a Glass Darkly *Margaret Haines*

THE SUPERVISION OF THE BAPTISTERY OF FLORENCE was entrusted by
the city's government to the ancient and powerful guild of cloth merchants
known as the Calimala, whose members managed the temple dedicated
to the city's patron saint, John the Baptist, with the same acumen that had
contributed to their wealth and power in the bustling commercial world of
the late Middle Ages.[1] The Florentine mercantile elite had a propensity for
writing history as it unfolded, scrupulously recording and conserving the
memory of their family and business enterprises against the background
of the great events of the Italian peninsula, and their efforts have provided
modern historians with the raw material for detailed and focused scrutiny
of the society and politics of the late medieval and early modern city.[2] The
history of art has also benefited from the wealth of documentation produced
for artistic projects, both public and private, at the dawn of the Renaissance.
Monuments such as the city's cathedral, Santa Maria del Fiore, possessed
systematic archives with complex and interlocking series of account books,
minutes of the resolutions of their governing bodies, memoirs of their daily
operations, and records of property and assets. Even after the devastating
effect of centuries of deselection and conservation disasters as recent as the
flood of 1966, enough records have been preserved to provide an ongoing
profile of the construction and furnishing of the city's main church from
the mid-fourteenth century.[3]

But the Baptistery, just across from the cathedral façade, has been less
fortunate. Unlike the cathedral, whose board of works (or *Opera*), appointed
by the rival guild of the wool manufacturers, developed into a thriving
organization with its own bureaucracy and administration, the Opera di San
Giovanni appears to have remained more closely reined-in by the parent
institution. In fact, although the Calimala consuls appointed their two main
officials, known as the Ufficiali del Mosaico in deference to their first and
continuing mandate to oversee the mosaic decoration of the building's
vaults, the guild itself seems to have retained much of the initiative and
control over the administration of the ancient temple. The result is that the
Opera di San Giovanni apparently produced little independent documen-
tation, none of which has come down to modern times, while the guild's
archive, where most records were kept, has suffered crippling losses due to
fire and to removal and discarding of documents during the institution's

vicissitudes, so that we are now deprived of most of the original records regarding the Baptistery's adornment with extraordinary works of art, such as its three great bronze portals.[4]

What we do possess are the results of early scholarship by local historians working before many originals were destroyed, particularly the systematic archival gleanings of the titanic researcher Senator Carlo Strozzi (1587–1670), himself a lifetime officer of the Calimala guild. His voluminous papers, now divided among two Florentine libraries and the State Archives, combine original documentation, often rescued from certain destruction, with archival notes, transcriptions, and essays based on these sources. They include three volumes of copies and annotations from the Calimala records in which numerous notices about the Baptistery doors are embedded.[5] Other early historians, particularly Anton Francesco Gori (1691–1757), an erudite provost of the Baptistery, seem to have relied on Strozzi's papers rather than the original guild documents, but even such derivative material contains unique testimony in the case of Strozzi's *Description of the Church and Baptistery of San Giovanni in Florence,* known only through Gori's copy. Information on assistants and costs of the third doors contained in this account appear to derive from additional, now lost, archival gleanings from the guild account books, themselves also now dispersed.[6] The seventeenth- and eighteenth-century copies, together with the few original guild codices and the documentation preserved in other archives (tax declarations of the guild and the artists, notarial records regarding Ghiberti's property, and ledgers of a private bank that disbursed some payments on the guild's account for the doors), constitute the windows, often mere peepholes, through which modern scholarship can witness the administration and creative process of Ghiberti's Gates of Paradise.

Nevertheless, as Francesco Caglioti demonstrates below with characteristic lucidity, it is possible to extract a number of fundamental certainties about the doors' chronology and the nature and roles of the workforces in and around the Ghiberti shop from the heterogeneous sources at our disposal. A fresh view of the documentation has been facilitated by a general review of the sources undertaken by Rolf Bagemihl in the context of an international workshop organized in preparation for the present exhibition.[7] Its purpose was to verify the transcriptions that had been assembled in Krautheimer's canonical corpus of half a century ago, integrating them with sources published subsequently or systematically traceable in the modern archives. Although most of the known transcriptions proved fully reliable under this test and gross omissions were nowhere encountered, the new research campaign allowed not only the scrutiny of individual documents, but also the reconstruction of a single chronological sequence of all the integrated sources.[8] Such an arrangement encourages comparison of parallel voices and paradoxically facilitates the characterization of various kinds of sources even as they recur interfiled in chronological order with other types of documents.

Of all the Calimala books that have not come down to us, the greatest loss was probably the so-called *Book of the Second and Third Doors,* dedicated to Ghiberti's north and east doors (after the first south doors by Andrea Pisano), a volume that disappeared sometime after Strozzi copied from it in the seventeenth century. His notes from this source contain some of the most important information on the east doors: the first iconographic program, dictated by the humanist Leonardo Bruni, the initial pacts with Ghiberti, permission to employ Michelozzo and Vittorio Ghiberti, new

agreements for the completion of the narrative panels and for the friezes and other decorative elements, the gilding and the mounting of the doors in the prime central position across from the cathedral, and final payment in the form of the workshop where the doors had been cast. The texts transmitted by Strozzi for Ghiberti's two doors could not have occupied an entire book, even of modest dimensions, so it is likely that the original contained greater frequency of documentation and detail. Its completeness may not, however, have approached that of the most illustrious example of the genre, the *Libro del Pilastro,* with its scrupulous records of the commission, casting, and financing of another work by Ghiberti, the bronze statue *St. Matthew* for the niche that the Bankers guild secured on the last available pier of the guild oratory of Orsanmichele.[9]

The books of the Calimala consuls' resolutions (*Deliberazioni*) provided Strozzi with some information that he had not extracted from the *Book of the Second and Third Doors,* such as the hiring of Benozzo Gozzoli for three years in January 1444. In this case we are presented with the opportunity to compare the scholar's summary with a text from one of the rare original books.[10] Strozzi records only that Ghiberti's son Vittorio acts in his father's name in hiring the young painter, identified with full name and address. The original document, on the other hand, furnishes not only the customary official formulas but also the terms of Gozzoli's engagement: three years, full time, at a gradually increasing, and substantial, annual salary of 60, 70, and then 80 florins. Another example is the commission of the remaining chiseling on the doors to three stonecarvers in 1449: the surviving codex lists the names of the contractors and the agreed price, while the Strozzi extract reports only "masons, election."[11]

For the 1452 decision to give pride of place to the third doors, on the other hand, it is possible to compare two Strozzi summaries, both from lost originals: the consuls' *Deliberazioni* and the special *Libro* of the two doors.[12] The latter is an extremely brief notice that the third doors, being entirely complete, should be placed at the portal facing the cathedral. The former not only provides more detail—most significantly, the consideration of the beauty of the new creation—but also alludes to what may have been a special consultation (*pratica*) before undertaking such a momentous decision. One longs to know who was consulted and what views were expressed, some aspects of which might have been recorded in the lost original consular records.

Another category of source that emerges from the Strozzi papers is constituted by the memoirs, or *Ricordi,* kept by the guild administrator. These too sometimes parallel the information summarized from the *Book of the Second and Third Doors,* typically with reduced detail, as for the new agreement for the doors in 1448.[13] In other cases, however, they provide unique sources of information: see, for example, the significant state-of-progress declaration of 1437, which notes that the ten narrative panels and twenty-four pieces of the surrounding friezes have been cast and that chasing will commence with the collaboration of Ghiberti's son and Michelozzo.[14] The *Filze,* gatherings of various files, seem to have contained only occasional scattered documents and the *Libri grandi* of the guild, nothing at all directly related to Ghiberti's third doors.

Occasional documents from sources other than the Calimala guild afford additional glimpses of aspects of the prolonged creative process of the doors. Ghiberti's own tax declarations, submitted four times during the twenty-eight-year span of work, provide scanty information on his activity

for this most important commission of his career. On the other hand, the debtors listed in the 1427 report of a Florentine goldsmith, Antonio del Vagliente, include not only Ghiberti himself but also Donatello and Luca della Robbia, both described as *fa le porte* ("working on the doors").[15] Such casual mentions are particularly significant in the absence of records of assistants comparable to the list for the central period of the north doors, known through Strozzi's Calimala copies.[16] Although the shop account book cited by Vagliente could have included old credits, the entry for Luca, at least, which appears on one of the last pages, must refer to the early years of the third doors. Tax declarations are also the source for the identification of Michelozzo in 1442 as a sculptor of the doors in an annotation, perhaps added after the fact by the fiscal officials, and for the goldsmith Bernardo Cennini's statement that he was a salaried worker on the doors of San Giovanni at that time of his report of 1451.[17] The sketchy rolls of shop personnel to be gleaned from the Calimala documents are also enhanced by the records of the Cambini bank, which made payments on behalf of the guild from September through December 1445.[18] Here we encounter regular installments paid out to Lorenzo Ghiberti as well as monthly salaries to otherwise unknown assistants. Purchases of bronze and casting materials are detailed for the early stages of the founding of the second frames. Such records, preserved by chance, might have existed for the entire duration of the workshop of Ghiberti's doors.

These, then, are the documentary tools for reconstructing the history of the Gates of Paradise. Sporadic in their appearances, inconsistent in their content, sometimes tantalizing in their allusion to richer material irreparably lost, they constitute one of the classic challenges to historians of Florentine Renaissance sculpture. Fortunately, the combination of intense scrutiny of the doors in the context of their restoration and of the archival sources appropriately reviewed on the occasion of the recent workshop has made possible not only a revision of the existing exegeses but also some significant steps forward, as Francesco Caglioti demonstrates in the following pages.

1. On the Calimala as wardens of the Baptistery since the twelfth century, see G. Filippi, *L'arte dei mercanti di Calimala in Firenze ed il suo più antico statuto,* Turin: Fratelli Bocca, 1889; K. Frey, "Aus den Statuten, Rechnungsbüchern und Protokollen der Arte dei Mercatanti, detta Arte di Calamala, zu Florenz," in G.Vasari, *Le vite dei più eccellenti pittori, scultori e architettori,* ed. K. Frey, parte I, band I, Munich: Georg Müller, 1911, pp. 328ff; R. Davidsohn, *Storia di Firenze,* 8 vols., trans. G. B. Klein, Florence, 8 vols., 1972–1973: *ad indicem,* esp. vol. VI, pp. 272ff; A. Doren, *Le arti fiorentine,* trans. G. B. Klein, Florence: Le Monnier, 1940, II:238ff.

2. The seminal work on this tradition is Christian Bec, *Les Marchands écrivains à Florence 1375–1434,* Paris and The Hague, 1967.

3. The situation of the sources for the cathedral and their editions is treated in Margaret Haines, *Gli anni della cupola. Archivio digitale delle fonti dell'Opera di Santa Maria del Fiore,* in *Reti Medievali* III:2 (2002), www.storia .unifi.it/_RM/rivista/mater/Haines.htm.

4. These events are not clearly documented. In the fullest published account of the Baptistery sources, Richard Krautheimer's introduction to the documentary appendix of the Ghiberti monograph, there is an undocumented reference to a fire in the Calimala offices in the eighteenth century (II:361–365). However, the 162 volumes of the Arte di Calimala now conserved in the Florentine State Archives (ASF) comprise ample material for the sixteenth through the eighteenth centuries alongside sporadic records for the earlier period that concerns us here, a situation that suggests other causes for the loss of many of the oldest sources, given the almost random conservation of others. An already despoiled archive would have been further shorn of routine account books when all the guilds were suppressed and incorporated into the newly founded Chamber of Commerce in 1770 (by kind communication of the archivist Vanna Arrighi, until recently responsible for the guild *fondi* at the ASF).

5. Archivio di Stato di Firenze, Carte strozziane, ser. II, vols. 51.1–3.

6. Observation of Rolf Bagemihl in his thoughtful introduction to the recent review of the documentation, as described in the next note.

7. *Lorenzo Ghiberti's Porta del Paradiso: Technology and Creativity* was organized by the Opificio delle Pietre Dure, the High Museum of Art, and The Metropolitan Museum of Art with the support of The Andrew W. Mellon Foundation. Although the group's attention was especially directed to considerations of technique that emerge from the vantage point of the restoration laboratory, the symposium steering committee recognized the importance of a careful review of the archival documentation regarding the creation of Ghiberti's doors and the history of their conservation up to the present. These two tasks were taken on, respectively, by Rolf Bagemihl and Gabriella Battista, and their work, produced in a limited edition for the use of the workshop, served as a precious foundation for the considerations of the participants. Francesco Caglioti and I, who proposed and coordinated this campaign, are particularly grateful to Angelica Rudenstine and Gary Radke for their support in the undertaking.

8. Krautheimer's division of the sources into transcriptions ordered by archival sources and a chronological digest consisting of brief summaries of these and other published documentation, although justifiable for philological and editorial reasons, has in fact constituted an obstacle to a clear vision of the sequence of events.

9. *Das Aktenbuch für Ghibertis Matthäus-Statue an Or San Michele zu Florenz,* ed. A. Doren, Berlin: Cassirer, 1906.

10. Krautheimer, Dig. 246, Docs. 71, 94.

11. Krautheimer, Dig. 273, Docs. 91, 72.

12. Krautheimer, Dig. 283, respectively, Docs. 73, 48.

13. Krautheimer, Dig. 263, Docs. 22, 44.

14. Krautheimer, Dig. 198, Doc. 23. Bagemihl provides argumentation for a possible redating of this text to April 1436.

15. A. Guidotti, "Del Vagliente," *Dizionario biografico degli italiani,* vol. XXXVIII, Rome: Istituto della Enciclopedia Italiana, 1990, pp. 381–383.

16. Krautheimer, Dig. 41, Doc. 31.

17. Krautheimer, Dig. 235, 277.

18. Mendes Atanasio, 1963, Docs. I–III; Krautheimer, Dig. 255a.

Reconsidering the Creative Sequence
of Ghiberti's Doors *Francesco Caglioti*

IN THE LAST TWO AND A HALF CENTURIES, the history of the creation of the Gates of Paradise has been recounted and published numerous times using available documents (at least since Giuseppe Richa, 1757).[1] There have been studies dedicated to this subject in the Italian, English, and German languages, generally with the goal of furthering the existing research through the use of newly discovered archival materials.[2] If these studies are viewed in chronological order, we see, however, that the most recent investigations do not always show the greatest clarity and deepest understanding, and often in the course of the debate there have been setbacks, sometimes even dramatic ones—not an infrequent phenomenon in literature on the arts. In the case of the Gates of Paradise, this seems particularly true for the last half century, since the fundamental monograph on Ghiberti by Richard Krautheimer in 1956. The rigor of the reconstruction made by this illustrious scholar, and the definitive character of many of his conclusions, should have allowed his successors to rest easily for a very long time. In effect, this was so for much of the related historiography, particularly in the English and German languages. But Italian scholarship has distanced itself from the findings of Krautheimer, sometimes even completely undermining them.[3] This reversal, while done with great discretion, was forceful and was justified on the basis that the surviving archival documents not only are full of gaps but also that the few that remain can be claimed to be quite contradictory. This author, however, is in wholehearted agreement with the final word of Krautheimer, expressed for the six-hundredth anniversary of the artist's birth (1978): the documents "speak in too clear a language to allow for a change"—for example, "in the final date 1437 for the casting of all ten reliefs."[4]

Of course, it is a shame that the vast majority of original documents have been lost, leaving us for the most part with citations and summaries from a later period that are often silent in response to our curiosity about certain details. But if one has the patience to spend the necessary time with the papers both in their entirety and in the individual passages, it can be verified in the end that the picture we find from the evidence is doubly consistent: consistent in itself and consistent in relation to the finished work that remains today. It is therefore perplexing that it has been primarily the Italian scholars—who because of their linguistic advantage should have a more direct and thorough comprehension—who overlooked this consistency. This is not the place to review all of the oddities which that attitude has produced, but they will be referred to later in regard to the collaboration of Benozzo Gozzoli on the Gates.

As always in art history, a rigorous philological approach to the documents is not sufficient. If the work survives, the comparison of the documents with the work should be as stringent as possible to fill in the gaps and correct the analysis of the archival information through the evidence of the work of art, and vice versa. In the case of the Gates of Paradise, Krautheimer observes that many scholars of the documents do not seem to have taken into account the critical importance of the length of time and difficulty required for the cleaning and chasing (*rinettatura*) once the bronzes were removed from the furnace (and this statement, made in reference to earlier colleagues, is also true for those who succeeded Krautheimer).[5] Improvising a somewhat forced but useful comparison with marble sculpture, one might say that bronze that has not been cleaned and chased is like marble that has

been only slightly roughed out and that the extended time necessary for finishing the stone becomes extremely long if translated to the finishing of metal. This is especially true for the bronzes of Ghiberti, among the most perfect creations that Western metallurgy from any era has ever given us. Therefore, if a document dated April 1437 states that the ten major panels of the door are already cast,[6] and in July 1439 a list was made of the five panels already completely or partially cleaned and chased,[7] then a document from June 1443 that mentions the four panels "still to be made . . . to complete the aforementioned ten stories"[8] is clearly a reference to the cleaning and chasing, and not to the creation *ex nihilo* (as has been believed frequently in recent times).

The following discussion is therefore based primarily on Krautheimer.[9] But it also hopes to offer certain variations—two particularly significant ones—that involve aspects of Krautheimer's reconstruction not discussed until now. The possibility of improving upon Krautheimer's interpretation following the same path that he and some of his precursors traveled has been encouraged by various concomitant factors: the revision by Rolf Bagemihl of all the documents related to the Gates, published or re-published in 1956 and increased by M. C. Mendes Atanasio in 1963;[10] the discussion of the documents among many colleagues during The Andrew W. Mellon Foundation Ghiberti Workshop in Florence in February 2006;[11] the opportunity to examine Ghiberti's masterpiece in the Opificio delle Pietre Dure at close range and with ease; and an extensive re-reading—always useful—of the scholarship not only after but also before 1956.

Krautheimer appropriately divides the entire creation of the Gates, which lasted at least twenty-eight years (1424–1452), into three major phases. The oldest (of thirteen years) concluded in 1437, the date by which the thirty-four figurative elements which adorn the two wings—ten *historie* (narrative panels of Biblical scenes) and twenty-four *pezzi di fregi* (statuettes of Biblical heroines and heroes in niches with botanical decorations on both of their extremities)—were completely cast, but all were still in need of cleaning and chasing.[12] The second phase was almost eleven years (1437–1448), during which, with negligible exceptions, the labor-intensive cleaning and chasing of the ten narrative panels was finished, and the *telai*—the two gigantic wings with the molded frames that were to be adorned on the front by the decorative inserts—were created. The third phase lasted slightly more than four years (until the summer of 1452), during which the preparation of all accessory parts (the twenty-four "heads" that protrude from the corners of the narrative panels and the complex ornamentation of the actual portal) and—before the assembly—the gilding of all the bronzes that needed it were completed.

The formal agreement between the Arte di Calimala and Ghiberti for the creation of the third portal of the Baptistery, destined for the only opening then without bronze doors (the north set), was executed on 2 January 1425.[13] In order to do this, it was necessary to dedicate some months to the preliminaries: in a letter that seems to be dated around the first half of 1424, Leonardo Bruni, Chancellor of the Florentine Republic, addressed the influential Niccolò da Uzzano and other "deputies" of a committee evidently charged by the Calimala to supervise the project of the Gates, and proposed a complete iconographic program for the door (see fig. 2.3).[14] The famous humanist was expressly requested to lend his expertise, as we know from a second letter of June 1424 between two other no less celebrated humanists—the Camaldolese monk Ambrogio Traversari and Niccolò

Niccoli—in which they maliciously criticize his inclusion.[15] Bruni's program faithfully respected the tradition established with the south doors by Andrea Pisano and confirmed by Ghiberti's first doors (then at the east): divided into twenty-eight sections and arranged on seven levels of two sections each per wing, allocating the twenty upper sections with an equal number of narratives (in this case, from the Old Testament) and the eight lower panels with eight single figures (in this case, Prophets). The number of twenty-eight sections must have been prescribed to Bruni by the Calimala guild: this was not simply in order not to break the symmetry with the other doors but may also have been inspired by the idea written down many years before,[16] to reuse in the narratives the *Sacrifice of Isaac* (see fig. 3.4) with which the young Ghiberti had won the competition for the second doors of San Giovanni in 1402—the seventh panel of Bruni's scheme was dedicated to that subject.

Bruni's respect for the past was such that, in developing the narrative material, he followed the top-to-bottom chronology set by Andrea Pisano, and inverted that which Ghiberti meanwhile had introduced in the second door, going from bottom to top. Such traditionalism in 1424 was excessive even for the "gothic" Ghiberti, who had already become successfully established in the creation of large bronze statues for the niches of Orsanmichele (the *Saint Matthew* and *Saint John the Baptist,* beginning in 1412; see figs. 3.1 and 3.6) and of unified and square narrative panels for the baptismal font of San Giovanni in Siena: *The Baptism of Christ* (fig. 4.1) and *The Arrest of Saint John the Baptist* (see fig. 2.9), beginning in 1417. These experiences are reflected intimately in the organization and style of the Gates of Paradise as they appear today. Ghiberti himself, as soon as he was commissioned, must have been among the first to recognize the need to reject Bruni's conservatism, arriving sooner or later at ten large narrative panels and twenty-four figures in the niches.

As Julius von Schlosser, one of the most important Ghiberti scholars, wrote in 1912, the change of program of the Gates of Paradise "is a subject that constitutes one of the most remarkable facts in Ghiberti's artistic career."[17] After almost a century, we can add that this is still the issue that most

Figure 4.2 Interior of the Gates of Paradise, east portal, Baptistery of San Giovanni, Florence.

adamantly points out the need for clarification and for further discussion of Krautheimer's thesis. Like all the scholars of the last century, up to the present, Krautheimer states that, after Bruni's plan and before the definitive version, the door went through a phase of division into twenty-four single panels. This idea, first put forward by Heinrich Brockhaus in 1902,[18] comes from the observation that the two current wings are divided on the back into 24 sections (fig. 4.2) and presumes that each wing consisted of two frames juxtaposed, one internal and one external: the two internal frames would have been cast earlier ("in 1428 or 1429")[19] and therefore would have reflected a program of twenty-four units (analogous to the first and second doors of the Baptistery, each divided into twenty-eight sections in front and back); the two external frames, cast much later, then would have been prepared to receive the finished narrative panels.[20]

Today, we can comfortably say that each wing was created in one enormous and magnificent casting of twelve blank squares on the back and of five large areas for the narrative scenes on the front; for this reason among others, the Gates of Paradise are a marvel of metallic art. If Ghiberti adopted two different subdivisions for the front and the back, he did so carefully, out of respect for the Baptistery's internal symmetry. In the many days during which only one sanctuary door was open, it would have been preferable that the two closed doors would not be out of keeping with one another. Because the wings of Andrea Pisano's doors and Ghiberti's first doors were divided internally into twenty-eight panels, a division of the third pair of doors into ten panels on the back would have created an unpleasant break, especially in view of the fact that the Gates of Paradise were originally destined for the opening to the north, facing Andrea Pisano's door, not alone on the east side. A new division into twenty-eight sections, on the other hand, would have been in excessive contrast to the rationality and lightness of the exterior; Ghiberti therefore wisely chose twenty-four sections, a number that from a distance fools the eye and appears to be twenty-eight.

As the creator of the second doors for San Giovanni, Ghiberti had already tried the idea of treating the internal and external parts differently through subtle optical corrections. The twenty-eight multi-lobed frames on the

Figure 4.3 Interior of Andrea Pisano's doors, south portal, Baptistery of San Giovanni, Florence.

Figure 4.4 Interior of Ghiberti's first doors, north portal, Baptistery of San Giovanni, Florence.

outside of the first two doors are so graceful that, on first impression and then in memory, they appear inscribed inside of square panels. But these panels when measured are revealed to be decidedly vertical rectangles.[21] Inside, conversely, thanks to a complete reorganization of the dividing frames, the twenty-eight sections of each door (figs. 4.3 and 4.4) are almost square (and wider than they are tall): both Andrea Pisano and Ghiberti understood that the absence of elaborately shaped frames and of figures would have made the optical illusion difficult,[22] so eurhythmy was achieved with more exact geometry.

If the Gates of Paradise had actually been based on a plan of twenty-four panels, scholars agree, it would have been necessary to eliminate one of the horizontal rows of four panels, with the reduction from seven to six levels. In this case, however, the width of the external compartments would have remained unchanged, while their height—their vertical scale—would have been increased. In a situation like this, Ghiberti would have had to reuse *a fortiori* the corrective trick of the multi-lobed frames: in other words, the Gates of Paradise would have been still more "gothic" than the two previous doors. Here, then, is evidence against the figurative plan in twenty-four episodes (granting that the technical argument of the wings is not sufficient). But there is more. Significantly, the twenty-four internal sections of the Gates of Paradise, although they are necessarily vertical rectangles, increase only slightly in height. In fact, as on the back of the previous doors, Ghiberti altered the dividing frames, in this case by widening them. In this way the rectangles became much smaller than they would have been on the front if it had been divided according to the hypothesis of Brockhaus and Krautheimer. At any rate, either the division into twenty-four sections would have been equal on the back and the front—and so the dimensions of the stories would not have increased in comparison with the first two doors (and therefore the new plan would have been a useless effort)— or there would not have been mirroring between the front and back, not even in the division into twenty-four sections, and thus the back in twenty-four sections cannot tell us anything about the development of the plan for the exterior.

How can we reconcile all this with the documents and the chronology? Here the issue seems again to become complex, while at the same time proving itself to be equally certain. Let us examine things in a little more detail.

During the years 1428–1452, the documents speak of bronze "frameworks" (*telai*) for the Baptistery doors at three distinct moments (1429, 1439–1440, and 1445–1449). In 1429 the Calimala's tax declaration mentions a large financial burden stipulated sometime previously, "when the frame of the door of San Giovanni was cast."[23] Brockhaus, who was the first to bring the document to light, connected it to the presumed internal frames of twenty-four sections. However, Krautheimer argued convincingly that the reference is to the frame of the *first doors* by Ghiberti, cast approximately ten years before.[24] Conveniently, the same document also mentions "costs for the third door which has been started," immediately adding, "you can't imagine the cost, the *maestro* alone costs 200 florins a year." In fact, the contract of 1425, like the one from more than twenty years earlier for the second doors (1403), established that the total price of manufacture would be decided only at the end, and that in the meantime the *maestro* would receive "on account" 200 florins annually. But the same Krautheimer to whom we owe these clarifications still concluded that the first parts of the frames of the Gates of Paradise—that is, the interior face—would have already been cast by "1428 or 1429."[25] Like Brockhaus and everyone else, he was misled by the misunderstanding about the twenty-four panels and failed to take into account how risky and imprudent it would have been for a master of Ghiberti's level to begin the preparations for the frameworks of the wings before completing the figurative elements. Not by chance, documents regarding the frame for the Gates of Paradise only appear from 1439–1440 and 1445–1449—that is, in two advanced phases of the work— the first when all the panels and all the niches were already cast and the second when almost all the panels had been cleaned and chased. The length of time between these two moments coordinates with the needs of two distinct wings, the casting of which—an extremely difficult and delicate job—could not have been done at the same time but rather in succession, each time using the same place and the same equipment in the workshop at Santa Maria Nuova.

The crumbling of the myth of the twenty-four-section plan has striking consequences for the chronology of the door. Having fixed at "1429 or 1430" the deadline post quem for the planning, the models, the waxes, and everything else related to the ten narrative panels,[26] with the casting complete by 1437, Krautheimer expressed surprise at the rapidity with which this phase of the work seems to have been completed.[27] This surprise would have been magnified if the scholar had understood the meaning of *spiaggia* (plural *spiagge*—a technical term no longer used today, that means an oblong metal bar), which appears in the documents concerning the door to indicate the twenty-four units inserted along the borders of the panels, each containing a statuette inside a niche and floral decorations above and below (see pages 134–137), or at the left and the right (between *spiaggia* and *spiaggia*, a *compasso*—that is, a tondo—is inserted with a head [see pages 138–139], so there are also twenty-four heads). The *spiagge* mentioned as already cast in 1439[28] are the same *pezzi 24 di fregi* (twenty-four frieze pieces) cited in 1437—together with the narratives—as already cast even then,[29] so the amount of work finished before 1437 is greater than it appeared to Krautheimer himself.

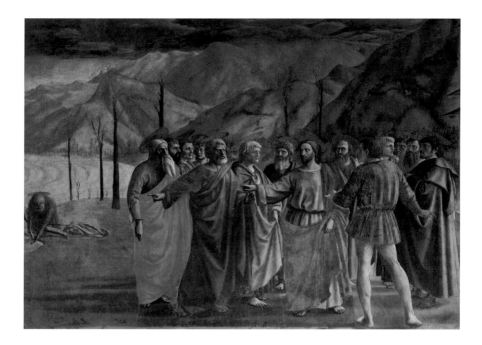

At this point there seem to be no impediments, either in the documents or the work of art, to arriving at the conclusion that the entire miraculous *corpus* of the ten narratives and twenty-four *spiagge* was initiated well before 1429. Indeed, this author sees no reason to doubt Ghiberti's autobiography, in which, beginning to speak about the third doors, he writes: "I was given . . . license to conduct the work in the way I thought that it would be most perfectly made," and "I began that work in squares that were one and one-third *braccia* in size."[30] One can suspect that the concurrence with other important works (including the Reliquary Chest for Santa Maria degli Angeli and the *Saint Stephen* for Orsanmichele) could have impeded the artist from applying himself immediately to the doors with the exclusivity that the agreement of January 1425 required. In 1427 and 1429, however, the tax declaration of the artist and that of the Calimala[31] does show that Ghiberti was actually working on the project and receiving his regular salary. Be that as it may and putting aside outdated prejudices, it seems that we must become accustomed to the idea that the heroic creation of the Gates of Paradise was contemporary not with the beginning of the two *Cantorie* (choirlofts) of Luca della Robbia and Donatello, but with the Brancacci Chapel of Masolino and Masaccio (fig. 4.5), which gives us a more coherent picture of the history of Florentine art at the time and a better valuation of Ghiberti's greatness.

We do not have other important documents regarding work on the door until 1437, but we cannot assume that the lost documents would allow us a glimpse of the daily workings at the workshop at Santa Maria Nuova. Beginning in 1437 the story becomes clearer, at least for those of us who share Krautheimer's interpretation. In that year the cleaning and chasing of the thirty-four principal figurative elements began, for which we see the appearance of Lorenzo's son Vittorio (already nineteen years old), Michelozzo, and "three other" regrettably unidentified artists working with Ghiberti.[32] Calculating the time spent beginning in January of 1438, the number of finished pieces was verified in July of 1439: the second and fifth panels (*Cain and Abel* and *Jacob and Esau*) were completely finished; the seventh (*Moses*) almost; the sixth (*Joseph*) "half way"; the tenth (*Solomon and Sheba*) "almost ¼."[33] This author maintains that the description of this last story panel (fig. 4.6) has until now been slightly misunderstood by mistakenly referring "almost ¼" to one part of it ("the figures on the right"), not to

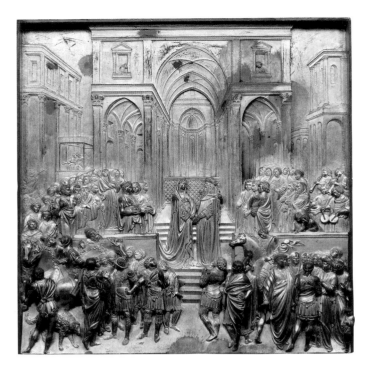

Figure 4.6 *Solomon and Sheba* panel.

the whole, as it would actually seem according to the list.[34] The document states: "One story of Solomon—the buildings were done and on the bottom a piece of the figures on the right side—[finished] almost ¼." The buildings occupy almost half of the surface in *Solomon and Sheba,* and besides, even if they were completely cleaned and chased together with some of the figures in the lower right corner, the work was still considered behind schedule. There were, in fact, large differences in effort and time between cleaning the simple surfaces of the buildings and the rather complex ones of the figures. In addition to the five panels, two of the twenty-four *spiagge* were cleaned, but "only the foliage."

It does not seem coincidental that at exactly the same time that this inventory of chased and cleaned bronzes was made, in July 1439, the casting of one of the two "frames" was begun.[35] For the casting, 17,000 pounds of bronze was acquired from Flanders in 1440.[36] In June of 1443, perhaps because of the length of time dedicated to the frame, it was noticed that the cleaning and chasing had slowed down: in fact, there were not more than six narrative panels finished (which most likely included all five mentioned in 1439). Consequently, a new agreement was made with Lorenzo, obliging him to forego any other commissions and, together with his sons Tommaso and Vittorio, to apply himself "continually" to the door and to complete one-sixth of the four remaining panels every six months (which amounts to two-thirds of a panel every six months). This phase of the work should, therefore, have been finished halfway through 1446.[37] The silence about Michelozzo in this instance, which continues through the completion of the door, leads one to believe that he had left the scene definitively; but we will have to return to this great artist later.

The departure of Michelozzo and the need to accelerate the pace of the work caused Lorenzo and Vittorio—who by this time was more and more frequently at his father's side in directing the work—to engage new helpers. Beginning on 1 March 1444, Benozzo Gozzoli, only slightly more than twenty years old (and who was learning to paint, according to the tax declaration of 1442), was hired for exactly three years (that is, until 28 February 1447). It is likely that Gozzoli complied fully with the terms of his agreement with Ghiberti,[38] since only in March of 1447 do we find documents

that show him elsewhere (with Beato Angelico in Rome). The period and length of time of his passage through the workshop at Santa Maria Nuova allow for only one possibility: that he helped to clean and chase part of the last four panels (from among the five not mentioned in 1439 as finished or underway—that is, *Adam and Eve, Noah, Abraham, Joshua,* and *David*). In spite of the dates of the documents and technical facts, recent Italian scholarship has instead conferred on Gozzoli a much more important creative role, attributing to him at various times different portions of the panels *Joshua, David,* and above all, *Solomon and Sheba.* In 1444, however, these panels had all been cast for at least seven years, and *Solomon and Sheba,* whose chasing had already been underway five years earlier, would have lacked only gilding. Furthermore, it is not convincing that the sixty-five-year-old Ghiberti —with all of his experience and fame, and aided by his sons Tommaso and Vittorio—would have relied on an obscure painter at the beginning of his career to resolve fundamental artistic problems of his masterpiece. The collaboration of Gozzoli was not enough to meet the deadline for the cleaning and chasing, which was finished only in the summer of 1447, one year late according to the last agreement.[39] Rather than asking what decisive contribution Gozzoli could have made to the Gates of Paradise, it would be better to ask what formative impact this exceptional experience had upon the young painter. At any rate, since cleaning and chasing was labor-intensive work and very well paid (Gozzoli was promised 210 florins for three years), the passage of the eager artist through the Ghiberti workshop seems analogous to those substantial but rare grants that today's young graduates hope to obtain after finishing a doctorate and while waiting to find a professorship at a university. The duties connected with the grant are not always in harmony with the candidate's research goals, but the student adapts for the purpose of earning money and for the opportunity to obtain wider experience.

While the four story panels were cleaned and chased, a large number of "workers," chosen in part from among the stonemasons (there is not enough space to name them here), provided the manpower for the creation of another "framework" (1445–1449),[40] referred to as the "second cast of the doors" (*sechondo gietto delle porte*),[41] or "last framework" (*ultimo telaio*).[42] For this purpose, another 14,263 pounds of metal was ordered from Flanders.[43]

With the completion of the two wings and ten narrative panels, the *iter* of the work on the doors entered its third and final phase. A new official agreement, dated January 1448, was concluded for everything that still remained to be done:[44] cleaning and chasing the twenty-four *spiagge*;[45] casting and chasing the twenty-four heads; and casting, cleaning, and chasing the portal itself. This last item also involved assembling many separate pieces: the threshold, the *cardinale* (lintel), as well as the molding or cornice *all'antica* placed above it (rarely reproduced in photographs), and two jambs (one of which was already said to be cast). The lintel and jambs—each cast in one piece and molded in neutral forms—were intended to be even more richly detailed with marvelous ornate plants and animals than Ghiberti's previous door. The plan called for three long bands to be cast separately in twelve parts (*spiagge*) and inserted in the front surfaces of the jambs following the procedure of the figures on the doors. Instead, floral bands were to be "chiseled" in low relief along the three internal sides, probably by the stonecutters who were cleaning the casting of the second framework (among them Simone di Nanni Ferrucci from Fiesole, father of the more famous Francesco, a sculptor).

As for the twenty-four *spiagge* for the wings, we learn from the agreement of 1448 that it took three-and-a-half months of work by a *buono maestro*

(master craftsman) to clean and chase each one. In particular, we discover that, while Lorenzo carefully directed the manual labor, he participated very little in the actual work: the agreement stipulated a charge of twenty-eight florins for each *spiaggia,* with twenty-five going to the artisan and three to the master of the shop. Among the master craftsmen who were involved in work on the *spiagge*—as well as on the twenty-four heads of the wings and on twelve *spiagge* of the portal—documents from 1448 and 1451 mention the young Bernardo Cennini,[46] born in 1415 and destined to become one of the principal goldsmiths of the second half of the fifteenth century in Florence.

In January of 1451, the parties realized that the work that had been agreed to three years earlier had not been entirely completed, and Lorenzo and Vittorio were given no more than twenty months to finish everything but the gilding and assembly.[47] This time, it seems, the Ghibertis departed from their usual custom and respected—even anticipated—the deadline, for fifteen months later (in April 1452) the door was declared to be "finished" and the gilding was commissioned to be done by the following June 20.[48] Apparently, the intention was to present the door, perhaps already in place, to the Florentine people for the holiday of St. John the Baptist on June 24. The gilding was completed as of June 16,[49] but at this point another delay arose, as usual brought on by the desire to obtain the best result. The Calimala was quite satisfied with the unique and beautiful new door and began to wonder if it didn't deserve to be installed in a place of honor at the Baptistery—that is, on the east side—facing the altar on the inside and the façade of the Duomo on the exterior. In this way Ghiberti would replace his own first door, which would be transferred to the north, the opening for which the Gates of Paradise were originally commissioned. In July of 1452, the official decision was made also to assume the costs and time necessary to disassemble and reassemble the first of Ghiberti's doors.[50] The modern bibliography fails to mention the date on which the Gates of Paradise were inaugurated, as Brockhaus lamented as early as 1902.[51] Shortly thereafter, however, the same scholar was able to locate this information and add it to the new Italian edition of his essay (which no one seems to have read): it was 6 September 1452, two days before the feast of the Nativity of the Virgin— as reported by a chronicler of the period, Filippo di Cino Rinuccini.[52]

The switching of the two doors is not the last detail of the story that shows how determined the Calimala was to make every effort to glorify the main civic temple of Florence, which had been entrusted to its care. Since 1452 there had been discussion of adding to the south portal (decorated with the doors by Andrea Pisano) a series of frames no less ambitious than those of the other portals.[53] In February of 1453 this commission was presumably assigned to the Ghibertis.[54] But Lorenzo was already over seventy, and for unknown reasons Tommaso had left his father's workshop some time before. Thus it fell to Vittorio, as the beneficiary of the commission, together with his father, to finish the work, continuing it even after Lorenzo's death.[55] An incredible new masterpiece in its genre, it was finished in 1462 or slightly earlier,[56] with the help of artists whose names are unfortunately absent from the old documents.

In spite of the scarcity of documents from the period, there are quite a number that we have left undiscussed. At least one of them deserves to be mentioned before we conclude: we cite it outside the chronology not only because its dating is uncertain but also because to do so earlier would have made for a lengthy digression on account of its importance. We are

referring to Michelozzo, whose collaboration on the doors from 1437 to 1442 is attested with certainty.[57] A note from Carlo Strozzi, however, based on a document prior to 1437, mentions that the artist received an annual salary of 100 florins (half that of Ghiberti). Based on the nature of the note, one might even suspect that it refers to a clause of the original agreement of 2 January 1425. This would mean that Michelozzo must have worked with Ghiberti from the very beginning, which would not be surprising, considering his role in the creation of the second door (ca. 1420–1424) and his even larger involvement in the *Saint Matthew* for Orsanmichele (1421–1423). On this point Krautheimer seems to fall into a strange contradiction. When he republished the documents, he related the information on Michelozzo to the agreement of 1425,[58] but when he commented on those same documents, Michelozzo only appears in 1437.[59] Based on the current archival information, it is impossible to decide in favor of either of these two chronological extremes—the solution may lie somewhere in between (ca. 1434?). In the future, however, it would be best to ask if Michelozzo was Ghiberti's right-hand man for some part of the initial creative phase. If this is true, it would finally explain certain differences of style observed by many in some of the story panels, especially the last three.

NOTES

1. G. Richa, *Notizie istoriche delle chiese fiorentine,* Florence: P. G. Viviani, 1757, V:xx–xxii, §VII.

2. The main documentary contributions, inspired at first by Carlo Strozzi's seventeenth-century collection of ancient papers, seem to be from T. Patch, in F. Gregori and T. Patch, [*La porta principale di San Giovanni in Firenze*], Florence: 1772–1774; G. Gaye, *Carteggio inedito d'artisti dei secoli XIV, XV, XVI,* Florence: G. Molini, 1839, I:105–108; G. Milanesi, "Intorno al lavorìo delle porte di San Giovanni," in *Le vite de' più eccellenti pittori, scultori e architetti, di Giorgio Vasari,* Florence: F. Le Monnier, 1848, III:126–131; G. Milanesi, "Documenti inediti dell'arte toscana dal XII al XVI secolo, raccolti e annotati," *Il Buonarroti* ser. III, II (1884–1887), pp. 109–121 (1885), especially pp. 115–116, n. 107; H. Brockhaus, "Die Paradieses-Thür Lorenzo Ghiberti's," in Id., *Forschungen über Florentiner Kunstwerke,* Leipzig: F. A. Brockhaus, 1902, pp. 1–50; K. Frey, "Aus den Statuten, Rechnungsbüchern und Protokollen der Arte dei Mercatanti, detta Arte di Calimala, zu Florenz," in G. Vasari, *Le vite de' più eccellenti pittori, scultori e architettori,* ed. K. Frey, Parte I, Band I, Munich: G. Müller, 1911, especially pp. 357–364; R. Krautheimer, *Lorenzo Ghiberti,* Princeton: Princeton University Press, 1956; and M. C. Mendes Atanasio, "Documenti inediti riguardanti la «Porta del Paradiso» e Tommaso di Lorenzo Ghiberti," in *Commentari* XIV (1963), pp. 92–103.

3. For the most recent examples, see A. Paolucci, "Le sculture," and "Lorenzo Ghiberti [. . .], La 'Porta del Paradiso' [. . .]," in *Il Battistero di San Giovanni a Firenze / The Baptistery of San Giovanni, Florence,* ed. A. Paolucci, Modena: F. C. Panini, 1994, pp. 143–187 and 559–562, especially 162–163, 561–562, and A. Paolucci, *Le porte del Battistero di Firenze. Alle origini del Rinascimento,* Modena: F. C. Panini, 1996, pp. 17, 125–126. Fortunately, there are exceptions: e.g., G. Poggi, *La Porta del Paradiso di Lorenzo Ghiberti,* Florence: Società Fotografie Artistiche, 1949, and the succinct but excellent A. Galli, *Lorenzo Ghiberti,* Rome-Florence: Gruppo Editoriale L'Espresso-Scala Group, 2005, pp. 170–201, n. 10.

4. R. Krautheimer, "A Postscript to Start With," in *Lorenzo Ghiberti nel suo tempo. Atti del convegno internazionale di studi (Firenze, 18–21 ottobre 1978),* Florence: L. S. Olschki, 1980, I:v–xii, especially p. x.

5. Krautheimer 1956, p. 167 note 12.

6. Krautheimer, Dig. 198, Doc. 23. The year of this document is not completely certain, since it has been handed down with the alternate date of 1436. See also Krautheimer 1956, pp. 164–165, for the reasons in favor of 1437.

7. Krautheimer, Dig. 208, Doc. 24.

8. Krautheimer, Dig. 241, Doc. 40.

9. In particular, pp. 159–168 and notes.

10. With the hope that the collation organized by Bagemihl will one day be prepared for publication, it is necessary here to refer to the various pieces of evidence basing oneself on the numbering established by Krautheimer ("Dig." is for "Digest of Documents"; "Doc." for "Transcript of Documents").

11. Among those who participated in the workshop, I would particularly like to mention and thank Margaret Haines and Aldo Galli, with whom I have also had extremely close and fruitful exchanges both before and since that event.

12. Krautheimer, Dig. 198, Doc. 23.

13. Krautheimer, Dig. 110, Doc. 36. For ease of use, all dates are here expressed according to the modern calendar and not the Florentine, which began the year almost three months later than the common calendar, on March 25, Annunciation Day.

14. Krautheimer, Dig. 106, Doc. 52. Before Krautheimer (in particular, pp. 159, 161–162 and notes), scholars simplistically dated the (undated) letter to 1425.

15. Ibid.

16. Krautheimer, Dig. 6, Doc. 33.

17. "ist ein Thema, das . . . zu den merkwürdigsten Tatsachen in Ghibertis Künstlerleben gehört," J. von Schlosser, *Lorenzo Ghibertis Denkwürdigkeiten (I Commentarii),* Berlin: J. Bard, 1912, II:180.

18. H. Brockhaus 1902, pp. 6–11 (including fig. 1), 46, 47, 48, 50.

19. Krautheimer 1956, p. 164.

20. The interior faces (back sides) of the three pairs of doors of San Giovanni are very rarely reproduced in photographs and art books. Exceptional is Paolucci 1994 e Idem 1996, where, however, the two photographs pertaining to the doors of Andrea Pisano and to the Gates of Paradise can be seen switched every time (1994, *Atlante/Atlas,* pp. 52 pl. 42, 110 pl. 167; 1996, pp. 72 fig. 103, 168 fig. 294), by which the author himself is misled in his text (1994, p. 561; 1996, p. 125).

21. The difference between the height and width of each rectangle is obviously less when taken at the external perimeter of the frames.

22. The individual lion heads inside the medallions on Ghiberti's doors are in fact a minor issue compared to the formal problem discussed here.

23. Krautheimer, Dig. 157, Docs. 87–88.

24. Krautheimer 1956, especially pp. 111–112 and notes.

25. Ibid., p. 164.

26. Ibid., p. 168.

27. Ibid., pp. 164–165, 168.

28. Krautheimer, Dig. 208, Doc. 24.

29. Krautheimer, Dig. 198, Doc. 23.

30. Von Schlosser 1912, I:48.

31. Krautheimer, Dig. 138, Docs. 81–81a; Dig. 157, Docs. 87–88.

32. Krautheimer, Dig. 198, Doc. 23; Dig. 200, Doc. 37.

33. Krautheimer, Dig. 208, Doc. 24.

34. Krautheimer 1956, p. 165.

35. Krautheimer, Dig. 209, Docs. 25, 59.

36. Krautheimer, Dig. 219, Doc. 38.

37. Krautheimer, Dig. 241, Doc. 40. Bagemihl notes that Krautheimer here wrongly transcribes *sexta parte* as *terza parte.* As a result, the time allowed to Ghiberti in 1443 decreases from three years to a year and a half. I would only add that this error is already present in Frey 1911, p. 360 n. 12, while the correct reading is already contained in Patch 1772–1774, fol. [I]v; E. Müntz, "Les comptes des portes des Ghiberti," in Id., *Les archives de l'art. Recueil de documents inédits ou peu connus,* Paris: Librairie de l'art, 1890, pp. 15–22, especially p. 19; and H. Brockhaus 1902, p. 47.

38. Krautheimer, Dig. 246, Docs. 94, 71.

39. Krautheimer, Dig. 259, Docs. 20, 42.

40. Krautheimer, Dig. 255, Doc. 41; Mendes Atanasio 1963, Docs. I–III (=Krautheimer, Dig. 255a); Krautheimer, Dig. 263, Doc. 44; Dig. 267, Doc. 98; Dig. 268, Doc. 99; Dig. 271, Doc. 102; Dig. 273, Docs. 90–91.

41. Mendes Atanasio 1963, doc. II. 13.

42. Krautheimer, Dig. 263, Doc. 44.

43. Krautheimer, Dig. 252, Doc. 18; Dig. 254, Doc. 19; Mendes Atanasio 1963, doc. II. 7.

44. Krautheimer, Dig. 263, Docs. 44, 22.

45. To whom Krautheimer also refers, Dig. 261, Doc. 79. For more on this, see Krautheimer 1956, p. 166 note 11.

46. Krautheimer, Dig. 265, Doc. 96; Dig. 277.

47. Krautheimer, Dig. 263, 275, Docs. 44, 11.

48. Krautheimer, Dig. 279, Doc. 46.

49. Krautheimer, Dig. 280, Doc. 47; see also Dig. 281, Doc. 12; Dig. 282, Doc. 13.

50. Krautheimer, Dig. 283, Docs. 73, 48.

51. H. Brockhaus 1902, p. 49.

52. E. Brockhaus, *Ricerche sopra alcuni capolavori d'arte fiorentina,* edizione italiana per cura di F. Malaguzzi Valeri, Milan: U. Hoepli, 1902, pp. 1–48, especially p. 19 and note 2, p. 47.

53. Krautheimer, Dig. 285, Docs. 74, 14.

54. Krautheimer, Dig. 288, Docs. 50, 16.

55. Krautheimer, Dig. 296, Doc. 77; Dig. 297, Doc. 51; Dig. 298, Doc. 78.

56. Krautheimer, Dig. 299, Doc. 68; Dig. 300, Doc. 9; Dig. 301, Doc. 69.

57. Krautheimer, Dig. 198, Doc. 23; Dig. 200, Doc. 37; Dig. 235.

58. Krautheimer, Dig. 110, Doc. 36.

59. Krautheimer 1956, pp. 87, 165, 167.

Ghiberti's Gold: Restoration
of the Gates of Paradise

Annamaria Giusti

Director, Museo dell'Opificio delle
Pietre Dure, Florence
and
Director of the Restoration
of the Gates of Paradise

RESTORATION OF THE GATES OF PARADISE has at last entered its final phase and will be completed in 2008, after more than twenty years of work (fig. 5.1). The duration and complexity of this project are in many ways comparable to the original creation of this masterwork, which lasted from 1426 to 1452. The upcoming mounting and exhibition of the Gates at the Museo dell'Opera di Santa Maria del Fiore (fig. 5.2) will provide a perfect opportunity for the Opificio delle Pietre Dure, which was responsible for the restoration, to publish the collected experiences of the restorers, project directors, bronze diagnosticians and technicians, and support teams involved in this monumental project. The work, which was conducted with the urgency and efficiency of a brilliantly orchestrated relay race, guaranteed continuity in further restoration in terms of both methods and results.[1]

This initiative will also offer audiences in the United States the unprecedented chance to view a significant selection of original reliefs from the Gates, which, following their tour of the three participating museums, will then be reintegrated into Ghiberti's unique masterpiece. The publication of an exhibition catalogue, intended as a synopsis of the studies that will appear in greater depth and detail in the final scholarly publication, will touch on the most salient points in this ongoing process of research and restoration. Obviously, this will not be the last chapter in the long history of the Gates. It will, however, mark the end of their presence on the exterior of the Baptistery, which has lasted more than half a millennium.

Once the original work was completed, the doors were installed permanently on the eastern façade of the Baptistery, where they formed a focal point for the daily civic and religious life of the Piazza del Duomo. Their location meant that the work was exposed to two forms of constant stress—one deriving from purely functional use-related aspects, the other from the innumerable operations aimed at polishing and maintaining the precious gilding of the reliefs. This gilding was executed using the mercury amalgam method, at the time the preferred way to ensure preservation of the work's luminous splendor (fig. 5.3). An idea of how the original might have looked can be gleaned from Donatello's well-preserved figure of Baldassare Cossa, which is also exhibited at the Baptistery.[2] While more durable than the common Renaissance procedure of "mission" gilding, mercury gilding in the long run was also characterized by inherent fragility arising from

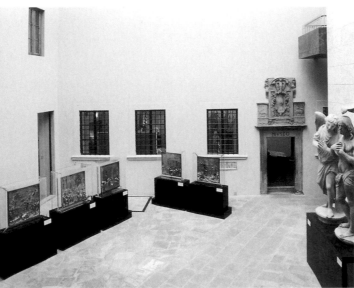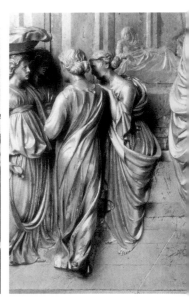

Figure 5.1 View of the frieze area, with which the cleaning of the Gates of Paradise concludes.

Figure 5.2 View of the Museum of the Opera di Santa Maria del Fiore in Florence, soon to be enlarged to receive the restored Gates of Paradise.

Figure 5.3 The mercury gilding shines again once deposits are removed from the surfaces of the reliefs.

contact between the two metals, bronze and gold, and from their chemically unstable bond. In addition to this intrinsic vulnerability, we should also keep in mind the various events that have affected the Gates. Aside from the vicissitudes resulting from long years of polishing,[3] the gilding shows clear signs of vandalism (fig. 5.4), whether intentional or otherwise, which has worn away the gilt layer as well as certain cast details. These damages were the result of simple human contact, scratching, or in some cases actual climbing on the doors, with the climber supporting his feet on the lower panels. This practice appears to have occurred frequently enough to have left an imprint on the gilding.

Other irregular yet often significant gaps in the gilding (fig. 5.5) may be attributable to the effect of acids improperly used in polishing the doors or to the splashing of corrosive liquids employed in cleaning the marble door frames. Scratching with sharp-pointed instruments is also evident. This may have been done out of sheer vandalism or out of curiosity about the gilt surface, which by the eighteenth century was obscured by a coat of dark varnish intended perhaps to protect the work, but also to add an "antique" patina, which was quite in vogue in Florence at the time.

Independent research, as well as the sculptural restoration undertaken by the Opificio delle Pietre Dure over the past twenty years, confirms that eighteenth-century Neoclassical tastes led to the performance of a variety of procedures on works of sculpture in order to dull the brilliance or purity of marbles, darken the patina on bronzes (fig. 5.6), and dim the luminosity of mercury gilding with varnishes, oils, and pigments[4] devised specifically for the restoration of ancient statuary.

Writings by antiquities curator Raimondo Cocchi, who oversaw court collections under Grand Duke Pietro Leopoldo, are particularly revealing in this regard. According to Cocchi, a recommendation was made by the artist Raffaello Mengs in 1772 to remove the reddish-brown varnish which then covered the Gates of Paradise. During that same year, Mengs had curated a casting of the doors, the first in a series of such procedures to take place over the course of the following century. This operation led to a "rediscovery" of many of the details of the reliefs, as well as the presence of gilding, which Mengs wanted to be permanently brought to light. The rejection of his proposal may have been motivated by technical or conservation considerations,[5] but the real reasons probably lay in the prevailing Neoclassical aesthetic tastes, as is poignantly expressed in the words of Cocchi:

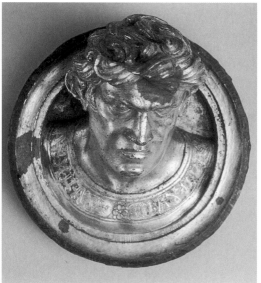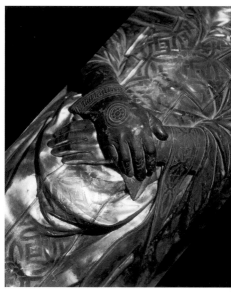

It would seem that some sculptures should be of a more uniform color, in order to best distinguish the play of light and shadow and thus play up the actual relief. Thus drawings are made preferably from plaster casts, rather than ancient statues, which may have become soiled due to improper maintenance by the antiquarian. Uniform patinas are deemed appropriate for reliefs in bronze. And if the Gates had been fashioned from solid gold, which might be more beautiful to the eyes of a miser, and in general more magnificent, this would not be satisfactory for a draftsman, since a bronze without a patina will be filled with reflections and false lights which only confound one's sight.

The Gates remained dark, and it is also probable that over the course of the nineteenth century yet another coat of varnish was added, since at the end of the century various sources affirmed that the gilding was covered by a number of layers.[6] During a later procedure, performed at some undocumented date in the twentieth century, the surface film must have been eliminated. The three doors of the Baptistery were removed during World War II to keep them safe from the vicissitudes of war, and they were reinstalled and repolished between 1946 and 1948. In 1948, when Bruno Bearzi (fig. 5.7) set to work on what would be the most recent restoration prior to the present one, it was discovered that there was no film or patina on the gilding aside from a layer of deposits. This was eliminated during a quick, and possibly overly aggressive, polishing with strong solvents.[7]

Following the restoration, Bearzi also made casts, which were used as the masters for the hand-gilded bronze copy that was substituted for the original Gates of Paradise in 1990 (fig. 5.8).[8] It was during this year that the two originals were transferred to the Opificio laboratories, where specially devised metal clamps provided the proper support and could be used to tilt the doors as required during the procedure (fig. 5.9). It was now possible to closely examine the physical structure of the Gates, which were painstakingly "explored" in the laboratory in extremely exacting scrutiny of the technical achievement as well as the inevitable flaws of this masterwork.

Using advanced technology, the technicians and casters discovered to their astonishment that these two gargantuan bronze doors, each weighing more than thirty tons, had been cast in a single piece, along with the front framework, which serves as a containment grille for the gilt reliefs and which was cast in a single block with the supporting doors (fig. 5.10).

Figure 5.4 Losses in the gilded layer of the surfaces caused by vandalism.

Figure 5.5 Missing section in the gilding perhaps due to acid treatment.

Figure 5.6 Cleaning of Donatello's *Baldassarre Cossa,* mercury gilding obscured by a dark varnish.

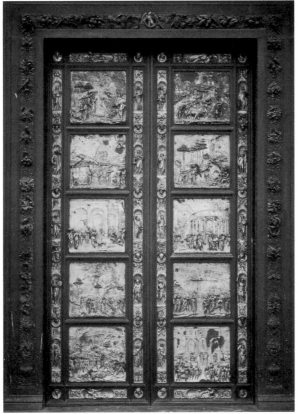

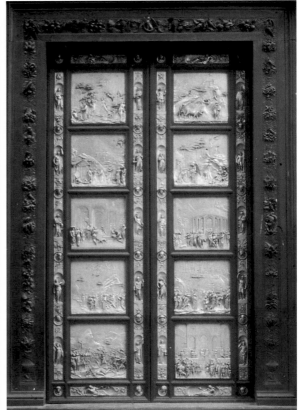

As a final reinforcement for these heavy doors, where casements had been inserted beneath bronze medallions and high-relief busts to secure them, Ghiberti thickened the width of the doors as well as the horizontal cross-pieces of the doorframe (fig. 5.11), not only to provide continuity and uniformity, but also because these areas were subjected to the greatest stress in opening and closing, since the doors were once used as the primary access from the Duomo to the Baptistery.

During the original mounting of the Gates, after the ten door panels and forty-eight cornice reliefs had been cast, smoothed, and gilded with mercury amalgam, they were inserted "by force" into the corresponding casement beds, after the bottom surface of each bed had been properly planed down with scalpels (fig. 5.12). The frame was also apparently heated to provide sufficient dilation for insertion of individual reliefs. Wherever small gaps had occurred between the bed frame and the borders of the relief—a frequent

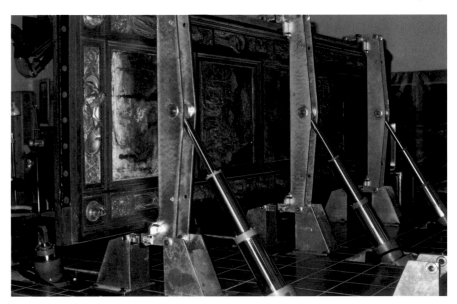

phenomenon due to slight shrinkage from cooling when the bronze was removed from the mold—Ghiberti had them filled in with wedges. These wedges were composed of fine sheets of bronze, hammered until they were nearly invisible. Any gaps or imperfections on the reliefs resulting from the casting process also had to be closed up by hammering in small bronze plugs from behind. This was evidently a rather common procedure during the Renaissance as well as afterward. On some sections of the reliefs, these plugs have come loose and been lost, a frequent enough occurrence on any work with affixed elements, which tend to be less stable.

The technical observations that emerged during the course of this procedure, and which have been only briefly mentioned here, were followed up in 2004 by more in-depth scientific research on the technology and casting method used on the Gates of Paradise. The major findings of this research, conducted by a group of experts and technicians under the direction of Salvatore Siano, are summarized below (see page 142).

Diagnostic studies on the state of preservation of the bronze and the gilding on the Gates have at times been deemed necessary before beginnning any restoration work. Since the end of the 1970s,[9] research has concluded that the major risks to the stability of this work are not from atmospheric pollution—which in less than forty years has left thick incrustations on the

Figure 5.10 The great bronze frames, each cast in a single piece, which form the doors of the Gates of Paradise.

Figure 5.11 Chisel work inside the compartments of the frame to allow insertion of the reliefs.

Figure 5.12 Copious micro-lacerations in the gilded layer caused by pressure from oxidized crystals.

reliefs—but from the presence of unstable oxides beneath the gilding, such as chlorides and sulfates. Due to variations in humidity, these oxides undergo cyclical processes of dissolution and recrystallization, thus creating a series of miniscule yet diffuse blisters on the gold overlay. Pressure exerted on these areas from microcrystals leads to the appearance of craters, which gradually reveal the underlying bronze surface (fig. 5.12). The entire phenomenon represents a "miniaturized" yet progressive corrosion of the gilding, which, over time, will result in complete loss of the gilt surface.

Polishing operations on the reliefs have had to confront this specific and complex situation. The tendency has been to work only on surface deposits, without intrusion into the stabilized oxides beneath the gilding or into stable chlorides and sulfates, the elimination of which would have led to subsequent widespread laceration of the surface gilding. The cleaning method selected for dealing with these particular circumstances—which involved a system of cleaning with distilled water, neutral acetone, and Rochelle salts (potassium bitartrate)—was perfected by Mauro Mattini, then

Figure 5.13 A panel of the Gates immersed in a bath with chemical solvents to remove deposits from the surface.

Figure 5.14 After the bath, the gilding shines again on the *Joshua* panel.

Figure 5.15 Dismantling from the back of a panel, taking advantage of the screw holes that were made to reattach it to the Gates after the flood of 1966.

Director of the Scientific Laboratories at the Opificio. Complete immersion of the reliefs in salt baths (fig. 5.13), followed by rinsing (fig. 5.14), was made possible by the fact that six of the ten panels depicting stories of the Old Testament had come loose from their frames in the doors during the flood of 1966. At that time, after the mud deposits had been removed from these panels with a naphtha solution, the restorer Bearzi then reinserted them by screwing them into place with a series of through-pins. This effective, if overly hasty method, which would obviously not be employed today, did in some ways facilitate the initial phase of the current restoration by permitting the removal (fig. 5.15) and washing of the six panels.

Other problems emerged with the four remaining panels and the entire series of forty-eight relief elements when the operation was resumed. In 1990 the Gates were dismantled and transferred to the Opificio so that the reliefs could be entirely restored. Up until this time, the preferred procedure had been to extract individual panels so that they could be worked on in the laboratory one by one, thus delaying the withdrawal of the doors from public view. However, once initial diagnostic tests had confirmed the presence of unstable oxides beneath the gilding, it no longer seemed feasible to leave the doors exposed to external elements. After operations on the six panels had been completed, the Gates were transferred in their entirety to the Opificio and contextually replaced with a bronze copy.

At this stage, two options were considered: either continue the process of chemical washing *in situ* by means of localized washing of the door reliefs or dismount the individual panels. The problems with the first approach were

obvious: the Rochelle salt solution could easily filter beneath the reliefs through the network of invisible microfractures, while the salts themselves, once they had worked their way under the reliefs, could trigger future corrosive processes. The second alternative involved boring into the doors, which had already been subjected to similar operations during the 1966 procedure, and pushing the reliefs out from behind so that they could be extracted from their casement beds. The decision was made to carefully wash and rinse the individual pieces, thus avoiding the risk of hazardous residues but at the price of boring invasively into the doors' bronze structure.

Conservation efforts at this point came to a standstill, due to the inherent dilemmas of the operation, which I inherited as the new director of the bronze section in 1996. A third alternative was sought, given the obvious difficulties involved in extracting the reliefs. It represented a new compromise, avoiding both the risk of chemical residues and of adding bore holes. Extraction was thus to proceed from the front by insertion of a steel frame around the ungilded borders of the relief, which would then be carefully

molded to the varying relief perimeters and contours. The next step in this difficult and delicate procedure involved exerting continuously controlled traction around the entire perimeter, in order to avoid any deformation or rupture of the relief bronze. This operation was at the same time supported by the exertion of pressure from behind the pieces through bore holes made during the previous operation, slight cooling of the relief undergoing extraction, and removal of the bronze wedges that Ghiberti had originally inserted to close up visible gaps.

We had hoped to have all ten panels extracted by now. After five years of continuous work in this operation, we managed to remove only the four panels that remained embedded in the doors (fig. 5.16), in addition to eight elements of the frieze, which posed far greater difficulties due to the range of plastic articulations of the border elements to which the extractor frame had to be molded and applied (fig. 5.17). We concluded that the removal of all the gilded parts would best ensure complete restoration of the doors, since this would allow for polishing all sections of the reliefs, including casement beds. The great time and incalculable complexity involved in this task, however, brought to light an alternative means of polishing that would enable us to leave the reliefs *in situ*.

The positive experience during the 1990s, at the Opificio as well as elsewhere, in the use of infrared laser polishers on stone materials has been applied to our own research. As a result, the Center for Applied Physics at the Consiglio Nazionale delle Ricerche (CNR) in Florence developed a laser for use on metals. A long trial period ensued, involving further perfecting of

Figure 5.16 After a very difficult operation involving traction from the front using a steel frame glued onto the non-gilded border, a panel is removed from the frame in which it had been wedged since the doors' creation.

Figure 5.17 Frieze zone from which eight reliefs have been removed.

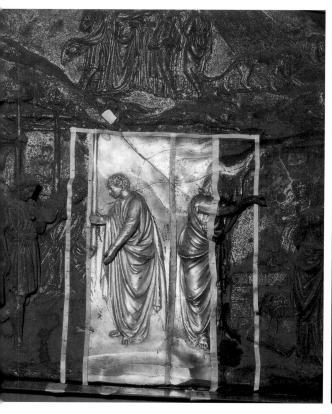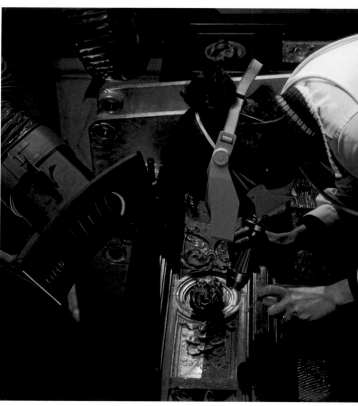

safe and effective laser parameters as well as comparative tests with Rochelle salts. Test parameters included safeguarding of gilt overlays, aesthetic results of the polishing, and typology of residual substances. This research was conducted jointly by our Scientific Laboratory and the CNR.

Tests with the laser have provided results that are comparable to the previously used chemical treatments, in terms of both conservation and aesthetic outcomes (fig. 5.18). The equipment employed produces a controlled laser that can be moved gradually over surfaces (fig. 5.19) with high thermal conductivity, such as bronze, in this case protected by gilding, which tends to limit absorption of light and relative heat.[10] Laser polishing has been completed on the eight extracted elements and on those frieze portions remaining on the doors.

However, the solution to one problem often gives rise to another: thus, the possibility of polishing the reliefs while keeping them *in situ* has meant finding some other solution for insulating these works from contact with the air. Unstable oxides are still present beneath the gilding, and even the laser has left them intact (as perhaps it should). This has highlighted the fact that once the work on the Gates has been completed, they must be protected not only from exposure to external elements, but more specifically from the air, since it is the air that serves as a vehicle for humidity, thus triggering the treacherous cycle of dissolution and recrystallization of salts.

For the reliefs removed from the Gates, as is the case with the ten panels that have been methodically restored and then exhibited at the Museo dell' Opera di Santa Maria del Fiore, insulation from the elements has been rather easily achieved. The panels are now in display cases that are filled with inert gas (nitrogen), which is replaced every six months (fig. 5.20). Providing the same insulation for the reliefs remaining in the doors is a more complex task, given that the inert gas will inevitably escape from the polyethylene cases insulating the individual reliefs, which are attached to the ungilded bronze by means of a special adhesive tape that does not leave residues. A mechanism was needed to produce a controlled stream of nitrogen[11] that is

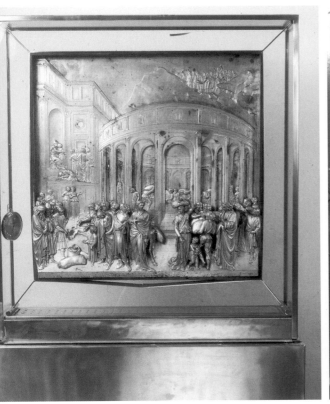

automatically distributed and recycled in the event of escaping gas, so that the atmosphere could be continuously saturated (fig. 5.21).

The present stage of restoration is focused on completing the process of polishing the Gates and then reinserting the extracted reliefs, which will begin in 2007 and be completed the following year. In the meantime, expansion and renovation should continue at the Museo dell'Opera di Santa Maria del Fiore, where Ghiberti's gold will once again shine in a new climate-controlled, high-tech exhibition space. This will nonetheless hardly compensate for the "disappearance" of the Gates from the site for which they were originally conceived and where they were displayed for centuries. However, given what we now know, these conditions are needed if this extraordinary legacy is to be preserved for future generations.[12]

Figure 5.20 The restored *Joseph* panel in its display case filled with inert gas to isolate it from humidity.

Figure 5.21 Cleaned reliefs that remain attached to the Gates insulated under nitrogen.

NOTES

1. Given the impossibility of mentioning all the names of those collaborating in this operation, I shall limit myself to stating that the project was directed by Loretta Dolcini until 1996 and by me from that time to the present. Restoration was initiated in 1980 by Paolo Nencetti and Fabio Burrini, the latter being responsible for the technical aspects of the operation. Participants since 1997 have included Stefania Agnoletti, Annalena Brini (Opificio restorer), and Ludovica Nicolai (outside collaborator). Diagnostic research was coordinated by the Scientific Laboratory at the Opificio, which until 2002 was under the direction of Mauro Mattini, at which point it was taken over by Daniela Pinna. In 2004 a research group coordinated by Salvatore Siano, member of the Florence Consiglio Nazionale delle Ricerche (CNR), was gathered to study the technology used to create the Gates of Paradise.

2. The marble tomb of Cardinal Cossa contains an image of the deceased created entirely of gilt bronze. The beautiful gold overlay was restored to its original luminous state in 1986 by the Opificio, which discovered the gilding under the dark surface of the metal. What had previously been thought to be the "original" patina of the bronze was in fact a later addition aimed at obscuring the brilliant gilding, which has been preserved in excellent condition. In this regard, see *Scheda di restauro sepolcro di Baldesarre Cossa,* in "OPD Restauro," 1988, pp. 121–124.

3. Due to the loss of earlier records from the Archives of the Office of Works at San Giovanni, maintained by the Baptistery, we are unable to completely reconstruct the history of conservation operations on the Gates of Paradise prior to the eighteenth century. Research on work after this period has been conducted at the Archives of the Office of Works at Santa Maria del Fiore by Gabriella Battista, under the coordination of Margaret Haines, in connection with a workshop on the Gates of Paradise, held in Florence in February 2006 and financed by The Andrew W. Mellon Foundation of New York.

4. To mention only two noteworthy cases that have been documented, we can consider Verrocchio's *David* and the analogous case of Donatello's *Atys,* recent restorations of which have revealed an original bronze patina and diffuse swaths of "mission" gilding, which had been obscured beneath a dark film. See pertinent remarks in catalogues of recent exhibitions of two restored sculptures: B. Paolozzi Strozzi and M. G. Vaccari, *Il bronzo e l'oro. Il David del Verrocchio restauro,* Florence, 2003; the version in English is *Verrocchio's David Restored: A Renaissance Bronze from the National Museum of the Bargello, Florence,* Atlanta: High Museum of Art, 2003; and B. Paolozzi Strozzi, *Il ritorno d'Amore: l'Attis di Donatello restauro,* Florence, 2005. The theme of patination on works of sculpture is dealt with more generally by A. Giusti in P. Tiano and C. Pardini, *Le Patine. Genesi, significato, conservazione,* Florence, 2005, pp. 77–82.

5. According to the report by Cosimo Siries, bronze specialist and Director at the Opificio, which at the time was the artistic laboratory to the court, Cocchi stated that "mission" gilding had been used, which was particularly fragile, and that a varnish "of apparently reddish tint" [ref] visible on the work was an original treatment applied by Ghiberti to improve the effects of the gold leaf. It is my opinion that these are merely pretexts for casting the discovery of the gilding in a negative light, on the basis of purely aesthetic reasons. It is actually quite difficult to believe that a technician as expert in bronze gilding, particularly mercury gilding, as Siries was, could have been so mistaken about the techniques employed on the Gates reliefs. This would not be the first or the last time in the country of Machiavelli when a "lie" was used to further a given agenda. A discussion of this eighteenth-century operation and related documents can be found in G. Poggi, "La ripulitura delle Porte del Battistero fiorentino," *Bollettino d'Arte* (1948), pp. 244–257.

6. In 1884 the Florentine journal *Arte e Storia* published an article about the arguments between the painter Marcucci and the bronze caster Lelli regarding the existence of varnishing on the reliefs. Lelli maintained that the dark appearance of the work was due entirely to deposit incrustations, while Marcucci claimed to have discovered at least three coats of varnish, which he successfully attempted to remove, on a section of the southern door executed by Andrea Pisano. Marcucci's observations on the "clear and evident crackling which are characteristic of old oil-based pigment which has been exposed to the sun" are very persuasive, since any attempts to obscure the gilding on the Gates would fit perfectly with the tastes of the time, which supported the "obliteration of any coloration or gilding on sculpture or architecture." This eighteenth-century debate is also discussed in Poggi.

7. At the time, the restoration laboratories at the Opificio did not deal with bronzes. The operation was therefore entrusted to a private restorer who was an expert in this field and who had long been connected with what was then called the Superintendent of Galleries. Scientific consultations were requested from the Istituto Centrale per il Restauro in Rome and from the Facoltà di Chimica (College of Chemistry) in Florence, which would authorize the use of acid in the polishing operations.

8. Production of the copy was curated by the Office of Works at Santa Maria del Fiore and financed by a Japanese design firm. Casting was carried out at the Marinelli Foundry in Florence. Gilding following the galvanic method was chosen instead of the mercury process, due to the toxicity of the latter and related prohibitions under current law.

9. Preliminary diagnostic tests in the restoration were reported in *Metodo e Scienza. Operatività e ricerca nel restauro,* an exhibition catalogue with related bibliography, edited by U. Baldini, Florence: Sansoni, 1982.

10. Descriptions of the laser used on the Gates, as well as scientific verifications concerning functional applications, have been given in various publications.

11. Major contributions in resolving this problem have been made by the Climatological Division at the Opificio, under the direction of Cristina Danti, and by the division's Technical Director, Roberto Boddi.

12. In 2005 a joint scientific research group was formed comprising members from the Opificio, the CNR in Florence, and the Universities of Florence and Bologna, aimed at developing an inhibitor for corrosion on gilt bronzes. The group will also be involved in upcoming urgent operations on the Baptistery's other two doors, which have already been subjected to diagnostic tests that have revealed problems analogous to those found on the Gates of Paradise. In the event that this experimental research, which is estimated to extend over a period of three years, should produce positive results, it may be possible one day to have a direct, contextual experience of the Gates without the "imprisoning" confinement in a climatically controlled environment. Given the gilding's fragility, which inhibits the required periodic maintenance, we cannot exclude the possibility that the Gates may never be returned to their rightful place, where they would soon be covered by a layer of deposits.

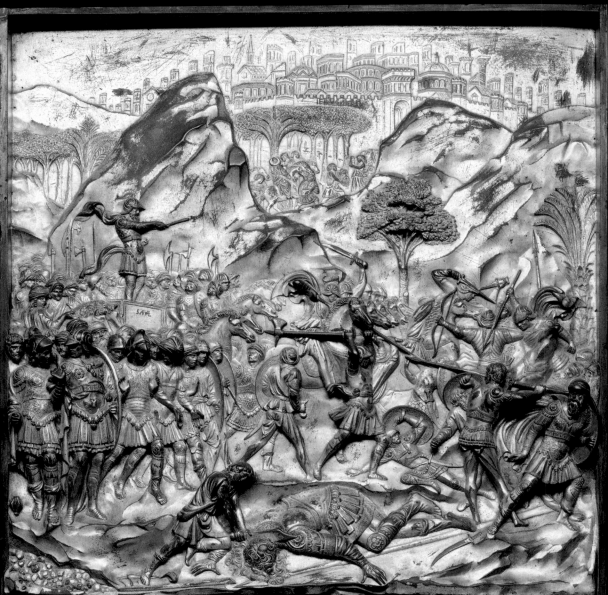

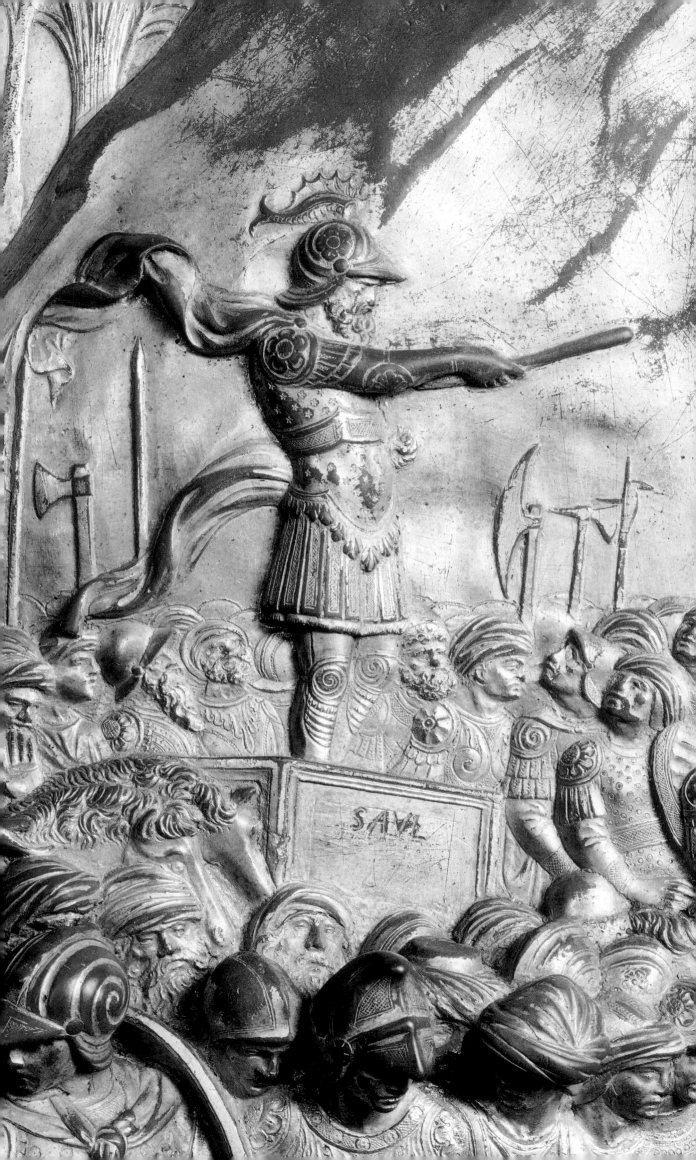

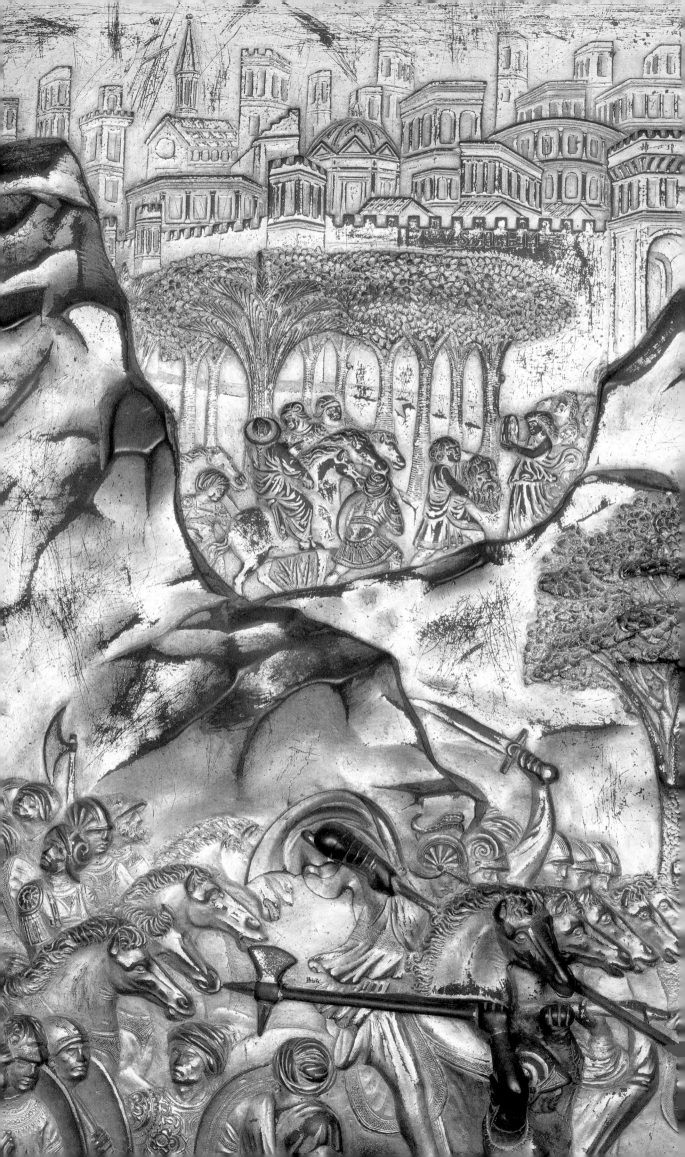

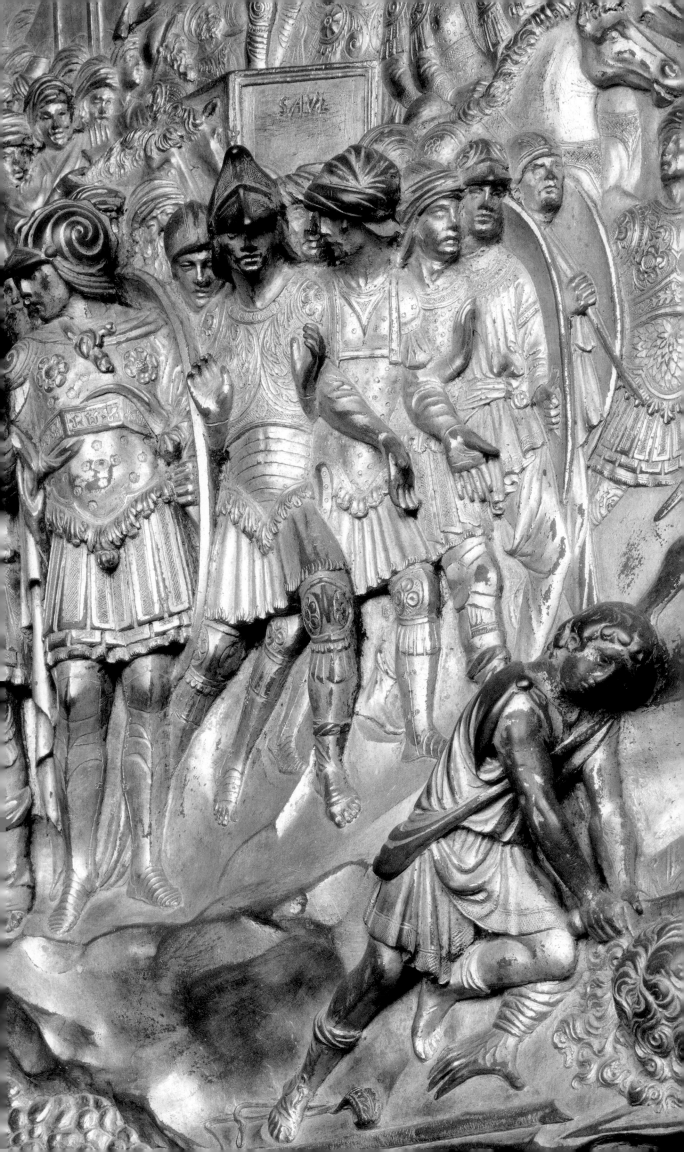

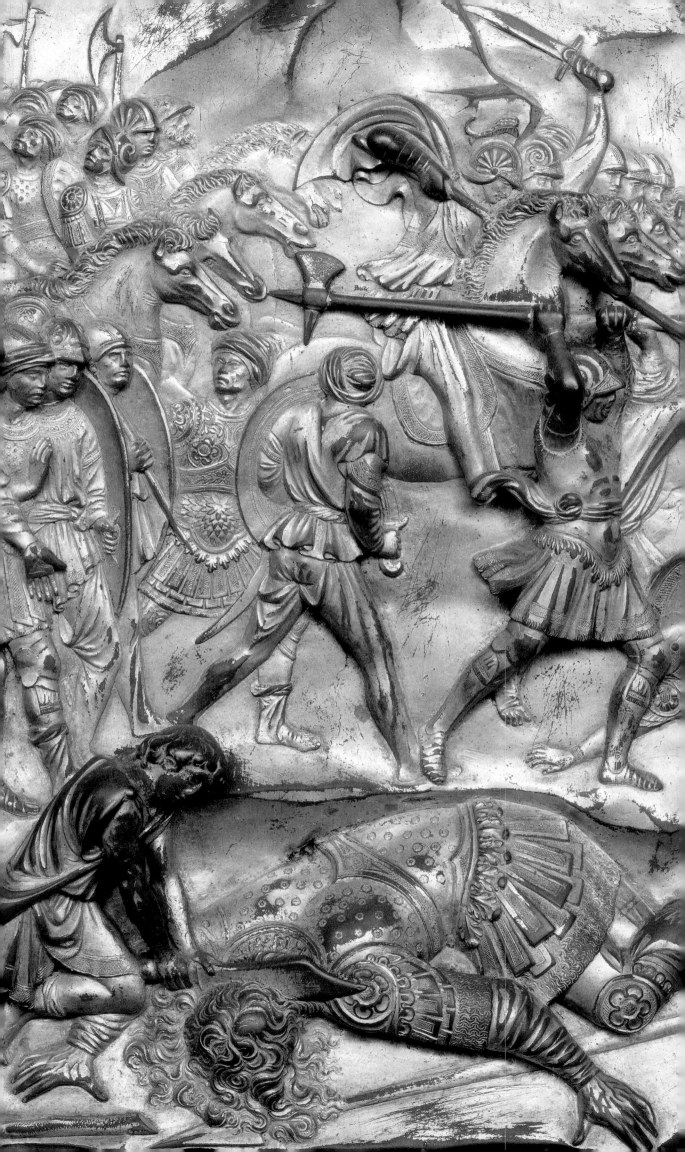

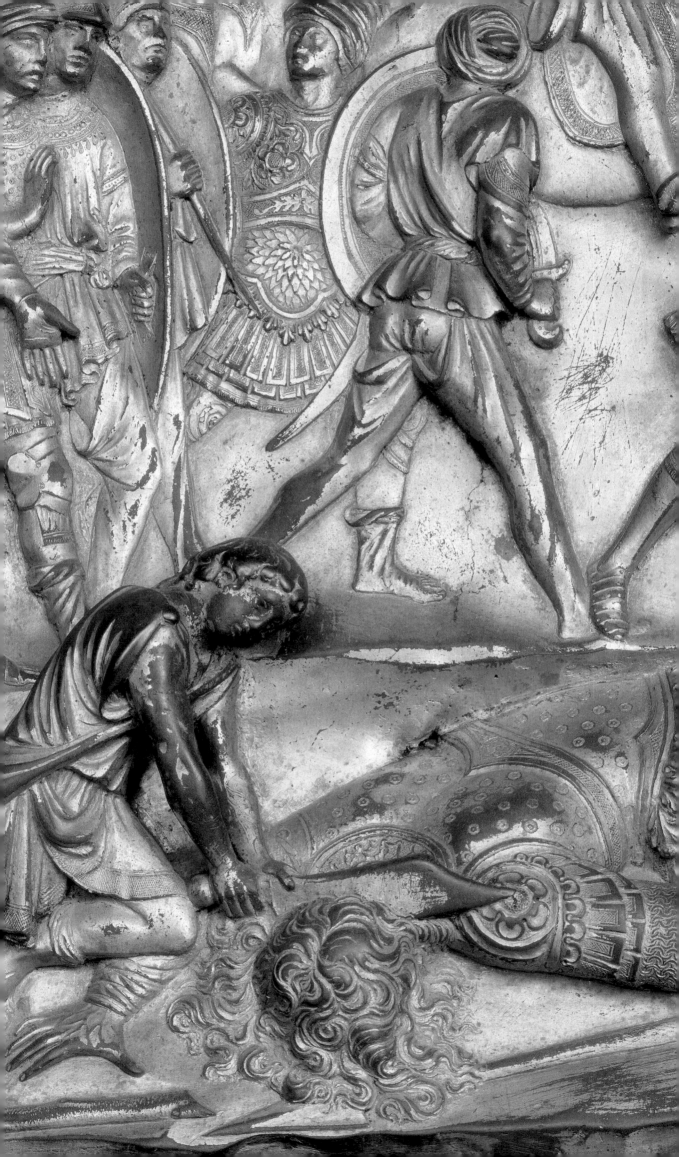

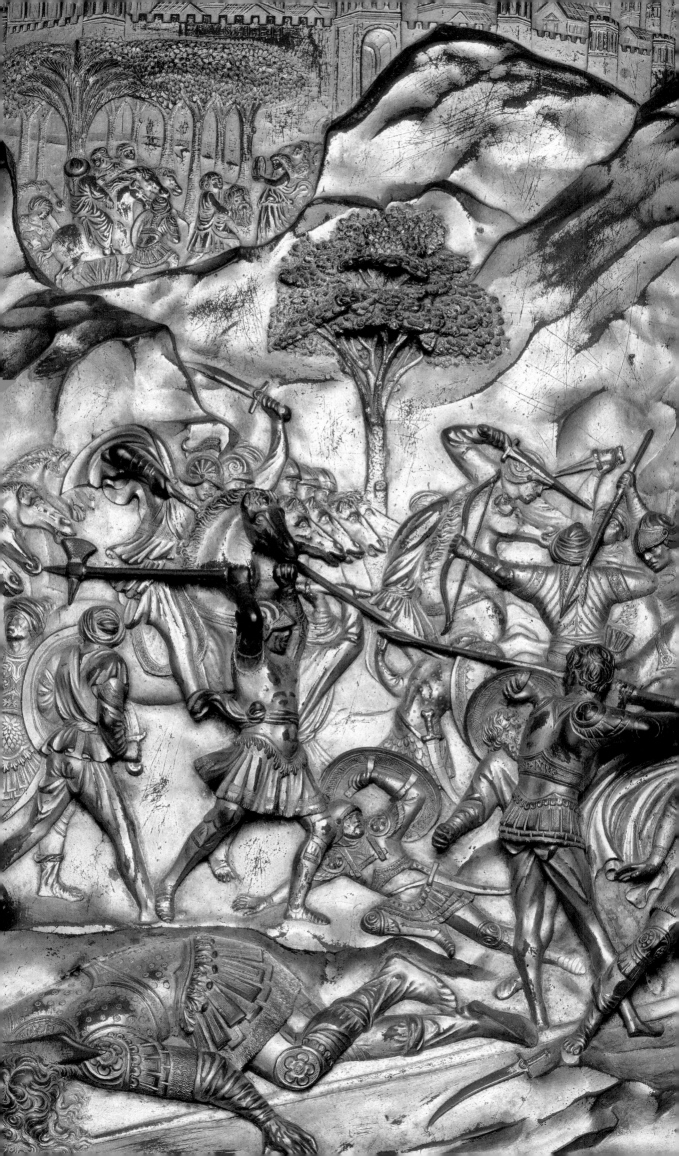

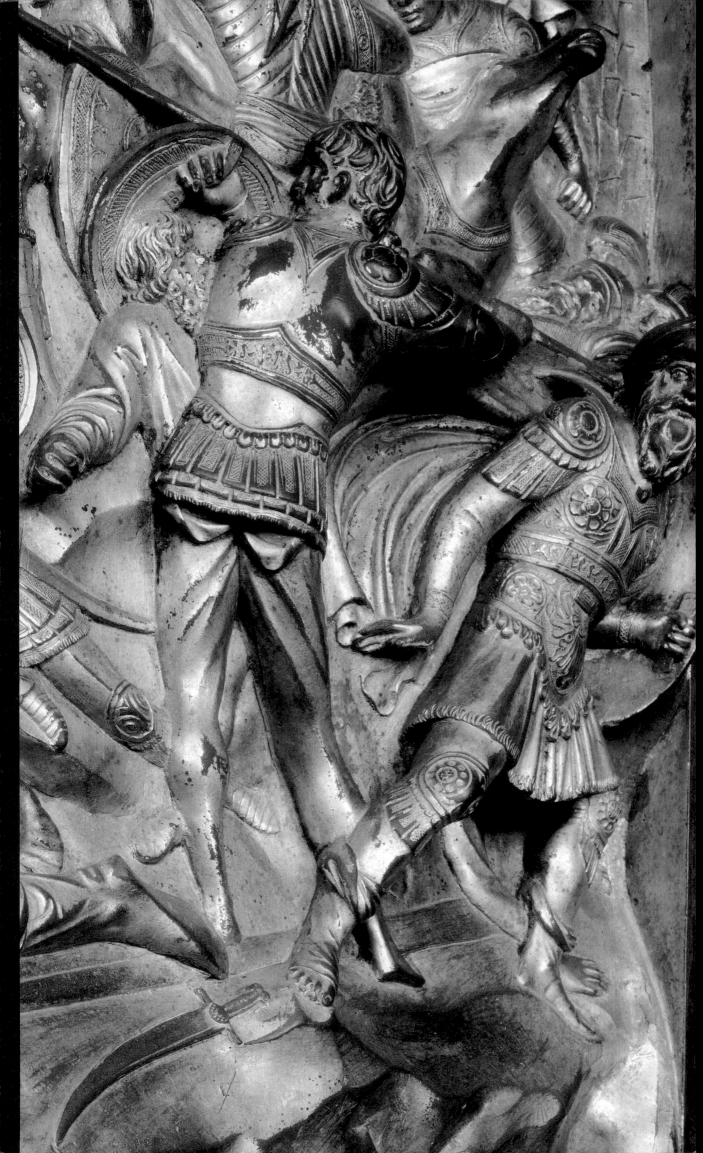

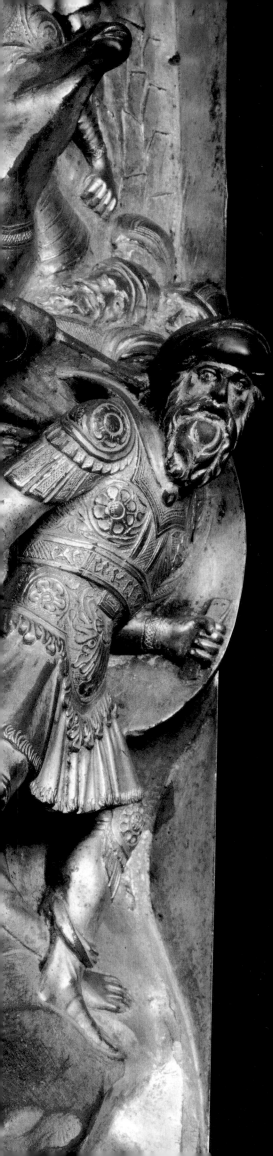

Ghiberti and the Art of Chasing

Edilberto Formigli

Director, ANTEA, Archeometria e
Archeologia Sperimentale, Murlo

Technique

CHASING (the hammering, carving, detailing, and polishing of cast bronze) represents an extremely important treatment in terms of the final appearance of bronze relief sculpture.[1] The process requires an intense material and creative commitment occupying a large part of the entire project. While greater artistic value may be placed on the process of wax modeling used to create the various perspectival planes on which figures are inserted in full relief against a natural landscape or architectonic background, what lends a work its refinement of style is in large part the result of incisions and meaningful lines made with chasing tools, which, as we shall see, are particularly evident in four of the ten relief panels of Ghiberti's Gates of Paradise. Very few of the most minute decorative elements on these panels were actually first executed in the wax model. Some details were in fact only sketched in the wax. An example can be seen in the rosette-shaped studs on the shoulder plates and breastplates of various figures, which were modeled in wax (individual petals were made by pressing small balls of soft wax around the center); however, the correct curve of the petals was achieved with a round-tipped punch after casting (fig. 6.1).

Taken together, all these cold-working touches enhance the overall sculptural quality, highlighting the play of light and shadow by creating greater depth in certain depressions and cavities, while also sharpening edges that had been softened in the casting process. Details worked into the wax are created by using coarser instruments than those employed in the cold-working of the metal. The palette knives and tools used on wax tend to stick to the material, and incisions sometimes leave smudges, ridges, and other unintended details, which are then reproduced in the bronze. Furthermore, bronze casting using the lost-wax method alone cannot faithfully reproduce the microscopic undercuts of the modeling or the sharp edges of the relief.

On the other hand, while it is relatively easy to make corrections in wax, what has already been cast in metal is not easy to change. Thus the artist, who in this case is also a goldsmith, works the basic shapes as well as many of the details into the wax, all the while being mindful of the improvements, additions, and alterations he will be able to make during the cold-working

process. For a successful outcome for the artwork, the tasks of modeling and casting cannot be separated from that of chasing.

Every chaser builds his reputation on the quality of his tools. To this day, engravers buy raw steel rods, which they themselves cut down into custom-sized lengths and then work with grindstones, files, and other abrasive instruments until the point has the desired shape and a completely smooth finish (fig. 6.2).

We can presume that Ghiberti had his own "palette" of chasing tools. Those that he might have needed at any given moment would have been kept in a small can, their points turned upward so that they could easily be retrieved as needed. Medieval and Renaissance iconography attests to this custom, which can still be seen in the workshops of fine goldsmiths today. Any collection of chasing tools can provide rather personal insight about the goldsmith, since these tools are made, as we have indicated, by the artisan himself according to his or her specific needs over the course of a lifetime of work. As such, they may even be thought of as something like an artist's signature.

Hammers and Planishing Punches

Planishing punches are used to compact surfaces by flattening out any irregularities or superficial pores that might have formed during the casting. These tools are also used to smooth porous sections on amalgam gilding, as we shall see. Planishing punches generally have rather large and flat tips. For broader and flatter surfaces, hammers (fig. 6.3) or larger punches are used, while smaller punches with slightly rounded heads are used in narrow or curved sections (fig. 6.4).

Planishing punches are gently hammered and then moved gradually across the surface, slightly overlapping the previously flattened section. These tools are subjected to numerous light blows. The artist's skill during this phase of work lies in his ability to use the tool without leaving any visible trace of individual blows. This may be relatively easy when the surface that is being compacted is flat—however, in areas modeled in relief, painstaking attention is required.

Marks left on the visible sections of panels must be as discreet as possible. Planishing punches are used to close up microporosity (tiny holes) resulting from the bronze casting, to even out surfaces where chisels were used, or to provide overall uniformity. Both this process of finishing and the subsequent coating with a layer of gold make it very difficult to document the tool marks.

Still, there are some points along the flat area to the right of the trumpeting angel in the *Moses* panel (see fig. 2.5) where efforts to smooth out casting porosity remain visible, along with some marks left from what was probably a square-headed hammer (fig. 6.5). Traces of a much smaller, round-headed planishing punch can be seen on smaller sections, such as in the background to the left of the figure of Solomon (fig. 6.6) in the panel depicting the meeting of King Solomon and the Queen of Sheba (see fig. 2.7).

Tracer Punches

Tracer punches have quite a different function than other chasing tools. The tip of this instrument is shaped like the keel of a boat (fig. 6.7) and, like a boat that glides through the water, it leaves a wake: a furrow with two higher lateral ridges. This tool must be held at an angle to the surface while it is inched forward by tapping gently and repeatedly with a hammer (fig. 6.8). In this way, it is possible to trace lines of varying depth and length, including curves, according to the desired design. Often, single blows from a hammer on the tracer punch can be recognized in the imprint (fig. 6.9).

Tracer punches can be used during the process of retouching—for example, to support or accentuate an edge in areas of varying relief, to better delineate the profiles of figures, or to create background effects by using parallel or hatched lines, which are characteristic of Ghiberti and are also found on his large bronzes.[2] Tracer punches can also be used to create completely new details on figures, and thus these tools can play a vital role in the creation of a work of art. Such is the case in some of the wrinkles, facial lines, and details in the hair of some of the figures as well as the lines on the palms of hands and the articulation of fingers.

The use of tracer punches of various sizes is evident on all the panels of the Gates of Paradise. As we have already indicated, tracer punches can be used for a variety of purposes. Probably the simplest and least involved application would be to accentuate lines that have already been traced in the wax to make them clearer and more obvious. The use of reinforcement

Figure 6.7 Liners.

Figure 6.8 Chasing work on a modern reproduction of the *Adam and Eve* panel (Marinelli Foundry).

Figure 6.9 Imprint left by a liner.

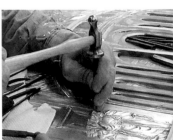

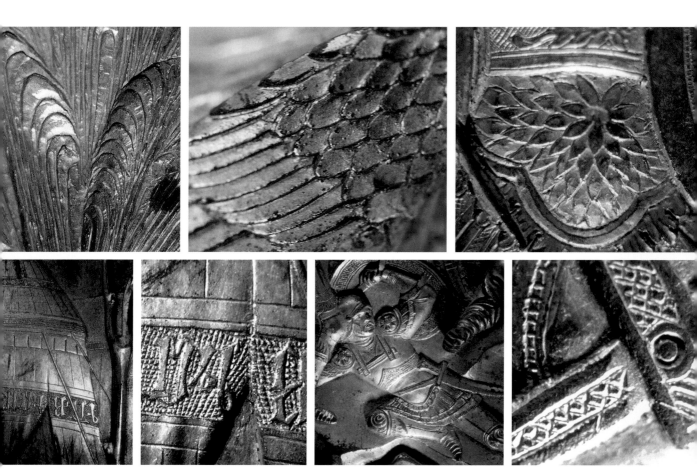

Figure 6.10 Liner chasing on the palms, *Adam and Eve* panel.

Figure 6.11 Liner chasing on wing feathers, *Adam and Eve* panel.

Figure 6.12 Liner chasing on a soldier's armor, *David* panel.

Figure 6.13 Scroll with inscriptions on the tents, *Moses* panel.

Figure 6.14 Crosshatched background on scroll, *Moses* panel.

Figure 6.15 Cross-hatching on soldier's armor, *David* panel.

Figure 6.16 Detail of crosshatching; note missing vertical lines on right.

lines is another phase in the retouching process. These may accentuate gaps or spaces between planes of varying depths or between background and relief figures, as can be seen in the palms and feathers of the angels in the *Adam and Eve* panel (figs. 6.10, 6.11) or on the petal decorations adorning the armor of a soldier in the *David* panel (fig. 6.12).

The creation of decorative crosshatched motifs on the surface of backgrounds is characteristic of Ghiberti's work. The artist used this technique for the background of bands with writing, such as the inscribed scrollwork above the tents in the *Moses* panel (figs. 6.13, 6.14). Cross-hatching is also particularly used on armor (figs. 6.15, 6.16).

Microscopic examination of line motifs reveals the typical superimposition of sequential single blows with the tracer punch. However, in the case of a very fine, close-knit line, the use of a stylus-point engraver should not be ruled out. This pointed instrument is used to trace lines, much in the way a pencil is used for writing. In this case, too, pressure exerted on the tool leaves an impression in the metal without removing material. It seems clear that an engraver's burin or graver was not used.[3]

Such texturing of the background requires that the artist merely select a specific section and then work in an almost mechanical fashion, even if this process is inevitably "humanized" by the occasional slip-up or oversight (fig. 6.17).

Other types of intervention using the tracer punch may demand a true act of creativity, especially when there is no precedent to follow from the wax model or when a specific space does not limit the intervention (as in sections to be filled with crosshatch motifs) and when motifs and details must be invented on the spot. The most crucial instances of this involve additions to faces or other parts of the human body, as in the second figure behind

Joshua in the *Joshua* panel (see fig. 2.6), whose face is visible in the background (fig. 6.18). With a few touches from a tracer punch, Ghiberti "drew" hair around the nape of the figure's neck, his temple, and in his beard and lines on his forehead and neck and around his eyes. None of these details was present on the wax model. With a few masterful taps from the tracer punch, the artist was able to convey the essential physiognomical features of this person. When we consider that the head is no more than a few millimeters in size, we can fully appreciate the artist's great skill in creating miniatures. This could only have been done by an expert goldsmith.

The hair of the young man to the right of Joshua was also created by using a tracer punch. In such miniscule dimensions, the marks left by the tool are relatively deep and lift the surrounding material, adding relief and dynamism to the figure's hair, which had been only superficially indicated in the wax model. Another extemporaneous intervention on this panel can be seen in the series of arches in the upper section, which represent the helmets or headgear of the figures standing in the background. Here as well, with a few touches from the tracer punch the artist created a sense of depth along with the tangible suggestion of a crowd approaching in a procession behind the ark.

A comparison between the original chasing and the retouching made on the modern copy currently at the Baptistery (figs. 6.19, 6.20) helps us understand the importance that chasing plays, not only in providing surface details on figures but also in creating anatomical realism and dynamism.

Figure 6.17 Detail of cross-hatching, *Solomon and Sheba* panel. Note lines extending beyond background area.

Figure 6.18 Chasing details on some of the figures in the *Joshua* panel.

Figure 6.19 Physiognomic details on a figure's head in the *Joshua* panel.

Figure 6.20 Attempts to recover details through chasing on a modern copy.

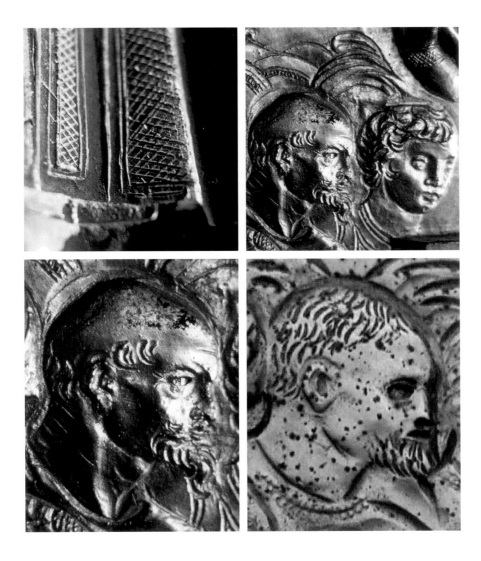

Figure 6.21 Chasing detail on a buckle.

Figure 6.22 Chasing detail on a hand.

Figure 6.23 Chasing detail on the hem of a garment.

Figure 6.24 Chasing detail on the falcon's feathers in the *Solomon and Sheba* panel.

Figure 6.25 "Half-moon" chasing punch.

Figure 6.26 "Circle" chasing punch.

Many other details on Ghiberti's panels were added directly by using tracer punches. These include, among others, boot buckles (fig. 6.21), lines on the palms of hands, the articulation of fingers (fig. 6.22), and the edges and borders of clothing, which are generally quite richly decorated, mainly with geometric motifs (fig. 6.23). All of the details in the plumage and beak of the falcon in the *Solomon and Sheba* panel were executed in freehand chasing work as well over a very cursory wax model (fig. 6.24).

Pattern-ended Punches

Pattern-ended punches serve only a decorative purpose. These tools have a shaped point that is designed so that each hammer blow leaves a particular decorative mark—for example, half-moons (fig. 6.25), circles (fig. 6.26), stars, etc. When such an instrument is used, for instance, to create a background motif, it must be repositioned before each strike of the hammer. Chasing

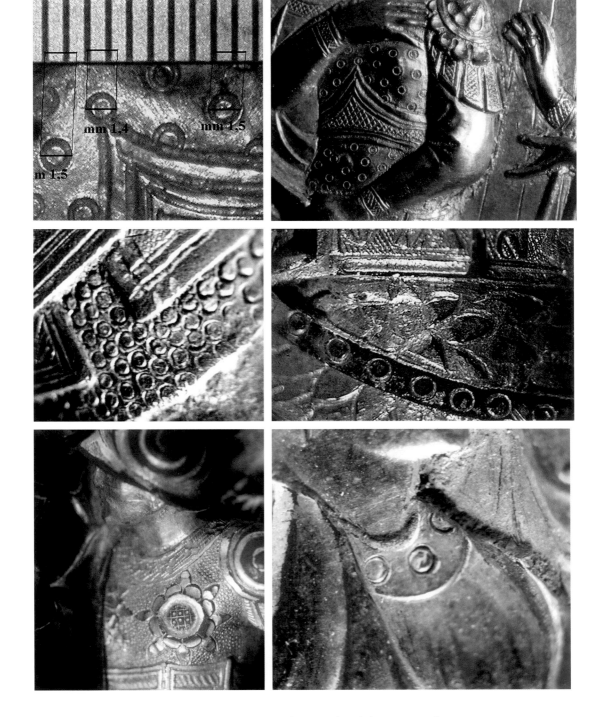

punches used for creating backgrounds on the panels of the Gates of Paradise are generally of three types: circles, rosettes, and stars.

CIRCLES

The circles reproduced on the bronze panels are of three different sizes, created with different sizes of the same type of hollow-faced circle punch. Slight differences in the diameter of a circle made with a circular punch result from variations either in the angle at which the instrument was held or in the force with which it was hammered (fig. 6.27). The punch tip is almost a perfectly circular crown with a concave center.

Medium-sized circles (1.4–1.5 mm) are found particularly on armor, as a motif on cuirasses (fig. 6.28), or as the individual links of chain mail (fig. 6.29) or belt buckles (fig. 6.30). Smaller circles (0.6–0.8 mm) are only seen in rare examples and were used as a subtle background motif tightly positioned one against another (fig. 6.31). Large circles measuring more than

Figure 6.27 Medium circles measuring 1.4–1.5 mm.

Figure 6.28 Medium circle motif on cuirass background.

Figure 6.29 Medium circle motif indicating chain mail.

Figure 6.30 Medium circle motif indicating belt buckle.

Figure 6.31 Small circle motif as decorative background on cuirass.

Figure 6.32 Large circles as decorative element on clothing.

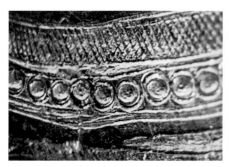

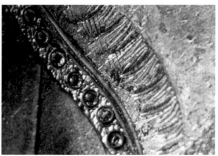

Figure 6.33 Composite circle motif on Sheba's robe.

Figure 6.34 Composite circles on the serpent in the *Adam and Eve* panel.

2 mm are also extremely rare. These would not be used as a background motif but only in special cases as a decorative element—for example, around the neck of one of the figures in the *Solomon and Sheba* panel (fig. 6.32).

COMPOUND CIRCLES

In two cases, the center of a larger circle was later imprinted with a small round-headed punch, thereby creating a concavity in the raised center. This technique was used to further embellish a circle motif or to provide some variety within a given section, as can be seen on the lower border of the lavish robe of the Queen of Sheba (fig. 6.33) and on the body of the serpent in the *Adam and Eve* panel (fig. 6.34).

ROSETTES

Figure 6.35 Large rosettes on a belt, *Solomon and Sheba.*

Figure 6.36 Large rosettes on a horse's bridle, *Solomon and Sheba.*

Figure 6.37 Large rosettes on a horse's bridle, *Solomon and Sheba.*

Figure 6.38 Large rosette background motif on armor, *Moses.*

Five different types of rosettes appear on the panels, each of them produced by the same type of chasing punch: five-petaled rosettes of three different sizes (3, 2.5, and 1.5 mm), six-petaled rosettes measuring 4 mm in diameter, and an eleven-petaled rosette measuring 5 mm.

The particular shape of a rosette formed by any given punch is distinctive, and it is repeated identically, apart from the inevitable distortions. By measuring the dimensions and examining the shape, it is possible to determine whether the various rosettes appearing on images in the same panel, or on different panels, were produced by the same chasing punch. Identifying the particular instrument may be complicated due to the different angles at which the instrument was used. Nevertheless, by selecting the best and

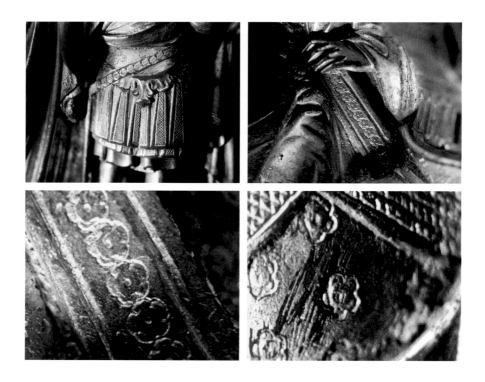

most uniform imprints from within a given group, we can identify common microscopic characteristics. Both rosettes and circles are found in decorative bands on belts (fig. 6.35), fabric, and harnesses (figs. 6.36, 6.37) or as background motifs (fig. 6.38).

FLOWERS

There is only one case in which a particular floral element was used as a decorative motif. In the figure of Joshua on the chariot, there is a series of large floral elements measuring nearly 3 mm in diameter. These were imprinted by the same large chasing punch, the tip of which was incised with five bi-lobed petals (fig. 6.39).

STARS

Stars have five hollow rays in an oval shape and a raised center. This means that on the punch the star's rays were in relief and the tip of the punch was hollowed. Proof that these stars were created by a single punch and not by two instruments—one imprinting the center and the other the rays of the star—is demonstrated by the presence of two superimposed stars, where the chaser must have repeatedly struck the punch (fig. 6.40), and also by the recurrence of the same characteristics in all of the stars.

Stars are a far less common motif than rosettes. Only one type of star is used, exclusively as a decorative motif on the armor of two important individuals—Joshua (fig. 6.41) and David (fig. 6.42)—as well as on the armor of one soldier (fig. 6.43).

Figure 6.39 Floral decoration on Joshua's armor.

Figure 6.40 Star background motif on Joshua's armor; two stars superimposed at upper right.

Figure 6.41 Star background motif on Joshua's armor.

Figure 6.42 Star background motif on armor.

Figure 6.43 Star background motif on a soldier's armor in *David* panel.

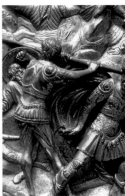

DOMING PUNCHES

In addition to creating rosettes, circles, and stars, another small and rather simple chasing punch with a rounded tip was used to form background motifs, align series surrounding decorative registries, and to create a "rosette" out of four punch marks. This last type of decoration is found on four male figures within the *Solomon and Sheba* panel (fig. 6.44) and on the central angel in the *Moses* panel as the final decoration on a background of parallel lines and cross-hatching.

HALF-MOON PUNCHES

Semicircular, or half-moon, patterned punches were used to indicate the furry lining on Solomon's robe and the chain mail on one of the soldiers in the *David* panel. In the first instance, the punch used was smaller and the curve only hinted at (fig. 6.45). In the second image, however, the imprints are clearly semicircular and are arranged to portray a series of interlocking iron links (fig. 6.46).

More Complex Work

Among the most impressive decorative forms found on the soldiers gracing the panels are the "rose" motifs. These may be used to represent functional parts of armor, but they also have a decorative purpose. The rose motifs, unlike the rosettes, are created through a process that is more complex than simple punching. The process entails altering a form that had been previously established in the wax model using a series of different punches.

One such rose motif can be seen in the form of a shoulder plate on the armor of the first soldier on the lower right in the *Moses* panel (fig. 6.47). The circular base of this decorative element was created first by flattening a ball of fine wax to shape a round-edged disc. This was then applied in wax to the soldier's shoulder, adapting it to the curvature of the figure. The central element was then prepared separately as a small round mass to whose perimeter a series of pear-shaped wax elements were applied two by two. This composition was then stuck on the shoulder at the very center of the wax disc. The rest of the decoration was executed with punches directly on the bronze. This included denting each petal with a round-tipped punch, thus forming a central hollow bordered by raised edges. The gaps between the groupings of two petals were defined with a dotting punch, which was also used to create the points on the disc and at the top.

A similar procedure was used to create the rose motif on the breastplate of the third soldier on the left in the *David* panel (fig. 6.48). Here, the cross-hatched background design was achieved with a tracer punch, which was also used to create the ribbing on the inside of the petals.

The most elaborately decorated part of the armor is the abdominal section, which bears lavish floral motifs (figs. 6.49, 6.50). These are developed around a central point, where a slight dent indicates the navel. Even though the figures here are executed in lower relief, the principal technique remains the same as that applied to the rose motifs: the curves in the petals and foliage are accentuated by chasing the center of cursorily modeled petals and leaves with a round-tipped punch. Thus these background details provide greater relief and three-dimensionality to the figures.

Figure 6.47 Shoulder plate on armor (*Moses*).

Figure 6.48 Complex decorative work on a shoulder plate (*David*).

Figure 6.49 Abdominal section of armor (*David*).

Figure 6.50 Abdominal section of armor (*Moses*).

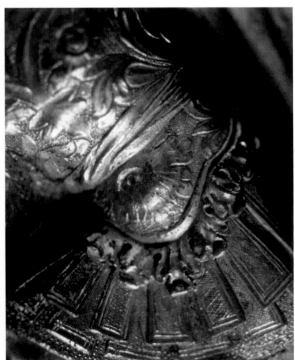

Figure 6.51 Irregular gilt surface with bubbling in the gilded amalgam (experimental reconstruction by A. Pacini).

Figure 6.52 Internal cavity on gilded amalgam layer.

Figure 6.53 Steel burnisher (above), agate burnisher (below).

Figure 6.54 Mercury (or amalgam) gilding: to the left, unpolished surface; to the right, gilt surface polished through burnishing.

Figure 6.55 Burnishing on a flat surface.

Figure 6.56 Irregularity by gilding with amalgam.

Gilding, Burnishing, and Retouching

Gilding using the process of mercury evaporation (mercury or amalgam gilding) often leaves an irregular surface that is marked by ripples, ridges, air bubbles, and even networks of tiny spherical or vermiform creases (fig. 6.51). Even in cross section, the air pockets created by the boiling mercury are quite visible (fig. 6.52). This type of surface tends to absorb light and thus has a matte quality. It is therefore necessary to smooth and polish this layer in order to obtain the shine that is typical of gold. This is generally achieved by rubbing and pressing the surface with extremely smooth instruments called burnishers, which are usually made of steel or agate (fig. 6.53). Gold treated with this method quickly becomes luminous (fig. 6.54).

Microscopic examination of the panels has revealed polishing with burnishers, particularly along flat surfaces and extended background sections (fig. 6.55). But in areas containing complicated reliefs or other, more restricted surfaces that would have been difficult to work with these instruments, the irregularities and porosity of the gilded surface are still readily apparent (fig. 6.56). On a hypothetical note, we might surmise that it would have been more opportune to initiate chasing after the gilding had been completed, since the pressure applied by the punches would help to compact the layer of gold. Microscopic observation, however, has revealed irregularities typical of unchased gilding even in the furrows left by the chasing tools (fig. 6.57).

Only in a few isolated cases, such as the tent ropes, were liners used to burnish the porous surface (fig. 6.58). This retouching, which succeeds the gilding of the surface, could be achieved relatively easily, since it would have

been performed in long, straight lines. In some small areas where the gilding was excessively amassed, obscured details of the modeling were recovered by using small planishers on the gilt surface (fig. 6.59).

The reasons for gilding on an already-chased surface are not of a strictly technical nature. We can advance the hypothesis that over the span of years required to complete work on the ten panels, it would have been far more practical to proceed with chasing on a piecemeal basis and then carry out the gilding of the panels all at the same time.

Comparison of Panels

Our technical research continued with a comparison of the ten panels of the Gates of Paradise with regard to the use of various chasing tools and punches. This comparison may be useful in identifying the possible contributions of Ghiberti's assistants, but only after having studied other works by Ghiberti as well as those by artists who may have been involved in the chasing work. Only then would we be able to recognize characteristics that are peculiar to a particular artist's "palette" of planishing punches and manner of working.[4]

By their very nature, the traces left by planishing punches, and especially by liners, are impossible to associate with specific instruments on the basis of their size or minor irregularities. Traces left by chasing punches, however, can be easily recognized by their particular dimensions and characteristics. Complex motifs that require a specific assortment of chasing tools, such as the roses and shoulder plates, are also very important. In these examples, identification and comparison might be more secure given the combination of many chasing tools and the overlapping phases of work.

SOLOMON AND SHEBA

The *Solomon and Sheba* panel is the work that shows the use of the greatest variety of chasing tools and applications. These include three types of five-petaled rosettes (two types, measuring 3 and 2.5 mm, are found on the same figure), a large eleven-petaled rose measuring 5 mm on the horse in the foreground, three types of circle motifs (measuring 2.0, 1.4–1.5, and 0.6–0.8 mm), various types of linear designs (including single parallel lines and cross-hatching) used in decorating clothing, designs created within hatching by a round-tipped punch, composite circles (on Sheba's robe), and a half-moon punch used on Solomon's robe and on various types of shoulder plates. Of the entire "palette" of chasing tools used on the Gates of Paradise, the only ones not employed on this panel are the six-petaled punch and the star and flower punches.

Figure 6.57 Irregularity of gilding layer within the circle punch imprints.

Figure 6.58 Retouching of tent rope after gilding.

Figure 6.59 Retouching with chasing after gilding.

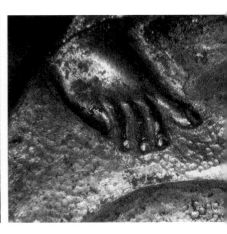

JOSHUA

In terms of the lavish use of chasing tools, the *Joshua* panel is second only to the *Solomon and Sheba*. All three types of circle punches were applied on this bronze, as were two types of five-petaled rosette punches (measuring 3.0 and 1.5 mm). The panel also reveals use of the star punch on the figure of Joshua.

DAVID

The *David* panel shows extensive use of chasing tools. Small and medium circle punches (0.6–0.8 and 1.4–1.5 mm), a large five-petaled rosette punch (3.0 mm), and the only example of a six-petaled rosette (4.0 mm in diameter) —on the breastplate of the horse—are visible in the foreground. A star punch has been applied to the figure of Saul and to the soldier bearing a scimitar beneath the crossed lances (this is the same tool that was used on the figure of Joshua in the previous panel). Half-moon punches were also used on the fringes of clothing.

MOSES

The fourth panel among those showing the greatest application of punch-work is the *Moses* panel. Here we find large five-petaled rosettes (3.0 mm) and medium circles (1.4–1.5 mm). A half-moon punch has also been applied to several shoulder and knee plates.

OTHER PANELS

The remaining six panels show far less chasing work, which, with few exceptions, is limited to compacting treatments on the cast surfaces, enhancing the contours of forms with the use of liners, and crosshatching some minor decorative work. Entirely absent in these panels are the rosette, circle, and star motifs or any more complex decorative elements. These panels would thus be of limited interest for studying possible interventions by Ghiberti's assistants.

On the *Abraham* panel, we find a crosshatched motif applied to the tent and to the figures' clothing, in addition to highlighting the outlines of trees and the feathers of the angel's wings.

The *Jacob and Esau* panel shows scant evidence of chasing work, aside from the detailing of the lamb, the dogs' fur and collars, and the woman lying beneath the draperies.

On the *Adam and Eve* panel, cross-hatching has been applied on one of the angels, and the same composite circle motif used on Sheba's robes has been applied to the serpent. Aside from these elements, there is some highlighting of contours, which in this case required particularly painstaking work, most notably on the various plants and also on the angels' wings.

Despite the presence of numerous personages on various planes in the *Joseph* composition, decorative interventions are limited to the use of crosshatching on the small figures in the upper portion of the panel.

On the *Cain and Abel* panel, chasing work is restricted to the use of liners, particularly on plants and on the hut.

Chasing on the first four panels stands out from that on the other six panels in the lavish details and the variety of tools employed. These panels were in fact positioned on the lower part of the work. The *Solomon and Sheba* panel and the *Joshua* panel reveal the most elaborate punchwork, followed by the *David* composition and the *Moses* panel. The need to represent a great number of figures on these four panels, including many soldiers,

only partially explains the difference. Other panels, such as the *Joseph* relief, include figures whose clothing could have been more elaborate or decorated through chasing. Evidently, the location of the four more lavishly decorated panels on the lower section of the doors was not an accident. Ghiberti must have taken into account that such minute details could only be seen from very close.

NOTES

1. For the techniques and instruments used by goldsmiths in the *Quattrocento*, see "Le tecniche e gli strumenti," in M. Bernabò, ed., *Oreficeria nella Firenze del Quattrocento,* exhibition catalogue, Florence: Studio per Edizioni Scelte, 1977, pp. 203–232. For medieval techniques and instruments, see E. Brepohl, *Theophilus Presbyter und die mittelalterliche Goldschmiedekunst,* Leipzig, 1987, which is in Latin with a German translation and includes many drawings of techniques and instruments. For general technical information, see *La sculpture, méthode et vocabulaire,* Paris: Imprimerie Nationale, 1978, pp. 640–653.

2. For information on the inscribed scroll on the bronze of S. Matteo, see S. Agnoletti et al., "Il restauro della statua bronzea del S. Matteo di Lorenzo Ghiberti da Orsanmichele in Firenze," in *OPD Restauro* 17 (2005), p. 63.

3. For the backgrounds traced with hatching or crosshatched etching on a copper plate, a burin or stylus-point engraving tool was used (the latter process is referred to as drypoint). The burin is a tool that is furnished with a wooden handle and a steel engraving point that creates metal shavings as it cuts into the metal surface. The tool is held in the palm of the hand and is pushed along the surface, generally with a continuous motion. Drypoint, on the other hand, does not create metal shavings. The engraving tool is held in the hand like a pencil. While its steel point is used to mark the surface, the mark that is left is caused by pressure, not *intaglio* or cutting.

The burin is the preferred tool for engraving on metal plate for the sharp, clean incisions it makes due to the material's flat surface and uniform strength. Chasing tools are favored for working on objects that have been cast or molded, which are generally characterized by an undulating surface and variable metallic consistency due to the microporosity arising from the casting process. A stylus may be used in either case; however, the imprints left by this tool are not particularly deep.

4. With respect to the range of issues concerning Ghiberti's collaborators, see M. G. Ciardi Duprè Dal Poggeto, "I collaboratori della Porta del Paradiso," in *Lorenzo Ghiberti, materia e ragionamenti,* Florence: Centro Di, 1979, pp. 392–404.

Prophets

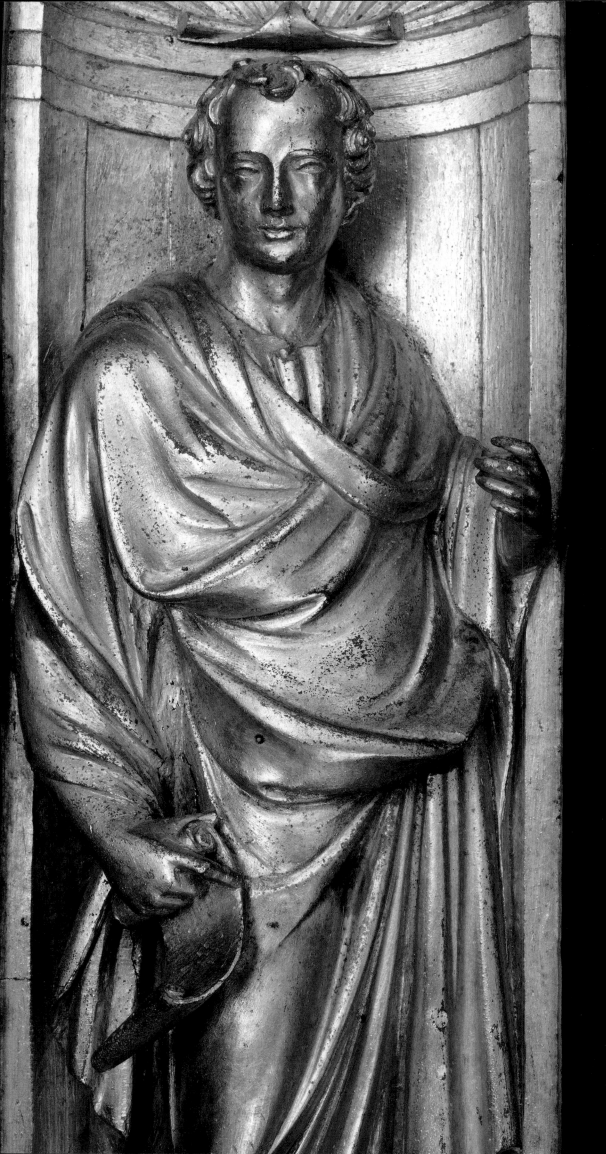

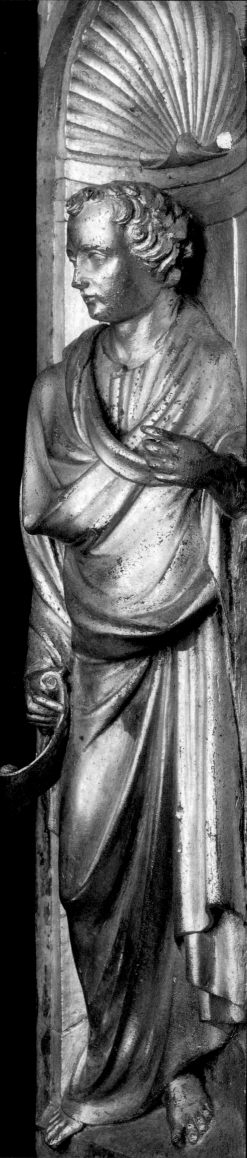

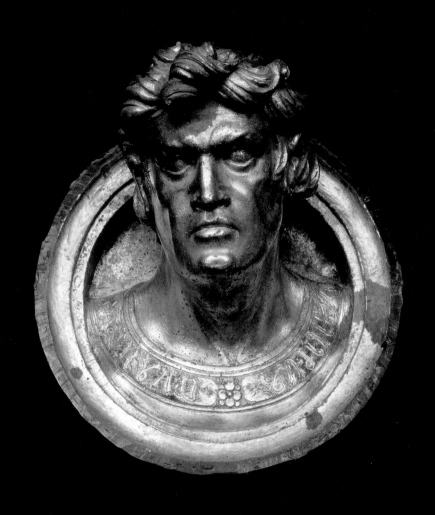

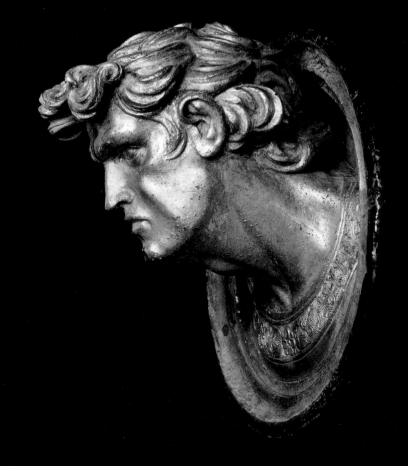

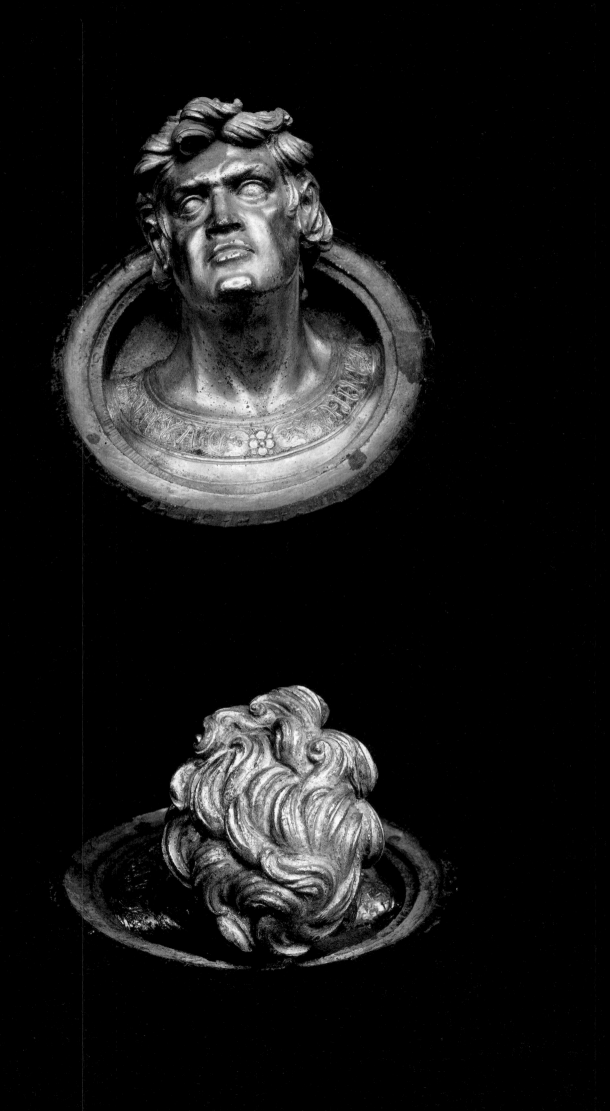

Casting the Panels of the Gates of Paradise

Salvatore Siano

Istituto di Fisica Applicata "Nello Carrara,"
Consiglio Nazionale delle Ricerche

Piero Bertelli and Ferdinando Marinelli

Fonderia Artistica Ferdinando Marinelli

Marcello Miccio

Soprintendenza per i Beni Archeologici della Toscana

Introduction

"I EXECUTED THIS WORK with the utmost diligence and discipline, and it is the most singular creation that I have produced, reflecting every art, measure, and invention at my disposal."[1] This is how Ghiberti described the Gates of Paradise in his *Commentarii*. These writings, which record the principles behind Ghiberti's painting and sculpture—disciplines that at the time were shifting in the general perception from craft to art—also highlight the major role the artist played in the early Renaissance.

Aside from a few references to metal alloys, Ghiberti's account does not touch on his rediscovery of art foundry techniques from the age of the "white temples,"[2] nor does he discuss the metalworking processes he used. Perhaps he did not yet consider it the right time to try to legitimize this type of work, or he may have planned to cover these methodologies at some later point in the *Commentarii*, in the portion that was left unfinished. It does not seem likely, however, that he failed to make reference to the significance of metalworking and the methods used—much discussed by a range of authors in the following century—solely because he did not wish to reveal his processes or the nature of his methodology. This is even more obvious if we consider that by the early fifteenth century, after the second Baptistery doors were created, Ghiberti's workshop had become a reference point for many others ("I have received great honors in their works") and was undoubtedly the period's most important training center for artistic casting. Such renowned early Renaissance artists as Michelozzo, Donatello, Paolo Uccello, and others were members of the shop.[3]

Ghiberti's pride in playing this role likely motivated another glaring omission from his commentary on modern art—there is almost no information about his own training, with the exception of a vague reference to his family life. He states, "My soul was focused mostly on painting," and then a few lines later he celebrates his victory in the contest for creating the second Baptistery doors in bronze, his "first work" of sculpture.[4]

Despite these omissions, Ghiberti's account is the only source that offers any concrete insight into the metalworking techniques of the fifteenth century, information gleaned chiefly from his chronology and the detailed description of his works (e.g., the artist's "hierarchy" of materials: bronze,

brass, fine brass, and gold). In fact, no studies or archival documents exist containing information on casting techniques, despite the impressive bronze production of the period. The only contributions other than Ghiberti's are found in the *Zibaldone* of his nephew Buonaccorso, and the notes of Leonardo da Vinci in the *Codice Atlantico,* which can be dated to the end of the century and which in any case focuses on the preparation of molds for casting bells and artillery.

What was drawn from "ancient commentaries," Pliny's encyclopedic *Natural History,* Theophilus's treatise *On Diverse Arts,* or from other lost sources —as well as what was newly introduced—cannot be derived from direct or indirect testimony. Neither can workshop techniques simply be reconstructed by transferring technical descriptions from Gaurico, Vasari, Cellini, and Biringuccio[5] to the prior century. Even in their own context, these texts require interpretation, verification, and integration regarding many working procedures.

Technological Study of the Gates of Paradise

For several decades now, greater credence has been given to the idea that a history of art foundry techniques can be best written by using a multidisciplinary scientific approach based on close study and instrumental analysis of individual pieces. The call for experimentation has been growing louder as well. Using these methods, a significant amount of information on ancient processes has been assembled, and the first important results with regard to Renaissance bronzework are beginning to emerge, although we are far from painting a complete picture and disagreements and often debatable interpretations abound.

Various issues make reconstructing technical processes through the study of the original work, macro- and micro-structural peculiarities, compositional analysis, and experimentation especially complex. Additional related factors arise from the inherent multiple interpretations of archaeometric data, the difficulty of determining reliable and representative analytical data, and the obstacles encountered when trying to plan, conduct, and summarize a multidisciplinary study. Even in the face of valid analyses, conclusions too often take the form of distinctly separate summaries in which each party attempts to provide interpretations that are cohesive in and of themselves, thereby inevitably sidestepping the problem of interaction, agreement, and harmonious coexistence with the others.

The approach to studying Renaissance bronzes endorsed by the Opificio delle Pietre Dure in Florence was developed with an awareness of these issues and of the need to get past them, and of the limits of planning and interpretation that run the gamut from "too academic" to "too empirical." A working method was chosen based on ongoing coordination of the various disciplines and professionals involved, thereby ensuring interaction and mutual agreement on the ensuing results.

Study of the processes used to create the Gates of Paradise—the metalworking knowledge that developed in Ghiberti's workshop—comprises a fundamental step in this research. The chance to carry out an accurate study of the ten main panels and eight ornamental panels removed for restoration, together with the availability of advanced analytical methods, allowed for exhaustive comparison, which means we avoided an entire series of limitations encountered by past work-groups due to certain specific technological aspects of this complex masterpiece.[6]

Provided here is a summary of the interpretive developments regarding techniques for casting the panels. These were formulated on the basis of information drawn from studying and analyzing the alloys of nine of the ten main panels, X-rays of panel VIII (*Joshua*), experimentation, and information that emerged through metallurgical studies undertaken in the early 1980s.[7]

The Preparation of Waxes

On the backs of the panels are indentations that clearly, if somewhat roughly, follow the projections on the fronts. For example, on the back of panel II (*Cain and Abel*), one can see a negative image of not only the three figures that project from the lower section of the front (a pair of oxen and the two representations of Cain), but also of all the rest of the panel, including less prominent areas such as the sacrifice scene (fig. 7.1).

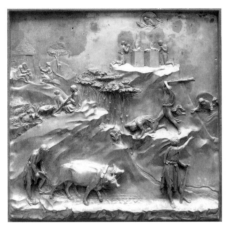

Figure 7.1 Comparison of the relief on the front and the indentations on the back of *Cain and Abel* panel.

These indentations are characteristic of indirect lost-wax casting, in which a positive wax relief to be cast in metal is produced using a negative mold of the initial model, which has been sculpted from a plastic material (wax, clay, etc.). In the case of these panels, creation of a mold indicates that the model's projections were cut when necessary, as were any undercuts that might have stood as impediments to extraction.

The use of the indirect technique, defined clearly by Leoni as use of a "salvageable mold,"[8] is also supported by the presence of numerous other morphological details on the backs of the panels, the surfaces of which quite closely resemble the surfaces of the wax models used for casting, with the exception of areas that were chiseled off or filed down.

The presence of numerous drips, brushstrokes, and manual thickening of the corners, with fingerprints visible in some cases (fig. 7.2), confirms that the various steps involved in creating the wax relief were performed from the back of the relief, working with a horizontally positioned mold. Furthermore, such evidence suggests certain methods were also used to thicken the wax. Specifically, the regular and leveled profiles, together with the presence of corners that are "reinforced" through local application of wax, suggest the use of the so-called "slush" technique, usually performed by first brushing on a thin wax layer in order to best capture all the surface details.

The "slush" phase continues by filling the entire mold cavity with liquid wax and waiting for it to harden to the desired thickness along the cavity walls. Once this process has been completed, the excess wax, while still liquid, is poured out into a container. In this way, uniform thickness is achieved, with the occasional exception of some corners where the hot wax has shifted, leaving thin spots. When this occurs, wax must be applied manually

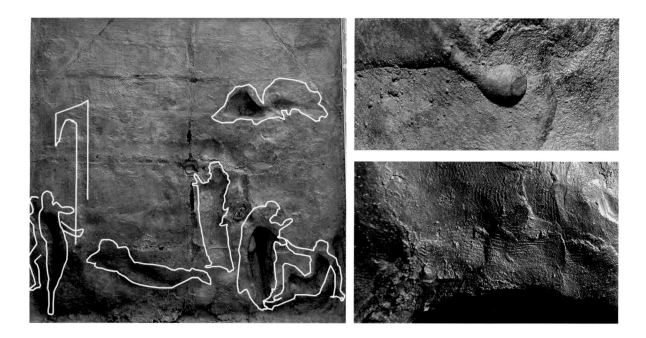

as reinforcement. It is clear that this was done on some of Ghiberti's panels (see fig. 7.2).

When numerous brushstrokes are detected along with the morphological characteristics discussed above, this indicates that additional liquid wax was applied either locally or over the entire surface after the slush and the possible reinforcement of the corners. This final step is performed after it has been determined that the first slush needs to be thicker. Conversely, if there are no brushstrokes and the profiles reveal abrupt undulations, sometimes accompanied by fingerprints, it is likely that the walls were thickened (in selected places or overall) by manual application of soft, pliant wax.

This second type of application applies to panels VI (*Joseph*), VII (*Moses*), VIII (*Joshua*), IX (*David*), and, at first glance, III (*Noah*), although such manual application is not always easy to determine, since the traces left vary greatly depending on the plasticity of the wax and the technique of the person applying it. In fact, this is starkly evident only on the back of panel VII, where we see the kind of deformation that frequently results from a thumb applying pressure, in addition to a large number of actual fingerprints (fig. 7.3).

There are, however, traces of brushstrokes on all or most of the back surfaces of panels II (*Cain and Abel*), IV (*Abraham*), and X (*Solomon and Sheba*). On panel X, the brush marks are not very visible due to the use of either

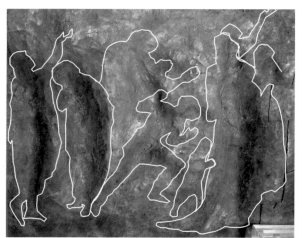

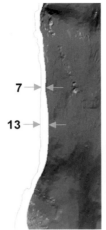

lumpy wax or coarse earth on soft wax. Representing a middle ground between these two possibilities are panels I (*Adam and Eve*), which has traces of brushstrokes on the upper part and shows signs of manual application on the lower part, and V (*Jacob and Esau*), which was painted only at the very top and bottom, with a small amount of manual activity in the remaining central area.

The use of the salvageable model technique and these conclusions about wax processes were further confirmed by studying three-dimensional digital images. For example, figure 7.4 shows details of the profiles of panels I and VII that clearly show strict front-to-back correspondence, and the greater grading of the front than the back, as compared to the unjustified variations in thickness that can be seen in panel VII, which may be attributed to manual deformation. In this last case, the presence of such strong modulations in which the wax is spread, as well as an average thickness that is less than those of the other panels (I, II, and VI were studied), led us to believe that the entire process had been performed manually. Such a significant conclusion would, however, require further verification and instrumental analysis of all the panels that present characteristics of spreading in their surface profiles.

Assuming that the above interpretations are correct, we can easily imagine what happened next, based on the standard art foundry processes still in use today. The wax relief was made in the mold and then was probably extracted and completed by working on the front, where projections that had previously been detached from the model and created separately would then be attached. Any background areas that had been left in rough form in order to allow the cast to be extracted would then be modeled directly. Various details would also be subjected to refinishing. The last step before covering the wax panel with an earth-based casting material (investment) would have been to create the channels, or spruing.

Spruing and Gating

X-ray studies of panel VIII (*Joshua*), together with information already gathered in the 1980s on panels II, VI, and IX, indicate the presence of macroporosity concentrated in the upper region of the bronze relief (fig. 7.5). The frequency of this phenomenon leads us to exclude the idea that the molds were positioned horizontally during casting, although it does not allow us to determine whether the molds were perfectly vertical, either in a natural position (erect) or upside down.

Information from earlier radiographic studies indicates "upward bubbling" —evidence that the molds were vertically positioned—with the understanding

Figure 7.4 Comparison of the profiles and thicknesses of panels I (*Adam and Eve*) and VII (*Moses*).

Figure 7.5 Negative radiographic portrait of panel VIII (*Joshua*) obtained by assembling six 30–40 cm² films.

that the figures remained in their natural (or viewed) position. However, the weighty issue of establishing how compatible this interpretation is with the detailed traces of spruing found on the backs of all the panels was not dealt with, nor were theories formulated on the configuration and dynamics of the casting. Before turning to this important point, we present the evidence.

Strange markings (fig. 7.2) can be discerned on the backs of all of the panels. These may be interpreted as traces of channels that ran along the surface. Losses due to their removal and chisel marks produced during the cleaning phase indicate that molten metal flowed through these channels, which connected to the main cavity at various points. Figure 7.6, showing the backs of panels VIII (*Joshua*) and IX (*David*), demonstrates that the arrangement of such channels can be deduced from the traces. Highlighted in white on panel VIII are the principal areas where liquid metal traveled through the channels and the relief cavity. These correspond to the surface losses and marks mentioned above.

This is extremely significant given that no other similar cases of channeling on bronze works have been documented. Nowadays—and we believe this to be true for the past as well—spruing is arranged to run upward (siphon-style) and is joined to the casting surface at a certain angle of incidence relative to the perpendicular direction—usually between 0° and 60°—and in any case never parallel (90°), as we find here.

While examining the peculiar configurations of the imprints, we first wondered whether these marks might truly correspond to spruing, given that during initial examination the possibility had been raised that the traces had been left by a support structure for the wax made from pieces of cane that burned off during the firing of the mold and the filling of metal during casting.

Closer observation of the surfaces and the residual paths of the channels visible on panel IX (*David*) allowed us to verify that this structure, applied when the wax-thickening process was completed, was basically made from pieces of cane of an appropriate diameter that were cleaned and cut to size. These were placed on the surface, joined together with soft wax, and then fixed in place with other small daubs of wax (fig. 7.6). Nevertheless, given the peculiarity and significant variation among the marks left when they were removed from the backs of the panels, and the imperfect adherence of the cane to the wax panel that these suggest, we can exclude the possibility that the structure was intended to offer support. Instead, it may have been of some help during the extraction of the wax relief from the mold and its later manipulation, but its primary purpose was to serve as a spruing and gating system.

Based on the information above, we can interpret the use of channels adjacent to the panel's surface as an ingenious solution that allowed the artist to overcome the difficulty of casting rather thinly across the width of the panel, which was further complicated by the use of a quickly hardening alloy (see below). Ghiberti probably went through a long period of experimentation in order to come up with this optimal system.

In addition to contact between the panel and the channels behind it, further observation turned up traces of predictable frontal connections between the projecting heads of figures and the main surface of the panel but no other gates, except for perhaps an additional channel on the back of panel II (*Cain and Abel*) and panel VI (*Joseph*).

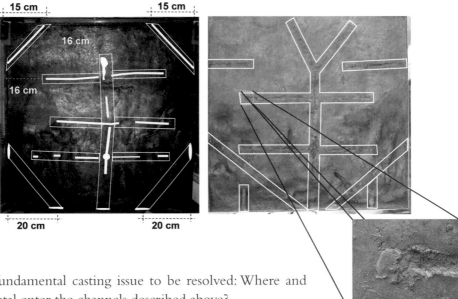

Finally, there is a fundamental casting issue to be resolved: Where and how did the liquid metal enter the channels described above?

There are two possible approaches. In all cases, the central channel and the two corner channels in the lower portion of the panel (fig. 7.6) appear to be sized to meet just below the base, and it would thus seem that a natural entry point—what Tuscan casters refer to as a *bevera* (funnel-shaped cup for introducing the metal)—was located here. In this case, casting would have occurred with the metal flowing downward into the mold with the figures positioned upside down. Conversely, if casting took place with the panels in their natural position, upward or siphon casting must have been implemented. If we exclude, due to its obvious impracticality, the possibility that metal might have flowed from a single entry point at the bottom corresponding to the previously mentioned point where the channels met, the only remaining possibility is that the system was filled through contact with another network of channels situated farther from the surface.

There is little to support this latter theory that channels were inserted along the panel walls. In an earlier work, we theorized that such a longitudinal system might have resulted in creating an air-hole that would have helped reduce the number of bubbles in the cast metal if the mold had not been perfectly vertical but positioned at a slight angle.[9] Despite its complexity, this possibility was taken into consideration, and since it bears greater similarity to the modern downward-casting technique, it promised more likelihood of success during the planned experimentation phase.

Alloys

There is a marked difference between the composition of the alloys used in the panels of the Gates of Paradise and those used by Pisano in casting the first door, by Ghiberti on the second door, and by Ghiberti for the framework of the Gates of Paradise themselves. Even though quaternary alloys of copper (Cu), zinc (Zn), tin (Sn), and lead (Pb), with significant traces of iron and antimony, were used for all, there are enormous variations in their relative weight percentages. Instead of the large amount of zinc present in earlier works (approximately 10 to 20%), which together with tin and lead amounted to somewhere between 17 and 26% total white metals, it seems that a bronze alloy with a low content of alloying elements was created especially for use in these panels. Table 1 provides figures for three panels, selected to give a representative overview of the whole.

Figure 7.6 Diagrams of the spruing on panels VIII (*Joshua*) and IX (*David*), originally made with pieces of cane. The white areas in the first image indicate areas of contact with the wall of the relief, as shown by signs of extraction and scalpel cuts. The detail of the metal surface at the right shows traces of the wax used to attach the end of a piece of cane.

SAMPLE	Cu wt%	Sn wt%	Pb wt%	Zn wt%	Fe wt%	Ni wt%	Ag wt%	Mn wt%	Au wt%	Co wt%	Sb wt%
VII (*Moses*)	93.51	0.13	1.14	3.78	0.13	0.14	0.06	0.00	0.00	0.00	0.13
White metals		5.05									
I (*Adam and Eve*)	91.12	2.09	1.37	3.43	0.47	0.22	0.05	0.00	0.00	0.03	0.44
White metals		6.89									
IX (*David*)	95.19	0.70	0.84	1.10	0.38	0.17	0.05	0.00	0.00	0.02	0.50
White metals		2.64									

Table 1. Composition of the alloys for three panels.

Panel IX (*David*) contains the lowest alloying element content, with a total of 2.64% white metals, while the percentage in the others falls somewhere between the percentage for panel VII (*Moses*) and the percentage for panel I (*Adam and Eve*), which has a higher alloying element content.

These alloys lend themselves well to mechanical intervention, such as work with a punch or chisel, and on account of their high copper content

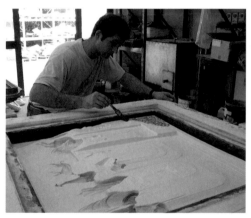
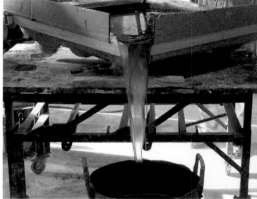

a b

Figure 7.7 Experimentation in the foundry—preparation of the wax reliefs and the spruing: a) brushing the mold with wax; b) slushing; c) forming the projections; d) finishing the front; and e) attaching spruing.

and low lead content also lend themselves well to mercury–amalgam gilding. The low alloying content and minimal amount of lead, however, contribute to low fluidity and relatively high hardening temperatures, both of which make casting difficult. Like the choice of spruing, the choice of alloys was the end result of extensive preparatory study by the artist. It is therefore reasonable to believe that the spruing system was a direct consequence of the choice of alloy.

Experimentation

Once the studies described above were completed, we believed it would be useful to perform some specific casting experiments, in order to more closely examine the relationship between the information collected and the various identified phases of the work and, above all, to offer a cohesive interpretation of the configuration of the casting.

To begin, two "slushed" wax copies were made from a silicon rubber version of panel V (*Jacob and Esau*), with the most protrusive parts of the figures at the bottom removed. Following the conclusions of earlier study, after slushing it was necessary to reinforce some corners. Furthermore, the

first of the two reliefs had to be thickened manually throughout because the time required had been underestimated.

The spruing contacts revealed by X-ray on the back of panel VIII (*Joshua*) provided us with a model. The sprues were made of canes joined to one another with wax. Small quantities of wax were then spread in the cavity between the pieces of cane and the panel walls in order to ensure thorough contact and subsequent transfer of liquid metal during casting.

Once the reliefs were removed from their molds, only one of the two was subjected to direct finishing on the front, while the other was left as it was. We then proceeded to apply a branched spruing system to the back, using the two different methods described above and the corresponding vents. For the first test, in both cases we chose to maximize the number of sprues, taking advantage of the frame as much as possible so that the attachment points would be rendered invisible after chasing. Figure 7.7 summarizes the various experimentation steps described above. Please note that in the photo in figure 7.7e, the downward branched spruing is on a copy of panel VI (*Joseph*), which was then replaced by another copy of panel V (*Jacob and Esau*) during experimentation.

In order to begin simulating the investment of the originals, we performed a series of preliminary tests using an earth-based slurry as similar

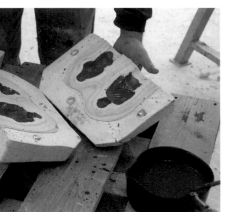
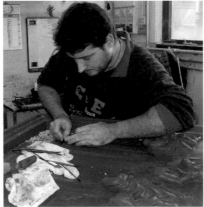

c d e

as possible to the one found in small quantities on the backs of the panels. This mixture consisted of a clay binder, sand, and plant fiber (straw). The combination of materials, completely different from the substance used in present-day casting techniques (plaster and slaked plaster), made construction of the investment very painstaking and time-consuming.

This was followed by carefully brushing the wax with thin layers of a finer slurry—without any plant fiber—waiting after each application for the preceding layer to dry gradually and completely. Given how critical this work was since it risked compromising the entire experimental phase, we limited ourselves to creating a layer of earth only a few centimeters thick on the panels (figs. 7.8a and 7.8b) and then completed construction of the investment with a modern substance, which was also used to cover the second panel. It is interesting to note that the application of a layer of earth a few centimeters thick took more than one month's time.

After the forms were invested, they were left to dry for a few days. They were then subjected to moderate heat in order to remove the wax and gradually fired to a maximum temperature of approximately 600°. After slowly cooling, the molds were buried at a slightly angled position and then

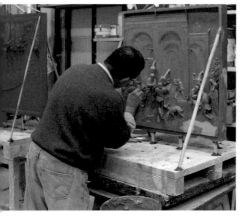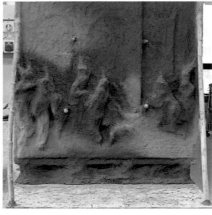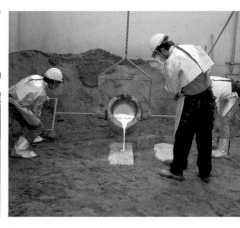

a b c

Figure 7.8 Experimentation in the foundry, investment and casting: a) and b) investment with clay, sand, and straw; c) casting; d) back of the panel with downward casting; e) front of the panel with upward casting; f) front of the panel with downward casting.

filled with molten metal, using a quaternary alloy with a composition similar to the average of those identified for the various panels.

Results obtained using the panel with the downward spruing and plaster coating were excellent (fig. 7.8f)—intact walls, few drips, and good coverage of the surface. This result was quite significant, since it demonstrated for the first time the practicability of downward casting.

Conversely, the use of upward spruing using traditional investment with earth yielded gaps due to the settling of the mold in the central area. This incident, which is not particularly relevant for the purposes of evaluating the experiment, stemmed from excessive compression of the containment earth during burial. It is significant, however, that small drips formed in the lower section and that there were small bumps due to erosion of the mold (fig. 7.8e).

Both panels were then x-rayed in order to examine where bubbles had occurred and for comparison with panel VIII (*Joshua*). We were surprised to discover that there was no significant bubble formation in either case and therefore no discriminating factor that might have helped us choose between the two methods. However, this fact turned out to be fundamental to working out final resolution of the casting problem.

Discussion and Conclusions

The information that emerged from close study, three-dimensional scanning, and experimentation leaves no doubt regarding the techniques Ghiberti used to create the wax reliefs. This was performed indirectly, using molds made from models that had previously been sculpted by the artist. Direct modeling was then performed to attach the projections, which was followed by the finishing of certain details.

In order to emphasize again the solidity of this conclusion—rather than looking further into already considered technical details—we suggest that the reader look at figure 7.9, which provides a comparison between the original and the panel created through experimentation with slush. The almost exact match between the profiles of the cavities is evident. This, together with specific details in the profiles themselves, leads us to conclude that the working methods were similar. The differences, however, stem from the manual work performed on the original: the brushing, the presumably reduced fluidity of Renaissance-era wax, and the slightly different cut of the figures, in addition to the obvious differences between the plaster mold and the silicon rubber mold that we used. While there are no documents that refer explicitly to the working methodologies demonstrated here, we believe it is useful to offer some commentary on sixteenth-century treatises as well as Ghiberti's own accounts.

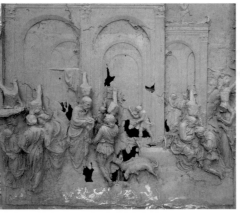
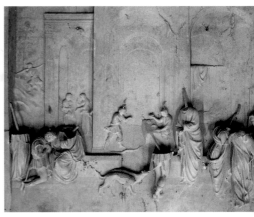

d e f

Vasari's detailed description of all the steps involved in the indirect method (sculpting the model, creating the mold, casting, etc.) leads us to believe that this was a widely used procedure. Furthermore, he reports that Ghiberti began working on the second Baptistery doors by creating "a large wooden frame . . . with head ornaments . . . and with friezes around it,"[10] from which he derived the mold. Thus he would have made a salvageable mold from the frame that, again according to Vasari's account, could be used to make another mold immediately if a first round of casting went badly. As already described in the introduction, the technical content of these sixteenth-century accounts must be considered cautiously. In addition to the vital importance of the account itself, we think it is interesting to note that an astute observer of such sixteenth-century techniques should describe quite naturally what (before the late fourteenth century), some—including Cennino Cennini—failed to mention at all. In fact, Cennini speaks of plaster and wax molds and mentions that wax casting is useful when making a model in pieces, but with regard to metal he defers to foundry workers ("Masters who understand casting and smelting")[11] or only discusses casting in lead.

One of the reasons to create a model is that it gave us the option of repeating the casting and adding the missing parts, but when crafting a complex piece like the Gates of Paradise there are other reasons to use a model. One is explained clearly by Cellini himself: "having that good model finished ahead, many young people and good workers can help to chase the figure while, without the model, to the poor master's dissatisfaction, the chasing of such works is performed in such a way that it requires more time and is not even done very well at all."[12]

As expected, Ghiberti's account also seems to make veiled reference to this methodology. Indeed, he describes the conception of the ten panels as a single, unified act: "I began the work in squares . . . stories from the Old Testament in which I had to call on all my ingenuity. . . . I performed that work. . . . There were ten stories all in settings, because I reasoned that the eye takes them in that way, and at a distance they appear to project."[13]

What runs through an artist's mind, many years later, when he recalls the various steps that were part of the birth of his masterpiece? What methods

Figure 7.9 Comparison of the back of panel V (*Jacob and Esau*) and the same panel as created during experimentation. Note the strong similarities.

and materials does he use to create his work? He models, corrects, and adds, observing the scenes on the individual panels, but it seems that he also refers to figurative choices and corrections in perspective that are very precisely executed on the group as a whole, which theoretically we can imagine in a wooden framework like the one Vasari described being used for the second door. There is indirect, if not definitive, proof of this process to be drawn from the complex metric relations between the figurative elements of the panels. For example, the eye and the mind work together to create harmony between the very tall Eve and young Cain nearby, who is somewhat shorter, and then the stonebearers, who are shorter still, positioned closer to the viewer. As Vasari essentially said ("This work presents itself as a whole"),[14] the results of this integral approach can be seen in its figurative choices.[15] In terms of perspective, the most salient point is the placement of the figures—there are few of them in the upper portions of the doors and crowds of them in the panels that are closer to the viewer. This is, of course, due in part to the story being told, but it also seems to have been done to achieve a certain effect.

Clearly, we have no incontrovertible proof that the ten panels were conceived together at one time or in groups. However, evidence of the indirect method leads us at least to consider these possibilities, as such work would have required more time than the casting. Conversely, it seems improbable that Ghiberti would have worked on the figurative group providing for the cast of the original, the preparation of the mold, and the casting of the mold soon after finishing each single panel unless he handled all design issues during the preparatory phase. In the future, we will look more closely at these aspects, which, since they involve the design and archival spheres, require further multidisciplinary analysis. In the meantime, we return to our main concern: casting technique.

What material did the artist use to make the models? It would need to have been pliant and easily manipulated, with the possibility for subsequent corrections and additions over relatively long periods of time. Most likely it was wax, the first material that Vasari mentions for small figures. From wax models Ghiberti likely moved to plaster molds and from these to creating reliefs for casting (basically, rinse casting).

In addition to the advantages of the indirect method, we should recall that the use of molds also offers the best method for creating thin walls, which allowed for savings on materials and for lightweight casting results while also emulating ancient techniques, which was clearly of interest to Ghiberti. This technical goal did not appear in the earlier bronze works *Saint John the Baptist* and *Saint Matthew,* while it can be seen clearly in the reliefs of the Gates of Paradise; it is interesting to note that it is also evident in the works executed by Donatello beginning in the 1430s.[16] Before drawing conclusions in this regard, however, an in-depth study of Ghiberti's first door is required.

Vasari, in claiming for the artist "an utterly ingenious mastery of casting," shows great respect for the technical aspect of metalworking. He says that mastery of this art was the great secret of Ghiberti's workshop—as does Buonaccorso in his *Zibaldone*—where he does not furnish any details on the methods and alloys used.[17]

The indirect and rinse methods are an essential part of "the secret of casting things so that they remain thin,"[18] but it is difficult to know the overall effect of this process due to a lack of information about earlier work. Other parts of that "secret" include spruing, the choice of investment, and

Figure 7.10 X-ray details of panel VIII (*Joshua*) corresponding to the greatest accumulation in the large cavity.

proper construction of the shell. For reasons of space, we will address the technical aspects relative to investment elsewhere. Here, we wish to focus on the first aspect and the important conclusion we drew from that.

Before beginning our experimentation, like those before us, we had overlooked one aspect that had been right in front of our eyes for nearly twenty years. The porosity made visible through X-ray examination, which had always been considered a result of bubbles, does not represent bubbles in the strictest sense. That is, these are not bubbles produced by gas. They are, instead, cavities in the metal made by trapped pieces of earth from the shell carried into the mold by the flow of molten metal. This was revealed clearly in X-rays (fig. 7.10), where the polygonal shapes of the cavities certainly demonstrate that they were not generated by trapped gas. The fragments of the shell that they enclosed came off from the branched channels applied to the back of the panel, as can be deduced from the irregular and random surface in the recognizably related areas above the arrows in figure 7.10.

We can thus conclude that, after a wax relief was created and finished, Ghiberti performed downward casting through an utterly ingenious spruing system that ran along the back of the panel. A likely solution is dictated by the fact that casting through a certain number of descending channels applied to the upper edge of the frame would not have given good results due to the alloy's lack of fluidity and rapid solidification. Ghiberti had to use this alloy composition because it was optimal for cold work (chasing) and resulted in good amalgam gilding, as had been decided from the beginning.

The flow of metal that reached the cavity through the channels effectively complemented the material that came from the base of the frame placed at the top, due to the short flow distance and the distribution across the width of the panel. This also resulted in a moderated flow of the metal through the most projecting figures, thereby helping to avoid serious erosive effects that would have had a significant negative impact on the casting.

The visible traces of such channels lead us to believe that these barely rested against the back of the panel and that the layer of earthy investment almost isolated them from the cavity of the mold. That means that as the mold was filled, the molten metal moved through it, partially breaking the fragile walls of earth bordering the small area between the channels and the mold itself. This was another ingenious trick for easily removing the metal structure that the channels left after casting. Ghiberti knew that this method "dirtied" the casting in the level area, but evidently this was considered a necessary evil. We even asked ourselves whether perhaps fragments of the

mold had been introduced on purpose, but at the moment that possibility does not seem to be supported in any way.

At least five different spruing systems were used to create the ten reliefs. This suggests two diametrically opposed possibilities: on the one hand, perhaps there was a series of incidents during the course of the work that then made it necessary to repeat some casting and caused some rethinking of the spruing; on the other, perhaps the underlying idea was considered so solid that workshop assistants were allowed a certain degree of freedom to apply their own interpretations. Assuming that attaching and distributing the channels over the entire surface of the panels was a given, we find the second possibility more likely than the first.

Final Notes

This project resulted in information and discussions that represent considerable advances in the knowledge of the techniques used to create the Gates of Paradise and of artistic casting in general as it was practiced in the early Renaissance. The conclusions reached open a window on Lorenzo Ghiberti's truly inventive casting technique and the basic methodologies that he used to achieve his artistic ideal through a complex command of bronze plastic arts, which in the case of the Gates of Paradise became sculpture in the strict sense of the word, considering the enormous amount of chasing that was done.

There is still, however, much to discover about this work and the work of Ghiberti's close collaborators in order to better understand the virtuosic evolution of metalworking techniques that reached complete maturity in the following century. We would like to conclude this voyage of discovery through one of the most brilliant minds of the Renaissance with a quotation from one of the most skilled artists and craftsmen of the sixteenth century. Cellini writes, "Lorenzo Ghiberti was truly a goldsmith, both because of the refinement of his skill and even more in terms of his infinite neatness and extreme diligence. This man can be considered an excellent goldsmith, who put all his ingenuity into the art of casting those small works . . . and that is why we call him truly a master of casting. He paid such attention to his profession and practiced it so well, that even today no other man has reached his level."[19]

1. L. Ghiberti, *I commentarii,* ed. L. Bartoli, Florence: Giunti, 1998.

2. Ghiberti uses the metaphor of the "white temples" (Classical precepts) in the *Commentarii* in reference to ancient monuments that have been destroyed, ignored, or white-washed [translator's note].

3. R. Krautheimer, *Lorenzo Ghiberti,* Princeton, New Jersey: Princeton University Press, 1956.

4. Ghiberti, *Commentarii.*

5. P. Gaurico, *De Sculptura,* 1504, with notes and translation by André Chastel and Robert Klein, Paris and Geneva: Librarie Droz, 1969; G. Vasari, *Le vite de' più eccellenti pittori scultori e architettori,* Rome: Newton Compton, 2005; Cellini 1568, *The Treatises of Benvenuto Cellini on Goldsmithing and Sculpture,* translated from the Italian by C. R. Ashbee, *Trattati dell'orificeria e della scultura,* ed. C. Milanesi, New York: Dover Publications, 1967; V. Biringuccio, *De la pirotechnia,* 1540, ed. A. Carugo, Edizioni Il Polifilo, Milan 1977.

6. M. Leoni, "Relazione delle indagini metallografiche effettuate sulla porta del Paradiso di Lorenzo Ghiberti, del Battistero di Firenze, danneggiata dall'alluvione del 4 novembre 1966," *Rapporto N. 68/17.918,* Istituto dei Metalli Leggeri, Milan, 1968; R. Cesareo and M. Marabelli, 1976, Analisi XRF di antiche porte Italiane in leghe di rame, in: *Atti del Convegno dei Lincei,* 409–420; M. Leoni, "Studio metallografico della Porta del Paradiso di Lorenzo Ghiberti del Battistero di Firenze," *La Fonderia Italiana* 4 (1981), pp. 99–101; P. Parrini in *Metodo e scienza operatività e ricerca nel restauro,* ed. U. Baldini, Florence: Sansoni Editore, 1982, pp. 168–206.

7. Parrini 1983.

8. M. Leoni, *Elementi di metallurgia applicata al restauro di opere d'arte,* Florence, 1984.

9. S. Siano, "Technical Notes," *Il ritorno d'Amore, L'Attis di Donatello restaurato,* ed. B. Paolozzi Strozzi, Florence: Museo Nazionale del Bargello, 2005, pp. 122–135.

10. Vasari.

11. C. Cennini, *Il libro dell'arte,* ed. F. Brunello, Venice: Neri Pozza Editore, 1982, p. 203.

12. Cellini.

13. *Commentarii.*

14. Vasari, p. 309.

15. Krautheimer; Caglioti, in this volume.

16. Siano 2005.

17. G. Scaglia, "A Miscellany of Bronze Works and Texts in the *Zibaldone* of Buonaccorso Ghiberti," *Proceedings of the American Philosophical Society* 120.6 (1976), pp. 485–513.

18. Vasari, pp. 309–310.

19. Cellini 1568.

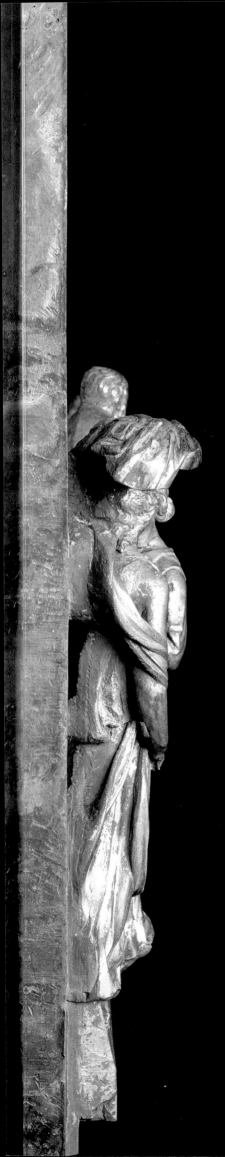

Reconstructing the Casting Technique of Lorenzo Ghiberti's Gates of Paradise

Francesca G. Bewer
Research Curator, Straus Center for Conservation
Harvard University Art Museums

Richard E. Stone
Senior Museum Conservator
The Metropolitan Museum of Art

Shelley G. Sturman
Head of Object Conservation
National Gallery of Art

IT TOOK LORENZO GHIBERTI and his large workshop twenty-seven years to accomplish the extraordinary feat of producing the enormous portal known as the *Porta del Paradiso,* or "Gates of Paradise," for the Florentine Baptistery.[1] This was the third set of bronze[2] doors commissioned in a span of ninety-five years for the main entrance of the Baptistery, facing the Cathedral.[3] The sparse surviving archival documentation of this project provides only the most basic chronology of the doors' production.[4] Florence's powerful guild of merchants, the Arte di Calimala, commissioned them from Ghiberti in 1425. The ten large narrative reliefs and twenty-four panels around them were cast by 1436–1437.[5] Preparations for casting the door frame were well underway by 1439.[6] Six of the large reliefs were completed by 1443, the rest by 1447.[7] There were clearly problems, as some of the smaller friezes had to be cast anew.[8] Work on the figures in niches, the heads, and other decorative elements—as well as gilding and completion of the frames—altogether took fifteen years.[9] The doors were installed in 1452.[10] Many questions remain. Some of these may be answered by a closer examination of the doors themselves.

The latest conservation campaign of the Gates of Paradise by the Opificio delle Pietre Dure gave occasion to a great deal of new technical research.[11] The disassembly and cleaning of the doors has brought to light the exquisite modeling and finish of the gilded sculptures (fig. 8.1). It has also revealed other surfaces on the backs and sides that were otherwise not meant to be seen. Access to these previously hidden surfaces has allowed us to investigate the doors' physical structure and to better understand how they were made.[12] Given a unique opportunity to examine the doors, we focused on reconstructing how the large relief panels were produced. We have tried to bear in mind the indisputable connection between style and technique.

There was a longstanding tradition, beginning in Antiquity and continuing through the Middle Ages, of casting monumental bronze doors, some of which were cast in one piece.[13] There can be little doubt as to why Ghiberti cast the relief elements of his doors separately from their wings. Producing the various elements individually allowed him to break down the modeling, mold-making, casting, and finishing into more manageable tasks and facilitated delegation of the work. It greatly reduced the risk of the entire door, decorations and all, being damaged, or even lost, if something went wrong

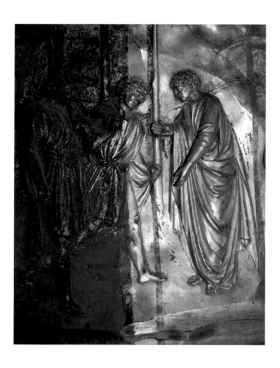

Figure 8.1 *Noah*, detail. The partially cleaned area is much more legible than the one still covered with accretions.

during the pour. And it was essential to gilding the reliefs. The mercury amalgam method that he used requires the bronze to be heated—hence the term "fire-gilding"—and heating and manipulating a large unwieldy door would have been impossible.[14]

We wondered how Ghiberti was able to translate into bronze such complex, large compositions that feature elaborate undercuts within and behind the flowing drapes and animated protruding figures. Had he used a "direct" or "indirect" casting method? Was his casting technique sufficiently fine to capture the expressive faces and delicate details in his original models, or did he need to carve most of them in the metal? Might there be a link between his technical abilities and his compositions? Could a closer technical comparison help us to discern the contributions made by the various known artists associated with the workshop? Did Ghiberti's technique evolve between the competition panel for his first set of Baptistery doors and these larger, more complex panels?

We focused primarily on establishing exactly how Ghiberti made his molds and, consequently, his models—that is, whether he used a direct or an indirect method,[15] as this bears important art-historical implications for the style and character of his work. The direct method of casting is a straightforward translation of an original, unique wax model into a unique metal cast. In the indirect method, the model used for casting is a wax copy of the original.

For direct casting, a sculptor creates an original model in wax.[16] Once the model is finished, it is prepared for casting. Wax conduits, or "sprues," which ultimately create the channels that ensure the efficient circulation of molten metal and air through the mold, are strategically attached to the model. A casting cup that serves as a funnel is attached to the top of this network of sprues. The sprued model is then encased (or "invested") in a fire-resistant (or "refractory") material, such as sandy clay. The invested model is slowly fired to dry the mold and burn out the wax—hence the expression "lost wax"—producing a mold with an internal hollow the exact shape of the sprued original wax model. Molten metal is then poured into the mold through the casting cup until it is filled. Once cooled, the investment (mold) is broken to reveal the raw cast, which will then need to be freed of sprues, core pins, and other excess metal, repaired, and then finished.

In order to minimize the volume of metal used and thereby reduce the cost, weight, and risk of flaws during casting, the artist may first fashion a more or less schematic, slightly smaller version of the model in a fire resistant material, or "core," and then build up the outer layer of the model in wax with all its details.[17]

The direct method affords the sculptor a tremendous degree of spontaneity. However, it entails the destruction of the original wax model. The obvious danger in using the direct technique is the potential of losing everything if there is a mishap during casting. This would result in the artist having to make an entirely new wax model. Indirect casting resolves this problem.

Indirect casting also begins with a model, frequently made from wax, though it could be made of any material. This original model, however, is not invested. Instead, an intermediary wax copy, or "inter-model," is made by means of a reusable mold.[18] In the fifteenth century, this was commonly a piece-mold made of a rigid material such as plaster of paris. A piece-mold is designed in sections, much like a three-dimensional jigsaw puzzle, in order to get around undercuts. The parts are made to key together and to be taken apart and reassembled without damage to either the model or the mold. The more intricate the model, the more pieces are needed. The separate pieces are held together by an outer "mother mold." The reassembled piece-mold forms a hollow mold into which wax is applied to produce the inter-model. If the bronze is to be cast hollow—which is generally the case—the wax is applied to the interior of the piece-mold in a layer only as thick as the desired bronze walls, and the remaining hollow in the mold is filled with core material. In indirect casting it is the wax inter-model, not the original, which is sprued, invested, fired, and cast.

If the surface of the original model is sufficiently irregular, with complicated undercut drapery or with multiple figures in complex poses, the piece-mold will have to be made in innumerable rigid pieces, small enough so that none of them would mechanically interlock with the surface of the model. Obviously, the subdivision of the piece-mold can be taken only so far. The sculptor is then faced with the choice of either simplifying the model so that it can be piece-molded or casting it directly.

There are several benefits to using the indirect method. It allows the artist to preserve the original model so that it might serve to guide workshop members as they perfect the wax inter-model—and, later, the bronze. A reusable mold thus allows the artist to delegate work. It also allows the sculptor to cast multiple more-or-less identical replicas of the original model. Furthermore, it provides a backup should the original casting fail. The indirect process also allegedly affords better control of the thickness of the bronze's walls—thin, even walls can be created equally well by the direct process, although it may require more skill.[19] Indirect casting also allows the sculptor to translate into bronze an original model that was made in a material that is not suitable for casting, such as clay. Yet, for many sculptors the disadvantages of indirect casting outweighed these many advantages.[20]

Some form of indirect casting was known in Ghiberti's time, but it was used for relatively simplified forms, such as low reliefs.[21] There is scant proof to date that indirect casting was used to produce complex freestanding metal sculptures in Florence in the mid-Quattrocento. The earliest freestanding statuettes known to have been made by the indirect process in the fifteenth century are the works of the northern Italian artist of the

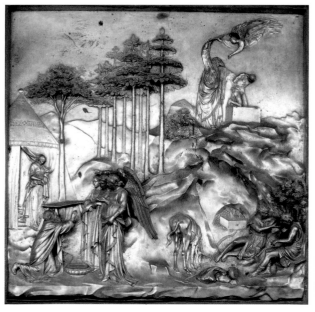

Mantuan court, Antico (Pier Jacopo Alari Bonacolsi, ca. 1460–1528). His sculptures are small replicas of ancient statues. In these, any heavily undercut or textured elements were drastically simplified to accommodate casting in rigid molds.[22] Antico certainly made replicas of some of his works, but there are no known multiples of Florentine bronze statuettes from the mid-fifteenth century.

Rigid plaster piece-molds are described in the fifteenth-century "Craftsman's Handbook" of the Florentine painter Cennino Cennini (ca. 1370–1440).[23] Ghiberti must have been acquainted with them and indeed may have used them to produce stucco or clay reliefs.[24] While it is not historically impossible that Ghiberti cast the doors indirectly, the physical evidence, when interpreted in the most reasonable and probable fashion, leads to the conclusion that he did not, as we shall demonstrate.

A flexible molding material would have made indirect casting more versatile. But there is no evidence, either physical or literary, that any such molds were used in Florence at the time.[25] Even if glue molds had been available, Ghiberti could not have used them, because he was making his models in wax. Since glue molding media must be applied hot, it would have melted the models before it set.[26]

It is within this historical context that our discussion of Ghiberti casting the Gates of Paradise must take place.

On first inspection of the panels, we were struck not only by the exquisite modeling and finishing (fig. 8.2), but also by the cast impressions of

fingerprints, waxy drips, and brushstrokes—even sketches and inscriptions—that are preserved on the reverse of the reliefs (figs. 8.3–8.5). Such features are often regarded as characteristic of an indirect method, especially with sculpture in the round. They could suggest that Ghiberti painted, poured, and pressed wax into a mold. In fact, they really prove only that he created a wax model of each panel and that he worked on them from the back as he prepared them for casting.

Upon closer scrutiny, we noticed several other clues that suggested Ghiberti indeed fashioned the models in wax and cast them directly.[27] The strongest evidence for this is the poor "conformality" of the narrative panels, particularly in the areas corresponding to the human figures.[28] The shapes of the background are fairly well represented, but in nearly all cases, the hollow recesses behind the most protruding figures rarely extend up into the torso and head of the figures (figs. 8.6–8.7). In some instances there is no recess at all behind a figure modeled virtually in the round. For example, there is no indication of the near-central figure of a man carrying a rock in his hands in the *Joshua* panel, and yet one would expect some hollow had the wax been fashioned indirectly. The only reasonable way to account for this solid figure is to conclude that Ghiberti modeled it directly onto the flat background or modeled it independently and then affixed it to the background.

The texture of the deep recesses that correspond to the reverse of most of the protruding figures provides another significant clue. It is often much coarser than the surrounding relief back and is free of waxy brushstrokes and drips. This texture suggests that the fire-resistant mold material that served to define these smaller recesses contained coarse sand and even organic inclusions.[29] In order for the wax to have picked up this texture, it must have been soft and modeled directly onto the core. But just the opposite occurs when wax is painted into a mold for indirect casting. In that case, the clay core captures the texture of the inside of the wax.

It would have been natural for Ghiberti to choose direct modeling, as he had used it to make other bronzes.[30] This approach would have given him the most freedom during modeling. It also would have provided him with access to the reverse of a panel in order to reinforce thinner parts and joins more easily and to sprue the reliefs without disrupting the fine modeling. One can only imagine how much extra finishing work would have ensued had he sprued the reliefs from the front.

Figure 8.6 *Joshua,* front. The arrow indicates the location of a man with a rock whose outline is represented in the following image.

Figure 8.7 *Joshua,* rear. The image is reversed for easier comparison with the front. The overlayed outlines of the figures show that there is no recess or other evidence on the reverse of the relief that corresponds to the central foreground figure outlined here and that most of the other figures only have vague indentations on the rear.

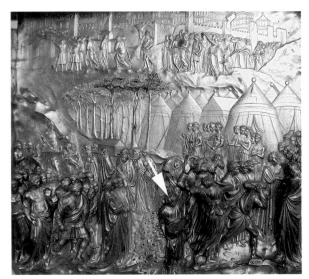

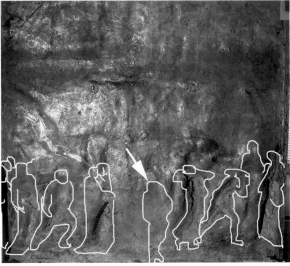

Figure 8.8 Diagrams of direct lost wax casting of a relief:

A. A temporary clay core is formed over a wooden modeling board that bears a compositional drawing to guide the core's placement.

B. The dried core is then coated with a continuous layer of wax. All of the shallow background relief is then modeled into this wax layer.

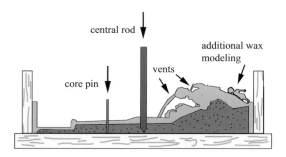

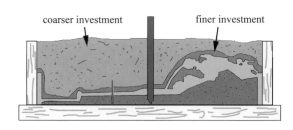

E. Iron core pins, as well as a heavy iron rod for tensioning the final mold, are carefully inserted through the wax relief, the core, and even the modeling board itself (not shown).

F. The wax relief, including all its recesses and undercuts, is first carefully coated with layers of fine clay investment, which are then backed with coarser ones.

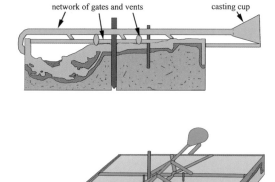

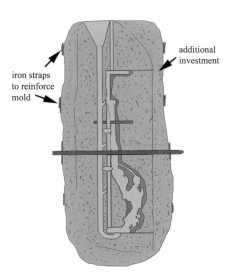

I (a and b). The temporary wooden molding frame can be removed. Sprues, as well a pouring cup and vents, all made of wax, are attached to the relief. The view in perspective clarifies the typical placement of the sprues that will eventually form the network of channels through which the molten metal will flow through the mold and the displaced air will be released.

J. The back of the sprued relief is invested in clay and the entire mold further thickened so it can bear the pressure of the dense molten metal during casting. The mold is additionally reinforced with iron straps.

163

separately modeled part
of protruding figure

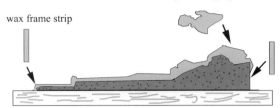
wax frame strip

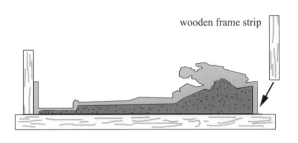
wooden frame strip

C. The projecting figures and figural groups—which have been independently modeled in wax—are attached to the background relief. The relief is surrounded with rectangular strips of wax on all four sides. These will ultimately form the bronze frame which surrounds the finished relief.

D. The relief is surrounded with a temporary wooden frame. This frame provides support to the wax model and investment during the next steps of the process.

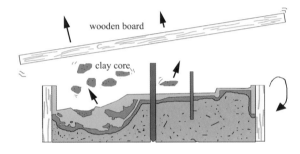
wooden board
clay core

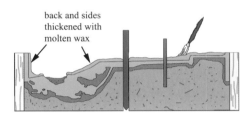
back and sides
thickened with
molten wax

G. After the clay investment has dried, the entire assembly (including the relief) is inverted. The board and temporary clay core are removed from the back of the relief.

H. The wax relief is further thickened and reinforced by spreading molten wax on its reverse.

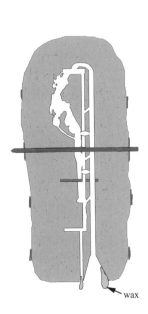
wax

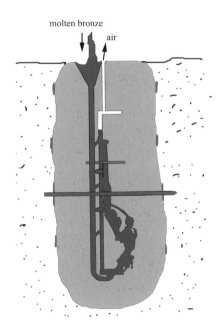
molten bronze
air

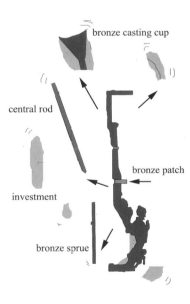
bronze casting cup
central rod
investment
bronze patch
bronze sprue

K. The fully assembled mold is heated both to melt out the wax model and sprues and to fire the clay. The mold is shown inverted, to permit the melted wax to drain.

L. The fired mold is buried in a casting pit dug into the foundry floor. It is filled with molten bronze from an adjacent furnace.

M. When metal has solidified and cooled, the clay mold is broken away. The raw casting must be cleaned, trimmed, repaired, and chased to produce the final work of art.

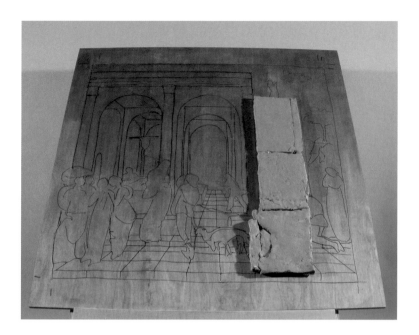

Figure 8.9 Experimental reconstruction. The clay core is built up on a wooden modeling board which bears a drawing of the composition.

Figure 8.10 Experimental reconstruction. The core is almost complete.

Figure 8.11 Experimental reconstruction. A transparent plastic sheet with the compositional drawing of the relief is used as a guide in fashioning both the core and the subsequent wax model.

Figure 8.12 Experimental reconstruction. The wax background is fashioned by pouring or painting molten wax onto the core, or laying a pre-poured layer of wax over it.

What follows is our reconstruction of the likely steps Ghiberti used to make the models of his relief panels and translate them into finished, gilded metal. This is illustrated with diagrams of the direct process as we reconstructed it (fig. 8.8) and photos of details from the panels themselves and from our own experimental work. The full-scale reconstruction being only partially finished, photos from a smaller copy were used to create a more complete sequence of visual documentation.

We believe that Ghiberti would have fashioned his model for the relief on a wooden board somewhat larger than his finished piece. Such a support would have allowed him to maneuver the reliefs while working on them. Although no preparatory drawings for the doors are preserved, it is inconceivable that Ghiberti could have planned and executed these reliefs without making many preparatory drawings and sketch models.[31] It is almost certain that there would have been some sort of drawing initially on the board itself, at least sufficient to layout the locations of the major relief elements (figs. 8.8A, 8.9).

As a goldsmith, Ghiberti would have been very aware of the advantages of saving metal—both for the sake of economy and to improve the quality of the casting. Thus, rather than modeling in solid wax, he would have started by fashioning a schematic core, reflecting the basic shape of the broader features of the background landscape or architecture and the placement of most figures in high relief (figs. 8.9–8.10; see fig. 8.20). Since any drawing on the board would have been quickly concealed by the core, Ghiberti may have transferred a sketch of his composition onto tracing paper as well, overlaying this on the wax model as he worked, in order to correctly position and size the various elements (fig. 8.11).[32]

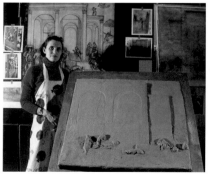

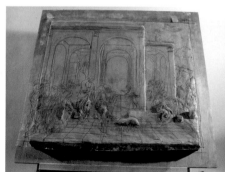

The relief with all its details would then have been built up in wax over this core. The shallower portions, such as the landscape and architectural elements of the background, would have been created first (fig. 8.8B).[33] The wax may have been applied in a number of ways: brushed on, poured on, modeled on—perhaps in fine sheets (figs. 8.12–8.13).[34] Next, figures in low relief would have been modeled directly onto the wax background. Protruding rows of figures were created in layers, as can be seen from the join line between two such figures in the *Joshua* relief (fig. 8.14). Flora and fauna, architectural details, facial expressions and gestures, and costumes and props were defined in some detail. The most protruding figures seem to have been modeled separately—at least in part—and then masterfully worked into the background, their lower bodies often gradually receding into low relief to create the illusion of depth (figs. 8.8C, 8.15). Modeling these figures separately would have given Ghiberti access to all sides of the figures. For

Figure 8.13 Experimental reconstruction. The wax background partially built up.

Figure 8.14 *Joshua,* detail. The arrows point to the join between the different layers of figures.

Figure 8.15 *Joseph,* detail. The angled view shows one way in which Ghiberti created the illusion of depth: by forming some of the figures in low relief at the feet and gradually bringing the upper bodies out from the background.

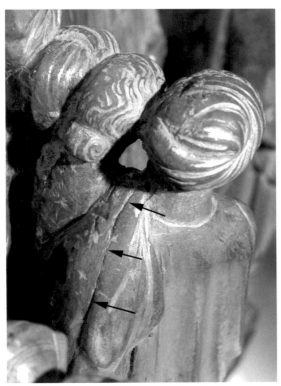

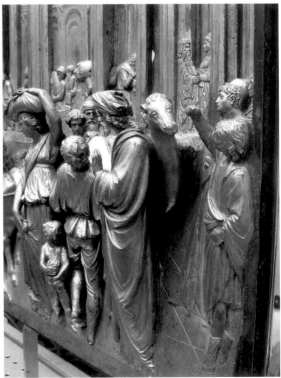

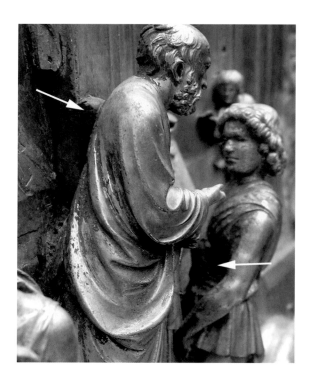

Figure 8.16 *Jacob and Esau,*
detail. One arrow points to
Jacob's right hand, which
is modeled on his belly.
Another indicates a hidden
sprue between Isaac's back
and the background, which
helped to ensure the circula-
tion of the metal during
casting.

Figure 8.17 Experimental
reconstruction. Preformed
wax strips are applied along
the edges of the relief to form
the relief's integral frame.

Figure 8.18 Experimental
reconstruction. A wooden
frame is built up around the
outside of the wax frame to
reinforce the model during the
subsequent steps of the process.

instance, he could not otherwise have modeled the delicate right hand and
drapery folds on the front of the figure of Jacob in the center of the *Jacob
and Esau* panel (fig. 8.16).

After the relief was modeled, its edges would have been trimmed
and straightened to receive the pre-formed wax strips that made up its
frame (figs. 8.8C, 8.17). These would have been welded with a hot tool
onto the four sides of the relief to form an integral frame around each
panel. Ghiberti must have used some kind of auxiliary frame, most
likely of wood, to help define and stabilize the outer dimensions of the
wax frame and also to reinforce the wax model during subsequent steps
(figs. 8.8D, 8.18).

At this stage Ghiberti could make last-minute alterations, refine the ele-
ments that abutted the wax frame, and repair any small mishaps (fig. 8.8E).
He then attached bridges of wax between the backs of projecting figures
and the background in order to ensure good circulation of metal in the
mold and prevent air from getting trapped. Most of these were removed after
casting, but evidence of some can still be found on a few projecting figures
(figs. 8.16, 8.19). These remnant struts or vents were a critical detail in our
ability to reconstruct the casting technique.

Each of the reliefs has a rectangular metal patch in its center to fill an opening that pierces through the entire thickness of the metal (fig. 8.20). Presumably, the patched rectangular opening originally held an iron rod that served as a tie bar for the metal straps used to brace the mold against the hydrostatic pressure of the molten metal and keep it from bursting.[35] In addition to the central iron tie-rod, four smaller bronze rods were positioned halfway between the center of each relief and its corners (figs. 8.8E, 8.21). These "core pins" were pushed through the full thickness of the wax model and protruded into the mold on either side. They served to secure the hollow space defined by the wax after it was melted out later in the process.

Once work on the front of the wax relief was completed, it was coated with refractory material to form part of the investment in which the bronze would be cast (figs. 8.8F, 8.22). The initial layers were made of very fine creamy slip, which would pick up minute surface details. This would have been backed with many more layers of coarser investment material, such as sandy clay mixed with fibrous organic materials.[36] The investment would have been allowed to dry on the front before the partially invested relief was flipped over and freed of the original modeling board. With the relief well supported from the front, the temporary core could be carefully pried out from the back of the wax. The newly exposed rear surface of the wax relief was cleaned (figs. 8.8G, 8.23). There was no need to excavate the core material from the recesses of the protruding figures, as they did not need to

Figure 8.19 *Noah,* detail. The arrow points to a small bridge of metal that connects the foreground figure to the background. This served as a vent to ensure that air would not be trapped in that area of the mold during casting.

Figure 8.20 *Jacob and Esau,* rear. A rectangular patch is visible in the center of the panel.

Figure 8.21 Experimental reconstruction, detail. A central rod and core pins are pushed through the wax model from the front.

Figure 8.22 Experimental reconstruction. The investment on the front of the relief is built up.

Figure 8.23 Experimental reconstruction. The temporary core is removed from the back of the wax model after the dried mold has been turned over and freed of the wooden board.

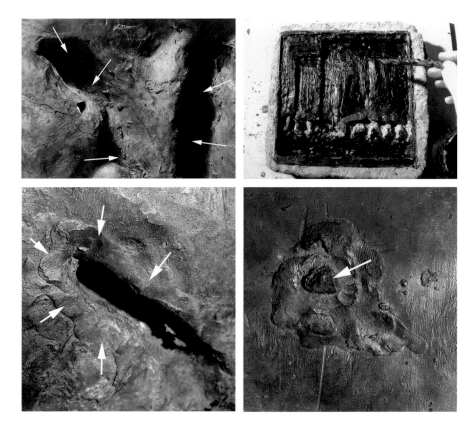

Figure 8.24 *Joshua,* rear detail. Arrows point to the coarser texture in the deeper part of the recesses. A drip from the subsequent application of wax on the model's rear surface and reproduced in bronze is also visible at the center of the image.

Figure 8.25 Experimental reconstruction. The model is thickened and reinforced with more wax, and the features created on the surface are similar to those found in Ghiberti's panels.

Figure 8.26 *David,* rear detail. Arrows point to wax reinforcement at the transition between figure and background.

Figure 8.27 *Joshua,* rear detail. The arrow points to the remains of a core pin that was pushed into the core and reinforced by pressing small bits of wax putty around it. These were translated into bronze with the rest of the model.

Figure 8.28 Experimental reconstruction. Sprues were applied to the back of the relief.

be thickened with wax. This accounts for the distinct, coarse texture of the core material, which is preserved in most of these recesses (fig. 8.24).

Next, molten wax would have been poured and brushed across the back of the relief to build up both the thinner areas and the joins between the strips of the frame and the relief (figs. 8.8H, 8.25).[37] This accounts for the brushstrokes and waxy dribbles that can be found on most of the reliefs (see figs. 8.3, 8.4, 8.24). In some instances, high points in the wax at the joins, between the protruding figures and the background, were thickened with malleable wax putty. One can see imprints of the fingers that pushed the soft wax around on the backs of some of the reliefs (fig. 8.26). Soft wax was also applied around the sides of the core pins to reinforce the connection. Though the core pins themselves were cut down flush with the surfaces of the reliefs after casting, the waxy additions are still distinct on the back (fig. 8.27).

A network of sprues—in this case, rods made either of hardened wax or reeds coated with wax—was adhered to the back of the wax relief and to points on the inside of its wax frame (figs. 8.8I, 8.28). Traces of these rods crisscross the back surfaces of all the reliefs as long, rough, fractured surfaces,

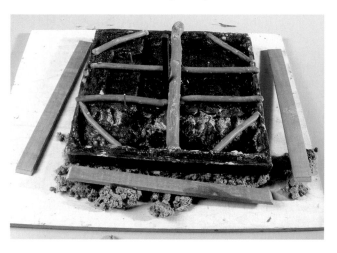

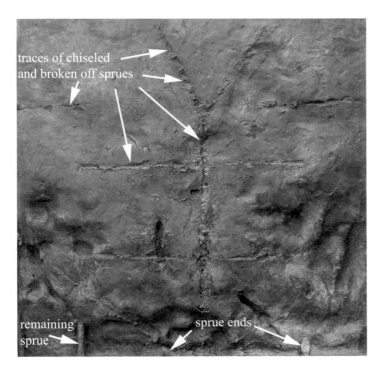

traces of chiseled
and broken off sprues

remaining
sprue

sprue ends

or coarsely chiseled marks (fig. 8.29).[38] In all ten reliefs, a central, vertical rod connected to the bottom rim and continued nearly to the top of the relief. Others ran diagonally across the corners, attaching to the inner surface of the side and bottom of the frame.[39]

The exact positioning and attachment of the rods varies from one panel to another (fig. 8.30). Their layout most likely would have been determined by factors such as the composition of the relief, a change in hands responsible

Figure 8.29 *David,* rear. Traces remain of a network of sprues that crisscrossed the back of the relief.

Figure 8.30 Schematic diagram of the doors showing the disposition of the sprue remains on the ten relief panels.

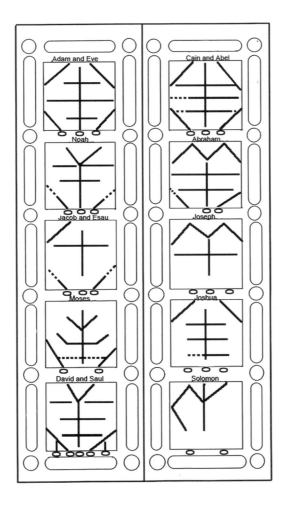

Figure 8.31 *Moses,* front. The colored overlay shows the location of the sprue remains on the rear.

Figure 8.32 *Joseph,* composite image of radiographs. The lighter areas represent the denser parts of the bronze. The dark speckling represents the porosity, which is noticeably greater in the upper part of the relief.

Figure 8.33 *Jacob and Esau,* rear detail. The large lacuna on Isaac's wrist is in a less visible area and was therefore not repaired.

Figure 8.34 *Adam and Eve,* detail. The arrows point to some of the rectangular patches, which are now visible due to the deterioration of the gilding.

for readying the relief for casting, or lessons learned in the course of experimentation. A preliminary overlay of the front and back images of the *Moses* panel shows that the rods appear to divide the relief according to sculptural groups and may have helped the metal flow in areas of transition between thicker and thinner metal and avoid casting flaws (fig. 8.31).[40]

To finish spruing the relief, any auxiliary wooden frame would have to have been removed from the sides of the model (fig. 8.8I). Then, additional sprues and the casting cup could have been attached to the outside of the frame and to the first set of sprues. These would have completed the network of sprues that served as casting channels. The newly sprued back and sides of the relief would then have been coated with refractory investment material (fig. 8.8J). The first layers of investment must have been just as fine on the back as on the front of the panels for it to retain minute details such as brushstrokes and fingerprints (see figs. 8.3–8.5).[41]

The invested mold containing the sprued wax model would have been reinforced with wrought-iron straps (fig. 8.8J), then baked to drive out all moisture and wax (fig. 8.8K).[42] The baked mold would then have been lowered into a pit adjacent to the metal furnace, and sand rammed tightly around the mold to further support it. Meanwhile, the metal would have been melted in the furnace. When liquid, the metal would have been released, flowing via a channel from the mouth of the furnace to the casting cup and into the mold (fig. 8.8L).[43]

The orientation of each mold in the casting pit remains a matter of speculation. The location of the porosity in the reliefs provides a good clue. Radiographs of several of the panels show that there is a greater concentration

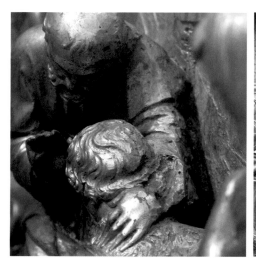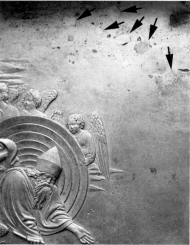

of porosity toward the top of those reliefs (fig. 8.32). Since gas bubbles rise in liquids, this concentration suggests that the reliefs were cast with the top rim upright—on edge.[44] If the reliefs had been cast face down (as many reliefs are cast today), the debris would have floated to the top of the molten metal—that is, to the relief's inconspicuous back surface. The apparent lack of any mold fragment embedded in the rear surfaces of the reliefs, along with evidence of vents connecting to the tops of figures' heads, further supports the theory that the panels were cast in a vertical orientation. Any debris would thus have floated to the top rim. Resulting imperfections could be removed during the subsequent trimming of the panels' edges.

Once cooled, the metal reliefs would have been broken out of their iron-reinforced molds. The lengthy process of freeing them of excess material, and then repairing and finishing them, now began. The iron reinforcements were removed, the chaplets cut back, and the sprues, now of solid metal (with few exceptions), were hammered and chiseled off (figs. 8.8M, 8.29).[45]

It would appear that the reliefs came out of the molds with much of the detail preserved. Inevitably, there were flaws: flashing where the liquid metal had flowed into cracks in the investment, stress cracks (a few major ones radiating from the central iron rod), considerable porosity, and in some cases larger miscasts that resulted in lacunae or in incomplete figures.[46] Only the visible surfaces were repaired and reworked. Less discernible flaws, such as those hidden in recesses, were left rough (fig. 8.33). Smaller lacunae were plugged by cutting rectangular recesses into the flawed areas and fitting them with metal patches cut to size and hammered in. Many of these are now detectable through the gold due to wear (fig. 8.34), and several have fallen out over time. The rectangular holes created by the central rods were also patched. Butterfly-shaped patches were used to hold together a crack in the *Joshua* panel. And in order to close up the gaps in the metal, the area around the crack and the repairs was worked over with a rounded hammer, producing dense peening (fig. 8.35).[47]

For larger flaws, a localized, miniature version of the lost-wax technique was generally used to "cast on" missing elements. The flawed portion would have been cut back to solid metal, some of the existing core removed, and the missing part modeled anew in situ. This new wax part would be sprued from the back of the relief, invested locally, then melted out, and molten metal of a similar alloy composition poured in place. From the front, the repair would be barely visible after the surface was reworked, but from

171

Figure 8.35 *Joshua,* rear detail. Several butterfly-shaped repairs like this one were used to secure the crack in the relief. The peened texture was created in the attempt to force the metal together. The crack and joins were micro-soldered shut during recent conservation.

Figure 8.36 *Joseph,* rear. Numerous *mattarozze* (pools of excess metal) are visible in the lower left section of the relief. The framed area is enlarged in the following image.

Figure 8.37 *Joseph,* rear detail. The *mattarozze* were formed in the process of casting-on more complex repairs from the back of the relief.

the back the pools of excess metal, referred to as *matarozze* in Italian, are
evidence of this method of repair (figs. 8.36–8.37). The sheer number of
repairs corresponding to the figures in the foreground of the *Joseph* panel
prompted earlier technical sleuths (who had access solely to this panel at that
time) to speculate that this was representative of Ghiberti's technique—in
other words, that he intentionally cast-on the protruding figures during a
second stage.[4] Given that the majority of reliefs have few such repairs, if any,
it is now clear that this was not the case.

More unusual versions of cast-on repairs can be found in the reliefs. A
complexly sprued patch was cast onto the back of the *Noah* panel to rein-
force an area with a large crack (fig. 8.38). And on several panels, both sides
of a cracked, flawed area were cut out into butterfly shapes to help key in
the cast-on fill (fig. 8.39).[49]

Once the necessary repairs were made, the unfinished surfaces of the
reliefs were heavily cold-worked and chased in the metal to close up the
porosity, enhance (or, if necessary, create) detailed features and textures, or
smooth the surfaces, as needed. Such work entailed compacting by hammer-
ing and planishing, smoothing with abrasives, and fine chasing with chisels,

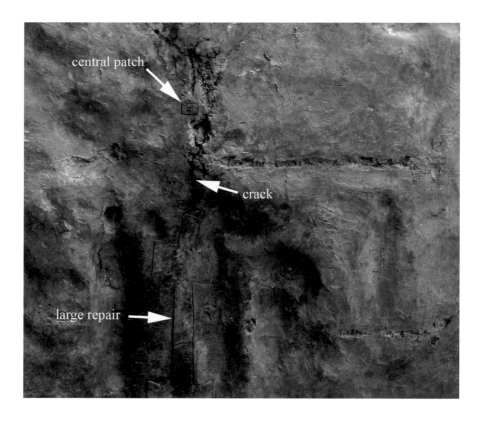

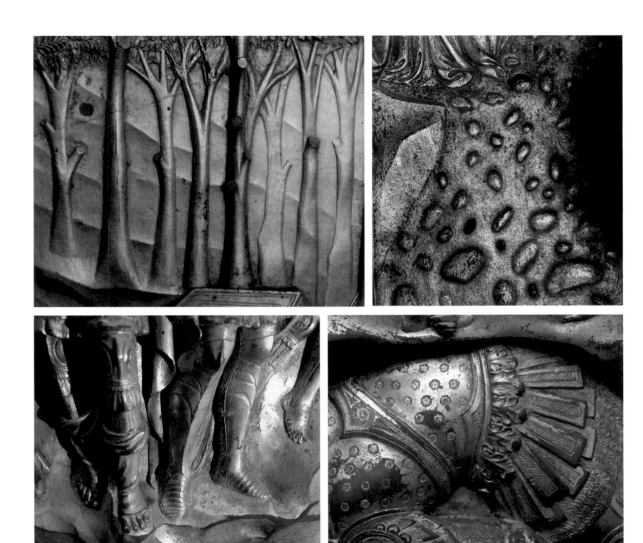

hammers, and punches (figs. 8.40–8.43). The degree of finishing and detailing varies greatly from panel to panel.[50]

Considerable trimming was required along the outer edges of the reliefs, and occasionally on the backs, to ensure that they would fit into the appositely made recesses in the wings.[51] The outer edges were pared down with flat chisels (fig. 8.44), while a convex gouge was used to thin areas of the back of several of the panels (fig. 8.45).[52] Such trimming would have occurred before the panels were gilded.

Figure 8.40 *Joshua,* detail. Subtle shifts in the highly smoothed surface planes create elegant gradations of shading in the landscape and trees.

Figure 8.41 *Joshua,* detail. The faceted texture of peened metal creates the sparkling effect of water in the river.

Figure 8.42 *David,* detail. The fine lines in the armored footware were created with punchwork in the metal.

Figure 8.43 *David,* detail. The decorative textures on Goliath's cuirasse are the result of punchwork in the metal.

Figure 8.44 *Abraham,* detail. The outer rims of the relief were pared down with chisels to fit the apposite recess in the doors; the coarse toolmarks remain, along with the porosity exposed by the trimming.

Figure 8.45 *Moses,* rear detail. The upper right corner of the bronze relief was thinned with a gouge in order to make it fit into the recess in the doors.

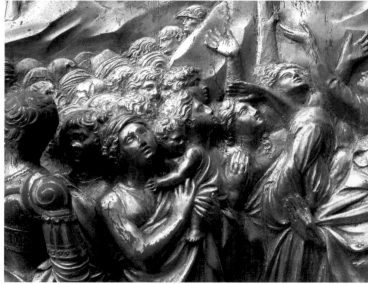

Figure 8.46 *Joseph,* detail. The arrows point to the brushstrokes from the application of the gold-mercury amalgam visible on the small background figures at the top of the relief. The darker areas have lost their gilding as a result of corrosion.

Figure 8.47 *Moses,* detail. Much detail may already have been present in the modeling of these foreground figures.

After polishing and final burnishing, the panels would have been ready for gilding.[53] This would have been done by fire-gilding, the predominant technique at the beginning of the Renaissance for applying a durable, thin layer of gold to various metal substrates.[54] The amalgam was prepared by heating gold foil in mercury to a pasty mix, which was brushed over the surface of the bronze. The sculpture thus coated would then have been heated sufficiently to volatilize the mercury, leaving the gold to form a metallurgical bond with the underlying bronze.[55] In some areas one can clearly see the strokes of the wire scratch brushes used to spread the relatively thick amalgam application (fig. 8.46).[56] The matte gilded surfaces would have been burnished to a high polish. The less visible unfinished areas behind the protruding figures were, for the most part, not gilded, for reasons of economy. The reliefs, once gilded, were carefully slotted into the appositely cast fitted recesses in the door wings and held in place by tension fit. Any remaining gaps at the joins were carefully corrected with thin bronze shims, which were hammered in and smoothed down.

The question still remains as to how much of the fine detailing (figs. 8.47–8.49) was accomplished directly in the wax or otherwise left to subsequent mechanical finishing in the metal. Modeling fine details in wax can be a challenge, because tools tend to stick in it. It is possible, however, to avoid this and achieve considerable detail by using mercury (quicksilver) with the modeling tools, as Ghiberti knew.[57] The back surfaces of the reliefs provide unanticipated proof of the high degree of detail that Ghiberti could expect of his casts. He never intended for these surfaces to be seen, as they were completely hidden within their slots in the door wings. Yet they preserve unusually fine details of the original wax model, such as fingerprints (see fig. 8.4). The quality of these surfaces attests to the technical abilities of Ghiberti's workshop. As noted earlier, he must have used at least as fine a quality of first-coat investment material on the back as he did on the front, where capturing the surface detail truly mattered. It is safe to assume that he could have expected even the finest details of his model to be reproduced in bronze. Such technical sophistication would have allowed him to reduce the amount of detail that he and his workshop had to chase into the metal later, even though they still would have had to rework the entire surface meticulously in order to reach the goldsmith's level of finishing demanded by Ghiberti.

In studying the technique of the panels from the Gates of Paradise, we felt that it was important to view them within the context of Ghiberti's bronze

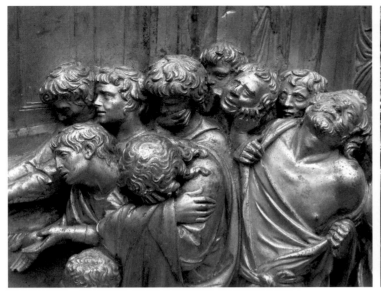

oeuvre, especially his other reliefs. We wondered how the various reliefs compared from a technical point of view and whether Ghiberti's method evolved. While we acknowledge that further research is needed to be able to fully reconstruct the history of his process, we did make some relevant preliminary observations. Ghiberti cast the competition panel for his first set of Baptistery doors (fig. 8.50) in one piece, except for the figure of Isaac, which was cast-on, and the small decorative relief on the altar, which was cast separately and neatly slotted into place.[58] As in the reliefs for the Gates of Paradise, there are hollow recesses on the back of the competition panel that correspond to various relief elements, and one can also see fingerprints and brushstrokes (fig. 8.51). Yet there are no conformal recesses behind the figures, and even fewer in the rocky ledges, which are much more massive than the rest of the background. In other words, the overall thickness of the competition panel is far more uneven than that of the Gates of Paradise reliefs. There seems to us to be no doubt that Ghiberti modeled and cast this relief using a direct process, thereby anticipating the method he used for the panels of the Gates of Paradise.

There is some indication that Ghiberti may have experimented with an entirely different approach on his first doors, the north set, at least in some of the reliefs. Indeed, in the *Annunciation* and the *Nativity* panels, one can discern a scalloped lip of metal that solidified around the edges of some of

Figure 8.48 *Joseph,* detail. Various degrees of detail can be seen in the modeling of these expressive figures.

Figure 8.49 *Joshua,* detail. Low-relief elements, such as these horses, may have been defined to a large extent in the metal by punchwork.

Figure 8.50 Ghiberti's competition panel.

Figure 8.51 Ghiberti's competition panel, rear. The relief is hollow but the overall thickness of the metal is very uneven, as can be seen, for instance, in the area of the large rocky outcropping that divides the scene. This is barely indicated on the back.

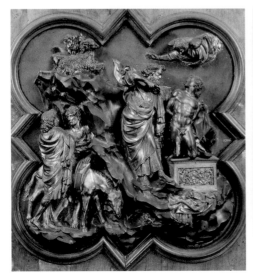

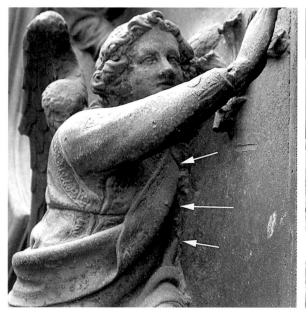

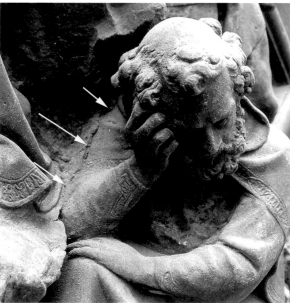

the more freestanding figures (figs. 8.52–8.53). This suggests that the more three-dimensional figures must have been cast in metal prior to casting the background. Thus, the background would have been modeled and cast around existing metal figures. It is too early to state whether this was a repair technique—some of the reliefs on the north doors are terribly flawed—or an attempt on Ghiberti's part to find a way to ensure that the figures were cast successfully. Further research should help resolve questions about the evolution of Ghiberti's technique.

As a fifteenth-century commentator famously remarked, Ghiberti's victory over Brunelleschi for the commission of the Baptistery doors was in part due to his greater technical skills. However, Ghiberti was also aided by his confidence and willingness to tolerate risk. Those attributes also served him in his bid to make the monumental *Saint John*—a bronze statue then of unprecedented size in Florence. In that effort, Ghiberti offered to pay for the entire casting of the sculpture himself should he fail.[59] That same confidence and daring led Ghiberti to cast the *Saint Matthew*—his second large and complex bronze figure—by the direct process, despite the risks and technical complications. Thus, it is logical that Ghiberti should choose the direct process to cast the reliefs of his crowning achievement. No other approach would have allowed the spontaneity and freedom inherent in this glorious assemblage of sculptures that this *excellente maestro*[60] so exquisitely made for the Gates of Paradise. With much of the Gates restored to a state akin to their earlier splendor, which originally stirred the consuls to install them opposite the Cathedral, we can once again delight in their magnificence and contemplate the mystery of their creation.

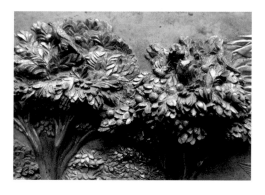

This paper is based on the study, experiments, and report that we prepared for the workshop on the Gates of Paradise held in Florence in February 2006 under the sponsorship of The Andrew W. Mellon Foundation, the Opificio delle Pietre Dure, and the Museo dell'Opera del Duomo. This research could not have succeeded without the assistance and collaboration of numerous individuals and institutions. We are grateful to Cristina Acidini Lucinat, Annamaria Giusti, Gary Radke, Angelica Rudenstein, and Philip Verre, whose wisdom and courage to pursue the organization of the international workshop on the Gates occasioned our research. We are grateful to Patrizio Osticresi and Beatrice Paolozzi-Strozzi for affording us the extraordinary opportunity to closely examine the above-mentioned works in their respective museums. Our work was generously supported by The Andrew W. Mellon Foundation, together with our individual institutions, the Straus Center for Conservation and Technical Studies of the Harvard University Art Museums, The Metropolitan Museum of Art, and the National Gallery of Art. At the HUAM, we wish to thank Angela Chang, Julia Day, Danielle Hanrahan, Teri Hensick, David Kalan, Narayan Khandekar, Henry Lie, and Anthony Sigel. At The Metropolitan Museum of Art we wish to thank James Draper, Marco Leona, and Ian Wardropper. And at the National Gallery of Art we wish to thank Daphne Barbour, Ross Merrill, Alison Luchs, Abigail Mack, Katy May, Judy Ozone, Nicholas Penny, Alan Shestack, and Julia Sybalsky. Our Italian colleagues discussed the Gates with us on several occasions, and we wish to express our thanks to Stefania Agnoletti, Annalena Brini, Fabio Burrini, Edilberto Formigli, Ludovica Nicolai, Mauro Matteini, and Salvatore Siano. Paul Cavenagh of the Paul King Foundry and Robert Shure of Skylight Studios graciously considered our thoughts about the molding and casting processes. We would also like to thank our fellow Ghiberti workshop participants—and especially Marco Leona, who examined the reliefs with the authors—for all that we learned from them.

1. Vasari-Milanesi, II, p. 242; Krautheimer Dig. 110, Doc. 36–Bagemihl Reg. p. 6, item 2, "2 January 1425, record of contract between Calimala Guild and Ghiberti."

2. The doors are only nominally bronze. The term "bronze" is often used in art-historical literature to describe what is from a metallurgical point of view a wide range of copper alloys, including bronze (copper/tin), brass (copper/zinc), and latten (copper/tin/zinc). In fact, the documents mention in at least three places that Ghiberti ordered vast amounts of brass from Flanders. Krautheimer Dig. 219, Doc. 38–Bagemihl Reg. p. 30, item 26: "Calimala deliberates to purchase 17,000 pounds of fine bronze in Flanders." Krautheimer Dig. 252, Doc. 18–Bagemihl Reg., p. 34, "Guild decides to sell 2000 florins of Monte Credits to pay for bronze from Bruges." Krautheimer Dig. 254, Doc. 19–Bagemihl Reg., pp. 34–35, item 36: "note of Guild about purchase of 14,263 pounds of bronze . . . with delivery in Florence."

3. The first set of doors was made by Andrea Pisano between 1330 and 1336. These were eventually moved to the south side to make room for the Baptistery's second set of doors, designed by Lorenzo Ghiberti. Ghiberti won the competition for these in 1401, the contract was drawn up in 1403, and the second set of doors was installed on the east side in 1424. Those doors were in turn moved to the north entrance to make room for the Gates of Paradise.

4. For an in-depth review of the chronology of the doors in light of recent archival research, see Francesco Caglioti's essay in this volume, pp. 86–97.

5. Krautheimer Dig. 198, Doc. 23–Bagemihl Reg. pp. 28–29, item 19: "4 April 1436 or 1437."

6. Krautheimer Dig. 209, Doc. 59–Bagemihl Reg. p. 30, item 24.

7. Krautheimer Dig. 259, Doc. 20–Bagemihl Reg. p. 41, item 42, "The Calimala guild declares that Ghiberti has completed the ten large reliefs. . . ."

8. Krautheimer Dig. 241, Doc. 40–Bagemihl Reg. p. 32, item 30, "new agreement for completion of ten stories of which four remain to be made." This could mean that Ghiberti had to start afresh with the full relief or, possibly, that he had to cast many repairs onto them. Indeed, quite a few of the relief elements, even the heads, have such cast-in repairs.

9. Fifteen years for the finishing work on the panels and all the rest of the work on the doors are deduced from the time the panels were cast in 1437 until they were finished in 1452. Krautheimer Dig. 282, Doc. 13–Bagemihl Reg. p. 55, item 75: "probably after 16 June 1452 or 18 April or 22 August, Lorenzo and Vittorio Ghiberti

declared to have entirely finished the third Baptistery Door."

10. Krautheimer Dig. 283, Doc. 48–Bagemihl Reg. p. 56, item 77, "the Guild installed the doors at the east portal."

11. On the conservation of the doors and recent technical analyses by the Opificio delle Pietre Dure, see the essays by Annamaria Giusti and Salvatore Siano in this volume. For results of early technical findings, see Paolo L. Parrini, "Lorenzo Ghiberti, Storia di Giuseppe e Beniamino, Storie di Adamo ed Eva, I. Sulla tecnica di esecuzione," in *Metodo e scienza: operatività e ricerca nel restauro,* exhibition catalogue, ed. Umberto Baldini, Florence: Galleria degli Uffizi, 1982, pp. 199–206 (23 June 1982–6 January 1983); and Emilio Mello and Paolo L. Parrini, "Lorenzo Ghiberti, Storia di Giuseppe e Beniamino, Storie di Adamo ed Eva, B. Stato di conservazione: esame di una microcarota," in Baldini 1982, pp. 176–180.

12. Previous studies of the doors are marred by misinterpretations of technical evidence. For instance, Krautheimer, the author of the seminal monograph on Ghiberti, thought that the back and front halves of the doors' wings had been cast separately and welded together, corroborated by an incorrect observation also made by Bearzi. Krautheimer 1970, p. 164. The design for the Gates of Paradise had started off with a programmatic layout similar to that of the two earlier sets of Baptistery doors, with at least 28 smaller reliefs (Krautheimer Dig. 106, Doc. 52–Bagemihl Reg. p. 4, item 1, "Bruni letter to Calimala with program for new door, New design consisting of eight rows and four columns of which the last row is blank"). In the absence of further archival information on the evolution of the programmatic design of the doors, Krautheimer took this technical information to be evidence that the discrepancy between the layout of 24 rectangles on the back of the doors and the ten reliefs on the front reflected a change of heart in midstream. The wings of the doors are, in fact, each cast massively in one piece (though flawed) with preformed, tight-fitting recesses for the relief elements. Clearly, Ghiberti could have cast the wings only after he had settled on the layout of the front.

13. For technical studies of a number of the Medieval doors, see *La porta di Bonanno nel Duomo di Pisa e le porte bronzee medioevali europee: arte e tecnologia,* ed. Ottavio Banti, Atti del Convegno internazionale di studi (Pisa, 6–8 maggio 1993), Opera della Primaziale Pisana, Quaderno n. 11, Pontedera 1999. See also Z. Godlewski, "Gamma-radiography of the Bronze Door of the Royal Cathedral at Gniezno," in *Radioisotopes in the Physical Sciences and Industry, II,* Vienna: International Atomic Energy Agency, 1962, pp. 165–175.

14. Metallographic examination of a sample of gilded bronze from one of the reliefs showed that the gold flowed into every dip and crack in the surface—evidence that it was applied in a liquid state. Mello and Parrini 1982, pp. 176–177 and p. 179, figs. 2–3. Further metal analysis by Auger spectronomy and XPS (X-ray photoelectron spectroscopy) detected the presence of residual mercury in the gold on the reliefs. Parrini 1982, 201.

15. For in-depth descriptions with detailed diagrams of the direct and indirect casting methods in the Renaissance, see Jo Dillon, "The Lost Wax Casting Method and Some Related Technical Features Observed in Small 'Bronze' Sculpture," in V. Avery and J. Dillon, *Renaissance and Baroque Bronzes from the Fitzwilliam Museum, Cambridge,* London: Daniel Katz Ltd., 2002, pp. 224–239; Francesca G. Bewer, "Studying the Technology of Renaissance Bronzes," in *Materials Issues in Art and Archaeology IV,* 1995, pp. 701–709; and Shelley Sturman, "A Group of Giambologna Female Nudes: Analysis & Manufacture," in *Small Bronzes in the Renaissance,* ed. D. Pincus, Washington, D.C.: National Gallery of Art, 2001, pp. 120–141.

16. The sculptor might also use other organic materials that could be destroyed by heat, such as fabric or even flora or fauna.

17. In general, the smaller the amount of molten metal in a mold, the less gas is evolved on cooling and, accordingly, the less the porosity and fewer the flaws in the final cast.

18. See Richard Stone, "Antico and the Development of Bronze Casting in Italy at the End of the Quattrocento," *Metropolitan Museum Journal* 16 (1982), p. 95, for a discussion of the terminology of indirect casting.

19. Such a method is described in the important sixteenth-century technical treatise *The Pirotechnica of Vannoccio Biringuccio,* trans. Cyril Stanley Smith and Martha Teach-Gnudi, New York, 1959, pp. 230–231.

20. Even sixteenth-century sculptors such as Benvenuto Cellini or Adriaen de Vries, who unquestionably knew indirect casting, continued to frequently cast directly. In his

Autobiography, Cellini gives a heroic account of the direct casting in one piece of his *Perseus,* and he explains that though he started to make the model plaster in order to make a piece-mold, he realized that the process would be too involved, so he ended up making it directly. Benvenuto Cellini, *Vita,* Book II, LVII, in *Opere di Benvenuto Cellini,* ed. Giuseppe Guido Ferrero, Torino, 1959, pp. 482–483. Francesca Bewer, "Adriaen de Vries's bronze technique," in Frits Scholten, *Adriaen de Vries 1556–1626,* exhibition catalogue, Amsterdam: Rijksmuseum, 1998, pp. 64–77.

21. Replicas of low reliefs in clay and stucco, or of medals and plaquettes, from that period are known, some attributed to Ghiberti's workshop. But these required much less skill with regard to mold-making —no more than a simple two-piece "bivalve" mold or even a one-piece open-face mold.

22. Stone 1982. The recent technical study of Donatello's *Attis* presents it as an indirectly cast bronze on the basis of its even, thin walls. (Salvatore Siano, "Considerazioni tecniche," in *Il ritorno d'Amore: L'Attis di Donatello restaurato,* exhibition catalogue, Museo Nazionale del Bargello, 1 October 2005–8 January 2006, pp. 122–135.) But without further evidence than that published, the authors do not feel that it is clear how the figure was cast.

23. Cennino d'Andrea Cennini, *The Craftsman's Handbook,* translated by D. V. Thompson, Jr., New Haven, 1933, pp. 127–129.

24. For a discussion of Ghiberti's serial Madonna and Child reliefs, see Galleria di Palazzo Chigi-Saracini, *La scultura: bozzetti in terracotta, piccoli marmi e altre sculture dal XIV al XX secolo,* exhibition catalogue, ed. Giancarlo Gentilini and Carlo Sisi, Siena: Palazzo Chigi Saracini, 1989, pp. 37–47.

25. The first published mention of animal glue as a flexible mold dates 100 years after the doors were installed, and is found in Biringuccio, 1959, p. 33. This was in the form of a strong, hot solution that, when cooled, would set to a tough but reasonably flexible gel. Biringuccio mentions it rather tentatively, in a much-restricted role. Glue molds were already in use, though solely to reproduce fairly flat architectural relief elements, not sculpture in the round.

26. Wax is specified both as an expense in 1429 (Bagemihl Report, p. 9) and in Ghiberti's agreement with the Calimala for some of the other relief elements in 1449; see Krautheimer Dig. 272, Doc. 89–Bagemihl Reg. p. 49, item 59, "12 September 1449 or after 9 September and before 18 September, Calimala guild order Ghiberti to receive 1000 pounds of wax for the door." See next note.

27. Ghiberti did, of course, also know how to model in clay. In the *Commentarii,* he states that he helped a lot of painters and sculptors by making "moltissimi provedimenti di cera e creta et a' pittori disegnato moltissime cose." *I commentari.* ed. L. Bartoli, Florence, 1998, p. 97. However, as shall be demonstrated in this essay, Ghiberti made his models for the Gates of Paradise in wax, as he had for the first set of doors. Indeed, the contract for that set stipulates that Ghiberti work in his own hand on the wax and metal: "deva il d.o Lorenzo lavorare di sua mano in su Cera e Ottone e massimamente in su quelle parti che sono di piu perfezione come Capelli, ignudi, e simili." Krautheimer 1970, Doc. 27.

28. "Conformality" is a term coined by Stone to describe when the inside and outside walls of a casting are parallel to one another and, consequently, the overall thickness is constant.

29. A few of the recesses seem to bear the impression of some sort of fibrous vegetable material—possibly chopped straw, which would have been included in the core material.

30. In the *Saint Matthew* (cast between May 1421, with the defective portion recast by January 1422; Krautheimer 1970, p. 86), the wall thickness is grossly uneven and non-conformal, and its core was pre-modeled. Personal observation of the *Saint Matthew* by the authors during its restoration and its exhibition in *Monumental Sculpture from Renaissance Florence: Ghiberti, Nanni di Banco, and Verrocchio at Orsanmichele,* National Gallery of Art, Washington, D.C., 18 September–26 February 2006. Furthermore, the competition panel that Ghiberti submitted for the first set of doors shows every sign of having been cast directly. See below for further discussion.

31. Andrew Butterfield makes this point in his discussion of the compositions' great sophistication in his essay in this volume.

32. Tracing paper was commonly used in fifteenth-century Florence. Cennini describes how to make it in *The Craftsman's Handbook* (13–14). For our experiments, we traced the composition on a sheet of mylar.

33. The primary wax layer was probably thin enough for the drawing on the board to be more-or-less visible, at least in outline and composition. Whatever was visible

could have been re-emphasized by lightly scribing the wax.

34. From our experiments we came to appreciate how challenging it is to make broad surfaces perfectly smooth and straight.

35. The suggestion that the central hole held a long iron rod that was used to lift and maneuver the fully invested mold is not plausible; the torsion of the projecting iron rod would have cracked the mold if used for lifting. It should also be noted that the regularly spaced, rounded patches that run down the center of each wing of the Gates of Paradise were locations for larger rods with similar functions on a much larger scale. Evidence of comparable mold supports was found on the twelfth-century bronze doors at Gniezno Cathedral in Poland. Godlewski reconstructed the casting process of the Gniezno door using radiography and analysis of the distribution of flaws and repairs. Noteworthy is his suggestion that the mold was sandwiched between two iron plates fastened with flat iron tapes, which were held in place by rods passing through the center of the mold to secure it against sideways expansion. In that door, the rods were made of a copper alloy and thus were partially integrated into the cast when the metal was poured. Godlewski 1962.

36. Organic materials such as cloth shearings and horse manure were added for green strength and to provide the mold with porosity. Benvenuto Cellini discusses in detail how to prepare good investment material and mentions various organic components. See *The Treatises of Benvenuto Cellini on Goldsmithing and Sculpture,* E. Arnold, London: 1898, pp. 112–113.

37. The wax used was probably beeswax mixed with additions such as tallow, both to lower the melting temperature and to economize, since beeswax was expensive.

38. The fractured surfaces reveal that the metal was already extremely embrittled— there is essentially no ductile deformation on the fracture surface; furthermore, the porosity is extremely fine and diffuse. Metallographic analysis would help to establish their origin.

39. The rods' function as sprues is validated by a curious miniature version of this layout in a cast-on repair on the back of the *Noah* relief (see fig. 8.38). In this instance it is clear that the channels functioned to help feed metal to the repair.

40. It remains to be seen whether this argument works for other reliefs as well. Comparison of the casting dispositions on the various reliefs might also reveal a connection between the layout of the channels and the chronological order of the stories (see fig. 8.30). The uppermost panels on the doors appear to have fewer rods and a less complicated layout. Information from the new three-dimensional scans should be invaluable in mapping with precision the correspondences between features on the fronts and backs of the panels.

41. There are variations in texture from panel to panel. For instance, the surface texture of the bottom reverse of the *Solomon* panel seems rougher than many of the others, suggesting that it may have been backed with only coarse material.

42. Workers are documented as being paid to *armare* molds. The verb implies fitting the mold with an exterior strapping in iron, not making an armature, as Krautheimer suggested. The latter does not make sense from a technical point of view. Krautheimer Dig. 209, Doc. 25–Bagemihl Reg. p. 30, item 23: 17 July 1439, "Porta di S. Gio terza si da a armare," and Krautheimer Dig. 209, Doc. 59–Bagemihl Reg. page 30, item 24: 18 July 1439, "Tinaccio di Piero e Piero di Francesco segli da a fare l'armatura del getto del telaio della terza porta di bronzo di S. Gio."

43. According to surviving documents (see note 2), Ghiberti ordered large quantities of brass from Flanders at the time of the casting of the door wings, but there is no indication in the documents of what he acquired for the reliefs. Ghiberti needed to use an alloy that was malleable enough to be cold-worked extensively in the final chasing. Metal analysis would help identify the alloy Ghiberti used and whether it was fairly consistent throughout. Without further documentary evidence about the source and nature of the metal he bought, however, it will be difficult to draw any significant conclusions if the alloy compositions vary significantly. For earlier analytical results, see Parrini 1982, pp. 200–201; for more recent ones, see Siano's essay in this volume.

44. This was first observed by Parrini in the early 1980s when the *Joseph, Adam and Eve,* and *Cain and Abel* panels were studied and radiographed. Parrini 1982, p. 200.

45. The spongy texture of the metal at the breaks and its lack of ductility upon fracture are probably due not only to retraction porosity but also to hydrogen porosity from excessive poling (using a wooden pole to reduce the oxygen content in the molten copper). The one published cross-section of

metal cast by Ghiberti (Parrini 1982, p. 179, fig. 1) shows intergranular porosity typical of hydrogen evolution.

46. Contrary to the conclusion of Parrini, who published the results of the technical investigation of a few of the reliefs in 1982 (Parrini 1982, p. 199), Ghiberti did not systematically cast-on every protruding figure and indeed, while all the reliefs have protruding figures, in some of the reliefs there are no cast-ons at all.

47. The butterfly repairs on the *Joshua* panel have since been reinforced using contemporary laser soldering by Fabio Burrini at the Opificio delle Pietre Dure.

48. Parrini 1982, pp. 199–200.

49. Large sections of repairs on one of the wings of the doors have a sequence of such butterfly-shaped repairs. The shape helps to lock the repairs in place.

50. For in-depth discussion of the surface tooling, see Formigli's essay in this volume.

51. Trimming the metal exposed a quantity of large-vacuole porosity, visible now because the panels are exhibited separated from the Gates. The porosity was not repaired, as it would have been hidden inside the recesses.

52. The same kind of tool was used to pare down the surfaces of recesses in the door wings. These marks are reminiscent of the long rounded gouges left by a stonecarver's channeling chisel. The task of cleaning up the reliefs and door wings may in fact have been delegated to the numerous *scarpellatori* employed in Ghiberti's workshop. Some of these are referred to, for instance, in Krautheimer Dig. 255a, and in Bagemihl Report 13 December 2005, p. 10, and Bagemihl Register 14 December 2005, pp. 36–37.

53. The documents show that the doors were gilded in a few months. See Krautheimer Dig. 279 and 280, Docs. 46, 47– Bagemihl Reg. pp. 54–55, items 71, 72: "2 April 1452: Lorenzo and Vittorio are commissioned to gild the door" and "16 June 1452, Ghiberti's door declared completely gilded."

54. For more on fire-gilding in the Renaissance, see Andrew Lins, "Gilding Techniques of the Renaissance and After," in Terry Drayman-Weisser, *Gilded Metals, History, Technology and Conservation,* London: Archetype, 2000, p. 241.

55. Residual mercury was detected in the gold on the reliefs. Parrini 1982, p. 201. According to Andrew Oddy, "analysis of numerous gilded metal objects of the Roman period has shown that the presence of a trace of mercury in the gilding is common from the third century AD onwards, but rare earlier." Oddy, "A History of Gilding with Particular Reference to Statuary," in Terry Drayman-Weisser, *Gilded Metals, History, Technology and Conservation,* London, 2000, p. 5.

56. It is likely that some of the small, bumpy accretions in the engraved lines and on the surface are the result of gold amalgam deposits. Others are caused by copper corrosion products, which pushed up through the gold layer.

57. The fifteenth-century sculptor and theorist Filarete (Antonio di Piero Averlino, ca. 1400–1469), purportedly a student of Ghiberti's, described how to do this. In order to fashion "the finest details such as eyes and hair" in wax models for bronzes, Filarete recommends using quicksilver with the modeling tools; this "helps to keep the wax from sticking to the tools and allows one to make the details crisp." Filarete, *Trattato dell Architettura,* vol. 2, ed. and trans. J. R. Spencer, New Haven and London, 1965, fols. 184–185. "A chi volesse fare di bronzo e mestiere fare prima di cera a lavorare questa chera e mestiere di fare fuseghli di legno duro che sieno in questa forma [tool illustrated in margin] grand e piccolo e dogni ragione di grado in grado e mestiero fargli di piombo anchora e che gli fa di rame questi sadoperano avendo a fare cose minute. Ma a fargli di piombo con un poco di stagno dentro meglio e poi con largento vivo avivargli ogni minuta cosa ci si pu fare con essi poi capelli occhi ogni parte per picchola che sia perche avvivargli coll argento vivo non vi sapiccha la cera e poi lascia netto tale lavorio. E a lavorare di terra bisogna questi medesimi fusegli." Ghiberti no doubt used this method, for there is no other way of accounting for the "oncia di ariento vivo" he ordered while modeling the figure of *Saint Matthew.* For a transcription of the records relating to *Saint Matthew,* see Doren 1906, p. 33. Bewer originally discussed the Filarete quotation and its relevance to Ghiberti in her unpublished master's thesis, "Vannoccio Biringucci's *De la pirotechnia* (Venice, 1540) and Bronze Sculpture," Warburg Institute, University of London, 1986, pp. 66–67. Stone experimented with amalgamated modeling tools. The end of a thin copper rod was hammered to a typical spatula shape and then amalgamated with mercury. The amalgamated surface retained a surprisingly tenacious film of liquid metal even after being rubbed briskly with a cloth. The amalgamated tool proved to be very

effective for working with beeswax, as the mercury completely prevented the tool from adhering to the wax and also acted as an effective lubricant. The wax retained a slick, smooth surface; when viewed under magnification, a few tiny globules of free mercury were visible on the wax surface. In time, the coating crystallized into a mercury/copper inter-metallic phase formed by diffusion, but re-amalgamation restored the liquid coating. It would appear that Filarete's curious little shop trick actually works.

58. Abraham's index finger and blade are also repairs.

59. Baldinucci quotes Ghiberti's lost diaries: "Dec. 1, 1414, I undertook to cast it at my own expense; in case of failure I was to forfeit my expenses." Krautheimer 1970, p. 73, and Dig. 36, Doc. 163.

60. According to Strozzi's excerpts, one of the differences in the contract with Ghiberti for the third bronze door of S. Giovanni was the addition of the words *excellente maestro* to Ghiberti's name. Krautheimer 1970, p. 159.

Second printing, 2007.

Library of Congress
Cataloging-in-Publication Data

Ghiberti, Lorenzo, 1378–1455.
 The Gates of paradise : Lorenzo Ghiberti's Renaissance masterpiece / Gary M. Radke, editor ; Andrew Butterfield . . . [et al.].
 p. cm.
 Issued in connection with an exhibition held Apr.–July 2007 at the High Museum of Art, Atlanta, and at other museums in the U.S. at later dates.
 Includes bibliographical references.
 ISBN-13: 978-0-300-12615-0 (hardcover: alk. paper)
 ISBN-10: 1-932543-15-5 (hardcover: alk. paper)
 ISBN-13: 978-1-932543-16-2 (softcover: alk. paper)
 ISBN-10: 1-932543-16-3 (softcover: alk. paper)
 1. Ghiberti, Lorenzo, 1378–1455. Gates of paradise—Exhibitions. 2. Art metalwork—Technique—Exhibitions. 3. Bronze doors—Conservation and restoration—Italy—Florence—Exhibitions. 4. Bible—Illustrations—Exhibitions. I. Radke, Gary M. II. Butterfield, Andrew, 1959–. III. High Museum of Art. IV. Title.
NB1287.F6G43 2007
730.92–dc22 2007004427

Kelly Morris, Manager of Publications
Heather Medlock, Assistant Editor
Rachel Bohan, Editorial Assistant
Laurie Hicks, Exhibition Coordinator
Translations by Eriksen Translations Inc., New York

Published by High Museum of Art, Atlanta, in association with Yale University Press, New Haven and London
 www.yalebooks.com

Designed by Jeff Wincapaw
Proofread by Barbara McGill
Typeset by Maggie Lee
Color separations by iocolor, Seattle
Produced by Marquand Books, Inc., Seattle
 www.marquand.com
Printed and bound by Die Keure, Bruges, Belgium

Photography credits

The publishers wish to thank the institutions named in the illustration captions and below for supplying photographic material and permitting reproduction.

ARTstor. Photographer: Antonio Quattrone, Florence: cover, pages 1–3, 11–12, 16, 42–50, 72–80, 98, 110–118, 134–140, 156; figs. 2.4–2.7, 2.10, 2.12–2.20, 2.23–2.27, 4.6, 8.2, 8.6, 8.20.

Annamaria Giusti, Opificio delle Pietre Dure: figs. 1.1, 3.1, 5.1–5.21, 8.32.

© Scala / Art Resource, NY: figs. 1.2–1.4, 2.1, 2.8–2.9, 2.11, 2.21, 2.29–2.31, 3.2, 3.6, 3.8, 3.12–3.14, 4.1.

Detroit Institute of Art. Photographer: Dirk Bakker: fig. 1.5.

© Alinari / Art Resource, NY: figs. 2.2, 3.3–3.5, 3.7, 3.9–3.10.

© Erich Lessing / Art Resource, NY: figs. 2.22, 4.5.

© Victoria & Albert Museum, London / Art Resource, NY: fig. 2.28.

© Nicolo Orsi Battaglini / Art Resource, NY: fig. 3.11.

Foto Aurelio Amendola: fig. 3.15.

© Cleveland Museum of Art: fig. 3.16.

Franco Cosimo Panini Editore Spa: page 10; figs. 4.2–4.4.

Edilberto Formigli: figs. 6.1–6.59.

Salvatore Siano: figs. 7.1–7.10.

Francesca G. Bewer: figs. 8.1, 8.5, 8.7–8.15, 8.17–8.19, 8.21–8.23, 8.25, 8.27–8.28, 8.30, 8.33, 8.35, 8.37–8.38, 8.40–8.41, 8.44, 8.47–8.49, 8.51–8.53.

Shelley Sturman: figs. 8.3–8.4, 8.16, 8.26, 8.29, 8.34, 8.42–8.43, 8.54.

Marco Leona: figs. 8.24, 8.31, 8.36, 8.39, 8.45–8.46.

Museo del Bargello, Florence: fig. 8.50.

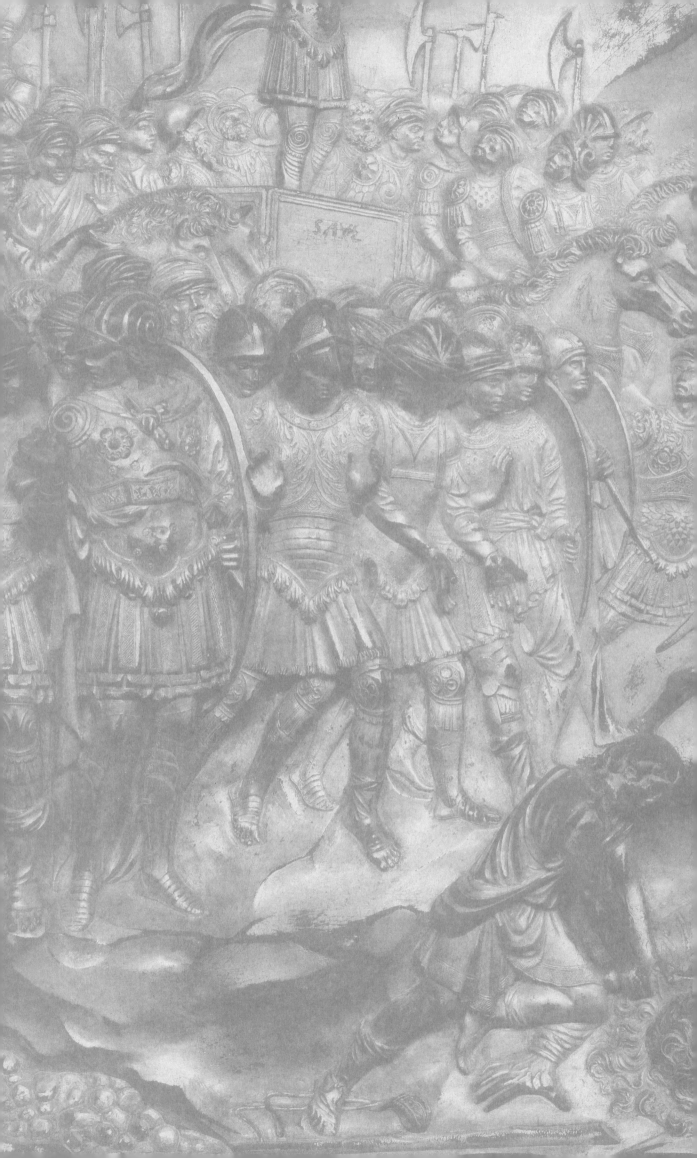